HOW TO READ
EUROPEAN ARMOR

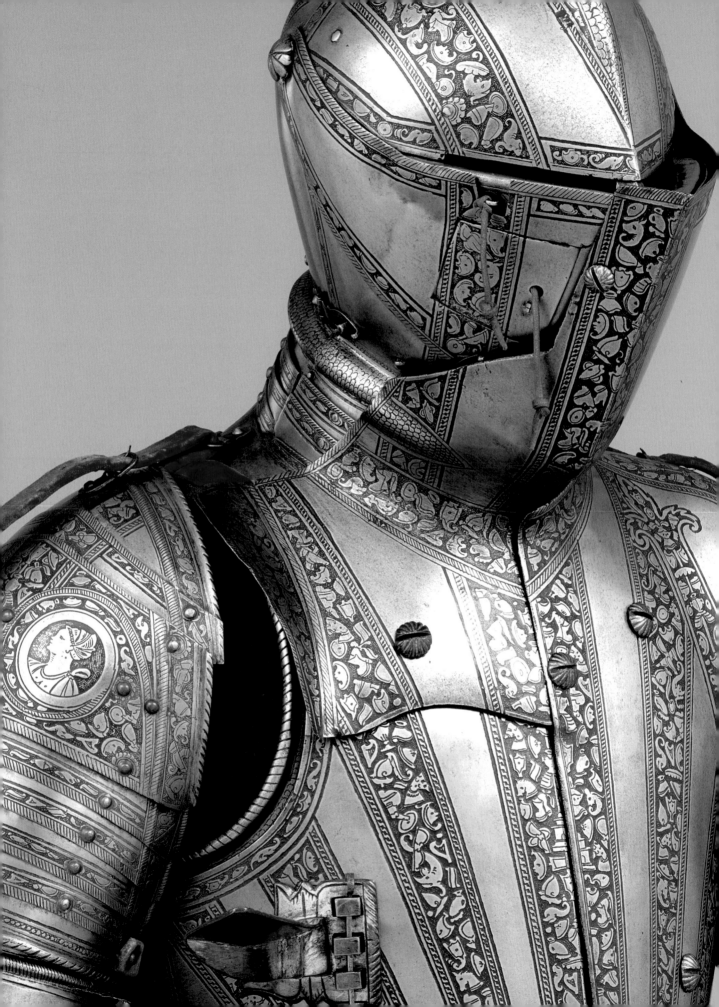

HOW TO READ
EUROPEAN
ARMOR

Donald J. La Rocca

The Metropolitan Museum of Art, New York
Distributed by Yale University Press, New Haven and London

This publication is made possible by the Diane W. and James E. Burke Fund. Additional support is provided by Ronald S. Lauder, Marica F. Vilcek, Laird R. Landmann, Kenneth Lam and Vivian Chui Lam, Irene Roosevelt Aitken, and Paul Ruddock.

Published by The Metropolitan Museum of Art, New York
Mark Polizzotti, Publisher and Editor in Chief
Gwen Roginsky, Associate Publisher and General Manager
 of Publications
Peter Antony, Chief Production Manager
Michael Sittenfeld, Senior Managing Editor

Edited by Barbara Cavaliere
Designed by Rita Jules, Miko McGinty Inc.
Production by Christopher Zichello
Image acquisitions and permissions by Elizabeth DeMase

The works illustrated in this publication are in the collection of The Metropolitan Museum of Art, unless otherwise indicated.

The primary photographer of the armor in The Metropolitan Museum of Art's collection is Bruce Schwarz, Imaging Department, The Metropolitan Museum of Art.

Additional photography credits: © Bayerisches Nationalmuseum München, Photo by Krack, Bastian: fig. 100; Gabinetto Fotografico delle Gallerie degli Uffizi: fig. 96; General Research Division, The New York Public Library, Astor, Lenox and Tilden Foundations: fig. 4; Ernst Thomas Groll: fig. 9; © Imperial War Museums (Q 11538): fig. 53; KHM-Museumsverband: figs. 19, 136; Su concessione del MiBACT, Soprintendenza archeologia, belle arti e paesaggio per l'area metropolitana di Venezia e per le province di Belluno, Padova e Treviso: fig. 5; The Morgan Library & Museum. MS M.775, f. 122v. Purchased in 1931: fig 8; The Morgan Library & Museum. MS M.638, fol. 39r. Purchase by J.P. Morgan (1867-1943) in 1916: fig. 91; The Morgan Library & Museum. MS M.775, fol. 277v. Purchased in 1931: fig. 103; ©Musée des beaux-arts de Dijon. Photo by François Jay: fig. 16; The Museum of Decorative Arts in Prague: figs. 36,76; Museumslandschaft Hessen Kassel, Gemäldegalerie Alte Meister: fig. 15; © The National Gallery, London: fig. 18; National Military Museum, Soest: fig. 44; © National Museums Scotland: fig. 17; Rijksmuseum, Amsterdam: fig. 173; RKO Radio Pictures/ Photofest: fig. 3; © RMN-Grand Palais / Art Resource, NY: figs. 45, 101; Scala / Art Resource, NY: fig. 2; Photo by Roland Seiler: fig. 10; © Victoria and Albert Museum, London: fig.141

Typeset in Documenta and Poetica Chancery IV
Printed on 150gsm GalerieArt Volume
Color separations, printing, and binding by Trifolio S.r.l.,
 Verona, Italy

Cover illustrations: front, detail of Armor of Henry II, King of
 France, French, ca. 1555 (fig. 139); back, detail of Close Helmet
 of the Dos Aguas garniture with the volant piece in place,
 Italian, Milan, ca. 1550–75 (fig. 155)
Title page: detail of the Dos Aguas armor equipped for the
 Italian tilt, Italian, Milan, ca. 1550–75 (fig. 83)
Frontispiece on p. 6: detail of Burgonet, German, Augsburg,
 ca. 1550–55 (fig. 140)

The Metropolitan Museum of Art
1000 Fifth Avenue
New York, New York 10028
metmuseum.org

Distributed by
Yale University Press, New Haven and London
yalebooks.com/art
yalebooks.co.uk

Cataloguing-in-Publication Data is available
from the Library of Congress.
ISBN 978-1-58839-629-7

CONTENTS

Foreword 7

INTRODUCTION 9
 Highlights in the Development of Armor in Europe 10
 Centers of Armor Production 27

THE SUM OF ITS PARTS: ARMOR FROM HEAD TO TOE 37
 Helmets 42
 Gorgets 48
 Breastplates, Tassets, and Backplates 51
 Pauldrons 56
 Vambraces 59
 Gauntlets 59
 Leg Defenses: Poleyns, Cuisses, Greaves, and Sabatons 59

THE DOS AGUAS ARMOR AS A GARNITURE 67

ARMORED SADDLES AND HORSE ARMOR 77

TOURNAMENT ARMOR 85

DECORATION 97
 Etching 98
 Mercury Gilding and Heat Bluing 111
 Engraving, Inlay, and Damascening 113
 Embossing 113
 Applied Borders and Appliqués 135

HOW TO READ EUROPEAN ARMOR 139

EPILOGUE 153

Suggested Reading 159
Acknowledgments 160

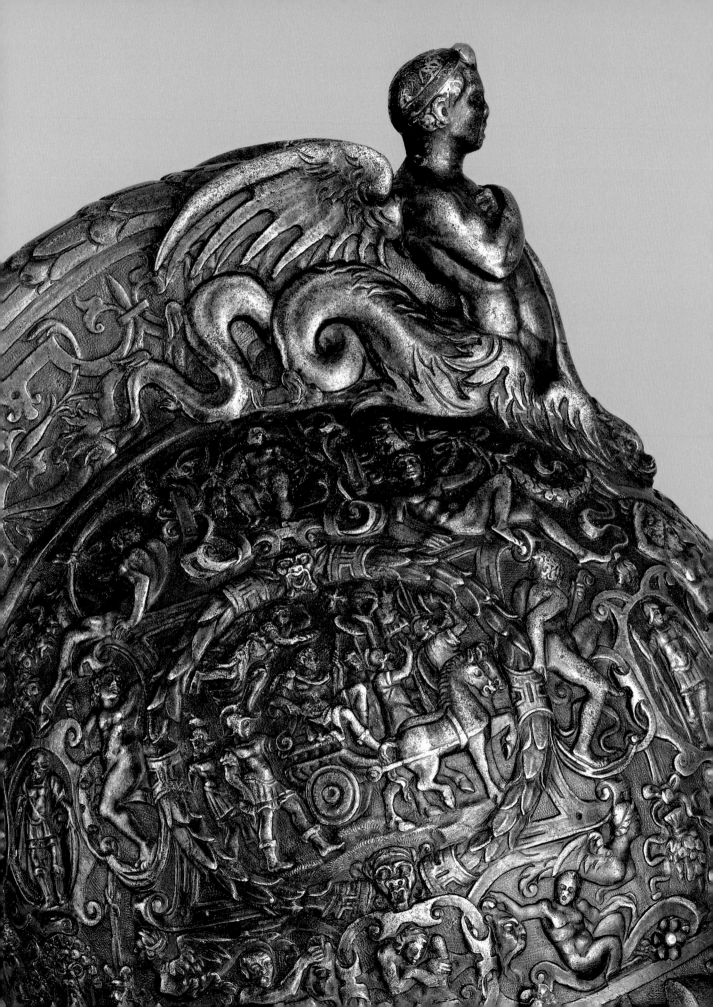

FOREWORD

At once beautiful and functional, armor provides protection and adornment for the wearer. European plate armor, created over centuries in a remarkable range of styles, is perhaps the greatest manifestation of this art form. From intricately etched breastplates to ingeniously embellished helmets, decorated armor is movable and wearable sculpture.

Established in 1912, the Department of Arms and Armor at the Metropolitan Museum comprises one of the finest, largest, and historically representative collections of its kind. For this publication, our curator Donald J. La Rocca has chosen a group of enlightening examples of medieval and Renaissance European armor from the more than five thousand European pieces in the Museum's holdings. Dating mostly from the fifteenth to the seventeenth century, they encompass all types of plate armor: field, tournament, and ceremonial.

How to Read European Armor is the seventh volume in the How to Read series, which is designed to introduce the general reader to a group of related works from the Museum's encyclopedic collection. The series elucidates works of art from around the world to encourage broader understanding and appreciation of the meaning of individual works and the cultures in which they were created. In this instance, any reader drawn to the chivalric and courtly life and art of medieval and Renaissance Europe will find that this richly illustrated volume enhances his or her knowledge of the art of the armorer, created during an era of astounding artistic brilliance, civic change, and cultural upheaval.

We are deeply grateful to Diane Burke and the Diane W. and James E. Burke Fund for providing lead support of this publication. We also wish to acknowledge the generosity of members of the Visiting Committee of the Department of Arms and Armor including Ronald S. Lauder, Marica F. Vilcek, Laird R. Landmann, Kenneth and Vivian Chui Lam, Irene Roosevelt Aitken, and Paul Ruddock for advancing the body of knowledge on these extraordinary works of art.

Daniel H. Weiss
President
The Metropolitan Museum of Art

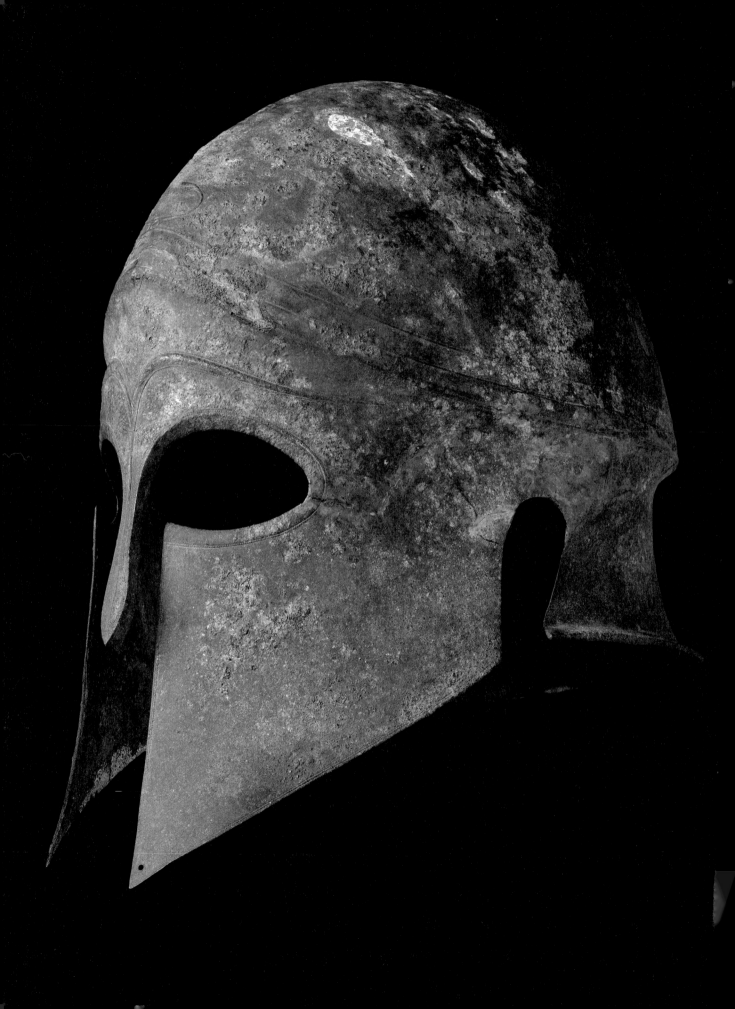

INTRODUCTION

Armor has been worn both as protection against lethal weapons and as personal adornment for over four thousand years (figs. 1 and 2). In nearly every culture around the world, rugged utilitarian armor was used alongside ornate armor that was essentially a form of wearable sculpture. Part of armor's fascination is this quality of combining functionality and beauty. Armor is familiar to most of us because we have seen it many times, on display in museums, as costumes in movies (fig. 3) and on television, or as illustrations in history books or our favorite children's storybooks (fig. 4). As evocative and deeply ingrained in our minds as these images may be, actual historical armor is more complex, inventive, and attractive than any film or literary version. The majority of European armor that survives today is from Western Europe and dates from the fifteenth to the seventeenth century. Therefore, this book focuses on that period, with the goal of providing the information necessary for us to better understand, appreciate, and enjoy the many fascinating elements that are creatively combined in actual armor, and to dispel the myths and misconceptions about armor that often cloud our perceptions.

Fig. 2. Gold Helmet of Meskalamdug, King of Kish, Sumerian, ca. 2600 B.C. The National Museum of Iraq, Baghdad (IM.8629)

Opposite: Fig. 1. Helmet of the Corinthian Type, Greek, early 5th century B.C. Bronze, h. 12 1/16 in. (30.6 cm). Purchase, Mr. and Mrs. Ronald S. Lauder Gift and Louis V. Bell, Harris Brisbane Dick, Fletcher, and Rogers Funds and Joseph Pulitzer Bequest, 2016 (2016.235a)

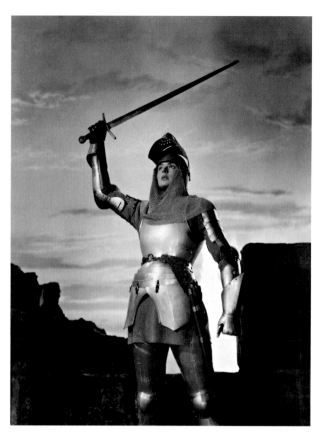

Fig. 3. Ingrid Bergman as the title character in the 1948 film, *Joan of Arc*. Her armor was handmade of aluminum at The Metropolitan Museum of Art in 1947 by the Museum's armorer Leonard Heinrich

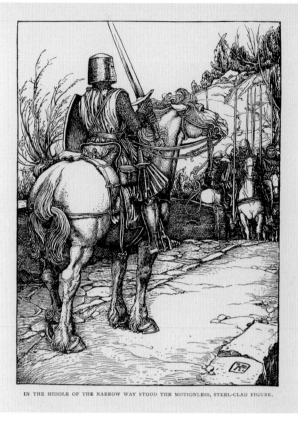

IN THE MIDDLE OF THE NARROW WAY STOOD THE MOTIONLESS, STEEL-CLAD FIGURE.

Fig. 4. *In the middle of the narrow way sat the motionless, steel clad figure.* Illustration from the first edition of Howard Pyle, *Otto of the Silver Hand*, p. 151 (New York, 1888). Courtesy The New York Public Library, Astor, Lenox and Tilden Foundations

HIGHLIGHTS IN THE DEVELOPMENT OF ARMOR IN EUROPE

For roughly one thousand years, from about the third century B.C. through the early fourteenth century A.D., mail, also called chain mail, was the predominant and most effective type of body armor known in Europe (fig. 5). A mail garment is composed of rows of iron or steel rings assembled in a four-into-one pattern, with each ring linked to the two rings above and two rings below it, to create a strong and flexible mesh. Up until about the mid-fourteenth century, some mail was made from rows of solid rings alternating with rows of riveted rings. After that period, mail usually consists entirely of riveted

rings. In the medieval world, a complete shirt of mail, or hauberk, was an expensive and treasured possession, often passed down and used over several generations. Mail shirts reached their most refined stage in the fourteenth to the fifteenth century (fig. 6). In a classic example from that time, the shirt is seamless and the borders are trimmed with rows of riveted latten rings at the cuffs and hem. On the chest is a prominent brass seal decorated with the phrase ZU NUERENBERG (in Nuremberg) surrounding the coat of arms of that city (fig. 7), indicating that the shirt had passed the rigorous quality control standards required by the Nuremberg guild of mail-makers (*sarworter*). A few rare mail shirts also include

Fig. 5. A figure of a fully armored warrior from a relief in the Church of Santa Giustina, Padua, ca. 1200. Soprintendenza belle arti e paesaggio per le province di Venezia, Belluno, Padova e Treviso

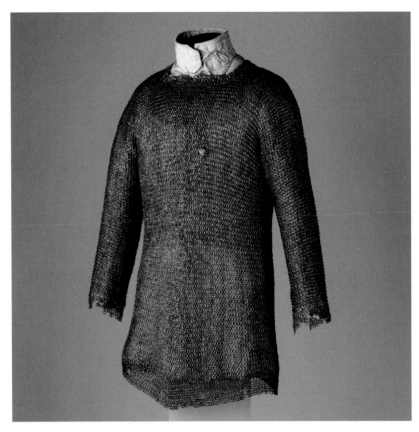

Fig. 6. Shirt of Mail, German, Nuremberg, 15th century. Steel, copper alloy (latten), iron, and brass, h. (as mounted) 36 in. (91.5 cm). Bashford Dean Memorial Collection, Gift of Edward S. Harkness, 1929 (29.156.68)

a ring cast with the maker's name. From about the mid-fifteenth century onward, when used in conjunction with full plate armor, mail was important for filling the gaps between plates (fig. 8). Separate mail sleeves were made to be worn with a cuirass (breastplate and back-plate); shaped panels of mail called gussets, covered the armpits or the crooks of the elbows and were attached to arming jackets, garments specially tailored to be worn under armor; and mail breeches, called brayettes or pairs of paunces, could be worn by men fighting on foot.

As early as the thirteenth century, mail was augmented by single or jointed plates, first of hardened leather and then of steel, to protect the arms and legs. The

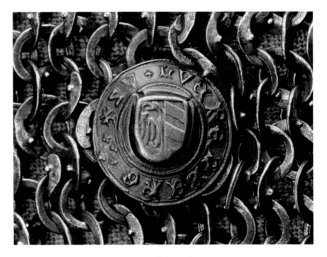

Fig. 7. Detail of brass seal on mail shirt, fig. 6

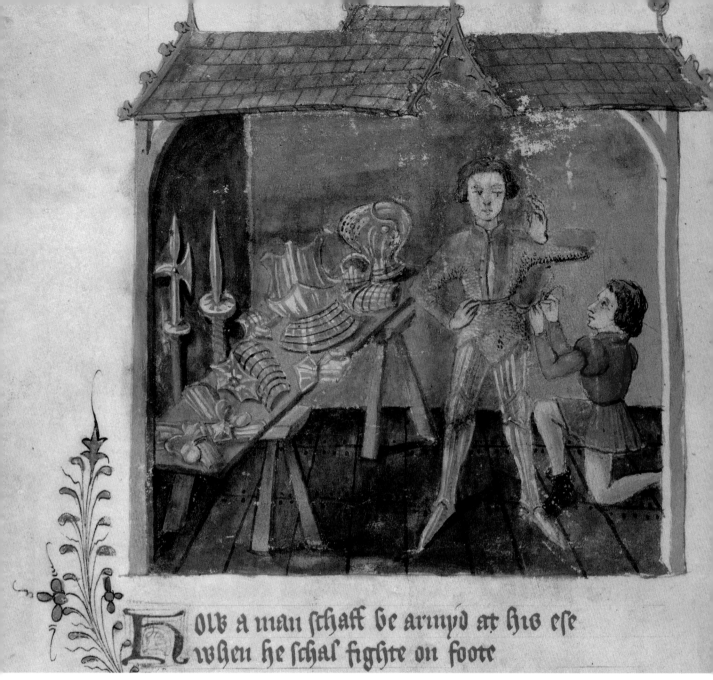

Fig. 8. *Ordonances of Chivalry*, England, late 15th century, detail showing a man being armed for a judicial combat. The Morgan Library and Museum, New York, MS M.775, fol. 122v

torso remained the most difficult area of the body to protect effectively without restricting movement. Over the centuries, armorers devised many different solutions to this challenge. One practical answer to the problem is the coat of plates, a type of armor that was used in varying forms throughout Europe in the thirteenth and fourteenth centuries (figs. 9 and 10). At its most basic, the coat of plates comprises a sturdy textile or leather tunic lined with steel plates of different shapes and sizes. The plates are riveted to the interior of the fabric, and the rivet heads are visible on the exterior of the tunic. No surviving examples of coats of plates are complete or intact;

Above: Fig. 9. Statue of Saint Maurice in armor, ca. 1240–50, Cathedral of Saints Catherine and Maurice (Magdeburg Cathedral), Magdeburg, Germany. Polychromed limestone, h. 45¼ in. (115 cm). The saint wears a mail shirt with long sleeves and mail mittens, a coat of plates, and a mail hood

Right: Fig. 10. Effigy of Otto VI von Orlamünde, showing a coat of plates with chains at the chest for attachment of sword and dagger, German, 1340. Convent Church at Himmelkron, Bavaria

most consist of groups of loose plates that have been excavated from medieval archaeological sites. Therefore, the coat of plates in The Metropolitan Museum of Art, although damaged, is extremely rare both for the extent of its completeness and as the only example to retain so much of its original textile (fig. 11). Shown laid out flat because of its fragility, with the interior facing up, it has a slight ridge embossed in the plates running up the center of the back. The scooped cutouts to the left and right accommodate the arms of the wearer, and the panels at either side would wrap around the torso and meet in the front at the center of the chest and abdomen. Now missing are the straps and buckles that originally fastened the piece closed.

During the mid- to late fourteenth century, coats of plates were superseded by brigandines, garments tailored to fit the torso and hips more closely, in which the plates are smaller and more numerous (fig. 12). Fifteenth-century brigandines usually open at a seam running vertically down the front or back and fasten closed with horizontal straps and buckles. That was the typical method of closure until about the end of the century, after which side seams and laced closures became the norm. Brigandines in general are made up of small overlapping rectangular iron plates, often tinned to inhibit rust, which were riveted to a sturdy fabric, such as canvas, usually faced with an outer layer of finer material, sometimes leather but more often silk. The rivet heads visible on the exterior are arranged in straight rows, made up of either single rivets or triangular clusters of three, and in addition to being decorative, they are also functional in fixing the plates to the fabric layers. On some fifteenth-century examples, the chest area was protected by a pair of L-shaped plates, which formed a rigid two-piece breastplate (fig. 13), and the center of the back was protected by a single wedge or hourglass shaped plate (fig. 14). This type is well represented in works of art, but surviving examples of the plates themselves are very rare. These larger breastplates and backplates went out of use toward the end of the fifteenth century. However, brigandines lined with close-set rows of very small rectangular plates were still made and widely used for much of the sixteenth century (fig. 15). Because of their versatility and relative affordability, brigandines were worn by some of the first Europeans who came to the New World in the late fifteenth and

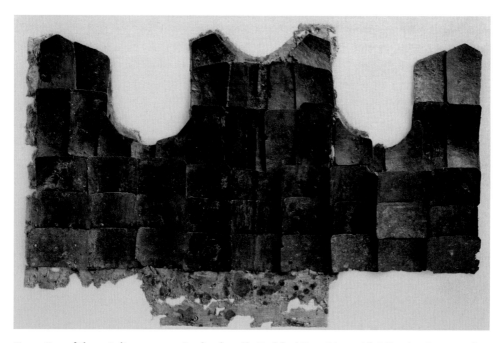

Fig. 11. Coat of Plates, Italian, ca. 1400. Steel and textile. Bashford Dean Memorial Collection, Bequest of Bashford Dean, 1928 (29.150.105)

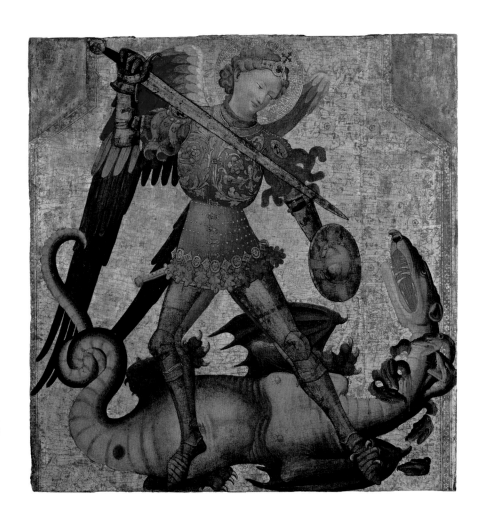

Fig. 12. *Saint Michael and the Dragon*, Spanish (Valencian) Painter (active in Italy, early 15th century), ca. 1405. Tempera on wood and gold ground, 41⅜ x 40¾ in. (105.1 x 103.5 cm). Rogers Fund, 1912 (12.192)

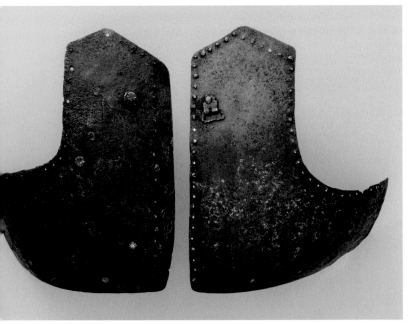

Fig. 13. Right and Left Breastplates from a Brigandine, Italian, ca. 1400–1425. Steel, brass, and textile, right: h. 11½ in. (29.2 cm); left: h. 11¹¹⁄₁₆ in. (29.7 cm). Bashford Dean Memorial Collection, Bequest of Bashford Dean, 1928 (29.150.92, .101)

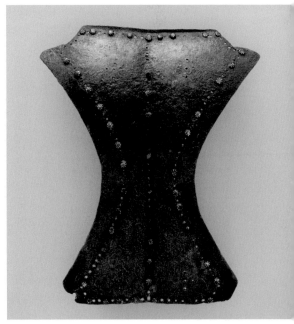

Fig. 14. Backplate from a Brigandine, Italian, ca. 1400–1450. Steel and copper alloy, h. 10 in. (25.4 cm). Bashford Dean Memorial Collection, Bequest of Bashford Dean, 1928 (29.150.95)

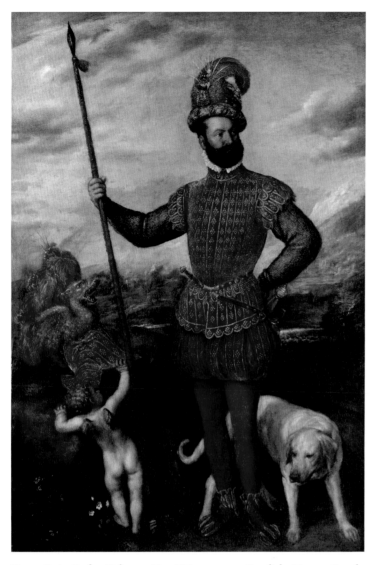

Fig. 15. *Portrait of an Unknown Man*, Titian, ca. 1550, Staatliche Museen Kassel, Museumslandschaft Hessen Kassel, Gemaldegalerie Alte Meister

Fig. 16. Statue of Saint George, late 14th century Retable de Crucifixion, Jacques de Baerze, detail. Musée des Beaux-Arts de Dijon, inv CA 1420 A

sixteenth centuries, as evidenced by historical documents and the brigandine fragments that have been found at several archaeological sites in the Americas.

Along with more effective protection for the torso, refinements in complete, fully articulated, and increasingly elegant armor for the arms and legs continued during the fourteenth century (fig. 16). A variety of helmet types were used, including a close fitting helmet called a bascinet, which has a distinctive snout on a pivoted visor (see fig. 54, top right); an open-faced helmet with a broad brim called a kettle-hat or *chapel-de-fer* (literally, hat of iron; see figs. 111 and 112); and the great helm, which covered the entire head and rested on the shoulders (fig. 17). Complete plate armor, with the torso fully clad in a steel cuirass (breastplate and backplate), was created by armorers in northern Italy by the late fourteenth century and soon evolved into the iconic form known as Italian Quattrocento armor that was exported throughout Europe and is

frequently depicted in great detail in Renaissance art (fig. 18). The breastplate was made in two sections, with a lower half, or plackart, overlapping the upper breastplate to provide added flexibility and a backplate of similar construction. Streamlined styles of helmets, including barbutes and armets (see fig. 54), and ingenious improvements to armor for the shoulders and the extremities were refined through the fifteenth century.

North of the Alps from the mid-fifteenth century to about 1500, the most significant developments in armor design coalesced in the German Gothic style, the quintessence of which is an armor made by the Augsburg armorer Lorenz Helmschmid (ca. 1445–1515) about 1485 for Emperor Maximilian I (1459–1519) when he was duke of Burgundy (fig. 19). In the early sixteenth century, the elongated lines of Gothic armor become broader, fuller, and more rounded. Within decades, between the 1490s and about 1510, in armor of the early German Renaissance, the smooth steel surfaces are worked with narrow ribs and channels, called fluting (fig. 20), to create what was

Fig. 17. The Pembridge helm, British, ca. 1350, steel. National Museum of Scotland, A.1905.489

Right: Fig. 18. *The Battle of San Romano*, Paolo Uccello (ca. 1397–1475), probably ca. 1438–40, detail. Egg tempera with walnut oil and linseed oil on poplar, 72¼ x 126 in. (182 x 320 cm). The National Gallery, London, NG583

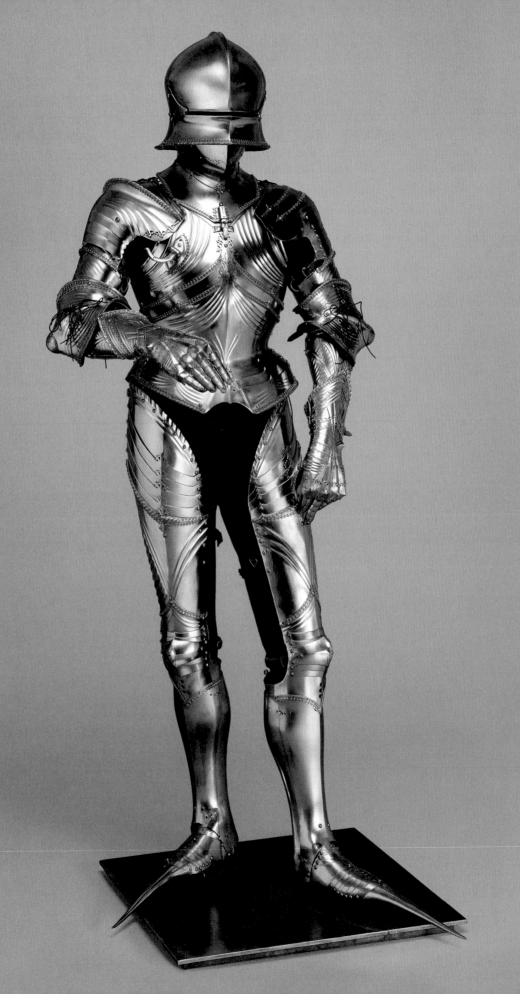

Opposite: Fig. 19. Armor of
Emperor Maximilian I,
ca. 1485. Height: 175 cm.
Kunsthistorisches Museum
Vienna, Hofjagd- und
Rüstkammer, A62—
KHM- Museumsverband

Right: Fig. 20. Field Armor in
the Maximilian Style, German,
Nuremberg, ca. 1525. Steel and
leather, h. 67 in. (170.2 cm);
wt. 49 lb. (22.23 kg). Rogers
Fund, 1904 (04.3.289)

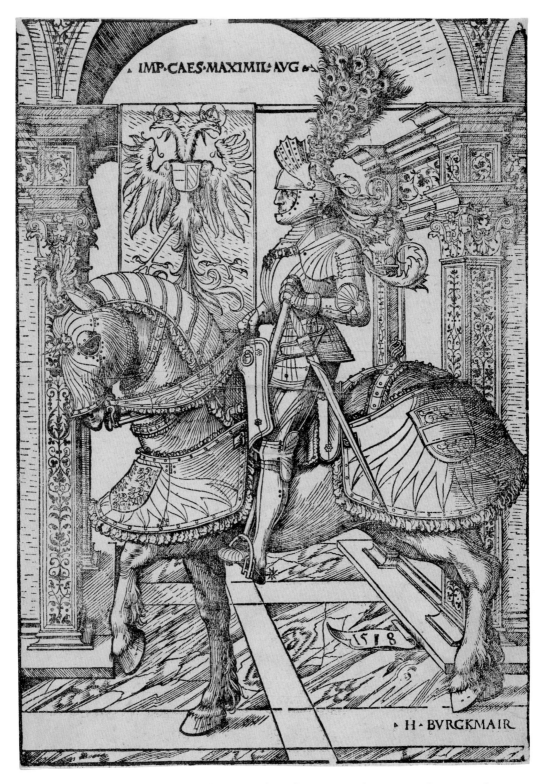

Fig. 21. *Emperor Maximilian I on Horseback*, Hans Burgkmair (German, Augsburg 1473–1531), 1518. Woodcut, 12 11/$_{16}$ x 8 15/$_{16}$ in. (32.3 x 22.7 cm). Gift of Felix M. Warburg, 1920 (20.64.24)

later termed the Maximilian style, a reference to its prevalence in the territories of the Holy Roman Empire during the reign of Emperor Maximilian and a generation beyond (fig. 21).

By the early to mid-sixteenth century, plate armor reached its peak in both stylistic beauty and functional perfection. Most armor of this period falls into three broad categories: field, tournament, or ceremonial. Field armor simply means armor made for use in battle. Tournament armor was used only in tournaments, which were organized events, with rules, judges, and spectators. The contestants required highly specialized armor, just as protective sports equipment today is unique to the particular needs of an individual sport and generally not usable in other sports. Ceremonial armor was designed for visual impact, to convey luxury and status rather than for protection. In addition to these principal categories of armor, and sometimes combining aspects of all three, armor garnitures were an important innovation of the early sixteenth century. A suit of armor is considered a garniture when it has matching extra parts that can be added or exchanged to adapt it for specialized uses, such as infantry, cavalry, or different types of tournament fought on horseback or on foot.

European armor was always undergoing changes and improvements in its defensive capabilities in order to protect against corresponding developments in offensive weapons, in addition to making changes related to considerations of style and fashions in ornament. In terms of pure functionality, while never completely impenetrable, armor evolved over many generations to guard effectively against bladed weapons such as lances, swords, and daggers; percussive weapons including maces and flails; and projectile weapons, principally bows and arrows and crossbows. However, after dominating the battlefields of Europe for almost a thousand years, body armor was gradually rendered obsolete by the destructive capabilities of gunpowder, unleashed in the form of increasingly sophisticated artillery and firearms. Matchlock muskets, developed in the late fifteenth century, were the first practical type of handheld guns (fig. 22). Their use changed

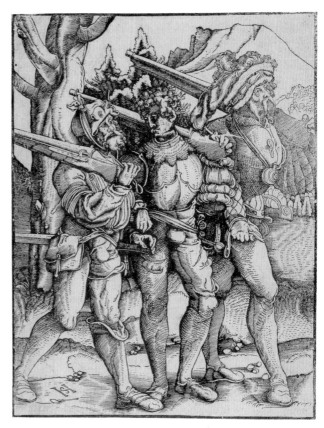

Fig. 22. *Three Soldiers with Muskets*, Hans Schäufelein (German, Nuremberg, ca. 1480–ca. 1540), ca. 1511–15. Woodcut, 8¼ x 6⅜ in. (21 x 16.2 cm). Harris Brisbane Dick Fund, 1931 (31.58.7)

military tactics across Europe, and eventually other parts of the world, with the proportions of troops slowly shifting in the course of the sixteenth century from an emphasis on heavy cavalry and lancers combined with archers or crossbowmen to a preponderance of infantry armed with muskets and other types of firearms supported by cavalry and pikemen. In order to be bulletproof, the thickness, and therefore the weight, of plate armor had to be increased to the point that it became impractical to wear for any length of time, causing it to go out of use, with limited exceptions, by the end of the seventeenth century. During that century, the dominance of firearms engendered three very recognizable types of armor: pikeman's armor, cuirassier's armor, and harquebusier's armor. After this, armor was largely abandoned, although steel or brass

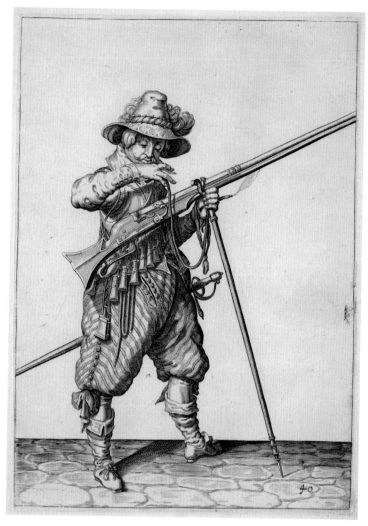

Fig. 24. A soldier blowing on a match, from the Musketeers series, plate 40, in *Wapenhandelinghe van Roers Musquetten Ende Spiessen* (The Exercise of Arms), Jacques de Gheyn II (Netherlandish, Antwerp, 1565–1629 The Hague), ca. 1610. Engraving; third state of five (New Hollstein), 13 13/16 x 10½ in. (35.1 x 26.7 cm). Bequest of Phyllis Massar, 2011 (2012.136.353.2)

helmets and cuirasses continued to be worn by some heavy cavalry until the start of the twentieth century.

Pikeman's armor has a characteristic broad-brimmed helmet and a cuirass with wide tassets (plates covering the upper thighs) (fig. 23). The armor takes its name from the steel-tipped spear, or pike, up to eighteen feet in length, that was a pikeman's principal weapon. Thus armored and arrayed in ranks with their pikes leveled, pikemen provided a nearly impenetrable wall to protect troops of musketeers from cavalry or infantry attack, particularly while the musketeers were in the vulnerable position of reloading their weapons (fig. 24). The combination of pikemen and musketeers is referred to as pike and shot, a key component of European armies for much of the seventeenth century.

Opposite: Fig. 23. Pikeman's Armor, British, probably Greenwich or London, ca. 1620–30. Steel and brass, helmet (a): h. 12 in. (30.5 cm); cuirass and tassets (c–f): h. 27 in. (68.6 cm); wt. 19 lb. (8618 g). Rogers Fund, 1919 (19.129a-f)

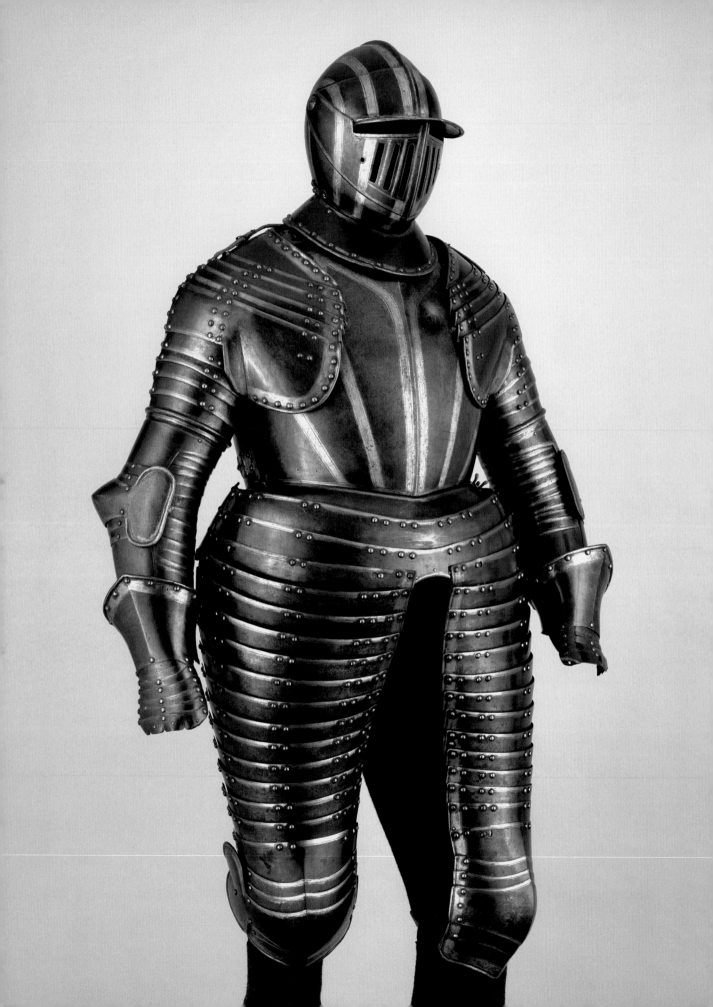

Fig. 26. The complete arms and equipment of a cuirassier, from Johann Jacobi von Wallhausen, *Art militaire a Cheval ... Frankfurt*, 1616. Library of the Department of Arms and Armor

Cuirassier's armor is three-quarter length, covering the body from the head to the knees (fig. 25). It was worn by heavy cavalry, known as cuirassiers, from about 1600 to about 1650. Cuirassiers were often armed with swords and pairs of pistols instead of lances (fig. 26). Armor of this type could be bulletproof in certain areas, such as the breastplate or helmet, or it could be made bulletproof by adding a reinforcing breastplate or extra plates to the helmet. Rather than battle damage, a bullet dent in one of the plates is usually a proof mark demonstrating that the armor was shot proof, meaning that it withstood the test firing of a musket or pistol and was therefore effective protection against those weapons.

Harquebusier's armor comprises a helmet and cuirass, and sometimes a long gauntlet, called a bridle gauntlet, for the left hand only (fig. 27). Usually, the cuirass was worn over a garment of sturdy leather called a buff coat. Harquebusiers were armed with swords, pistols, and a short musket or carbine called a harquebus, from which their name is derived. They were the last regular troops of armored cavalry before armor went out of general use in Europe in the mid- to late seventeenth century.

Opposite: Fig. 25. Cuirassier's Armor. Italian, Milan or Brescia, ca. 1610–30. Steel, gold, leather, and textile, h. as mounted 54 in. (137.2 cm); wt. 86 lb. 8 oz. (39.24 kg). Purchase, Arthur Ochs Sulzberger Gift, 2002 (2002.130a-p)

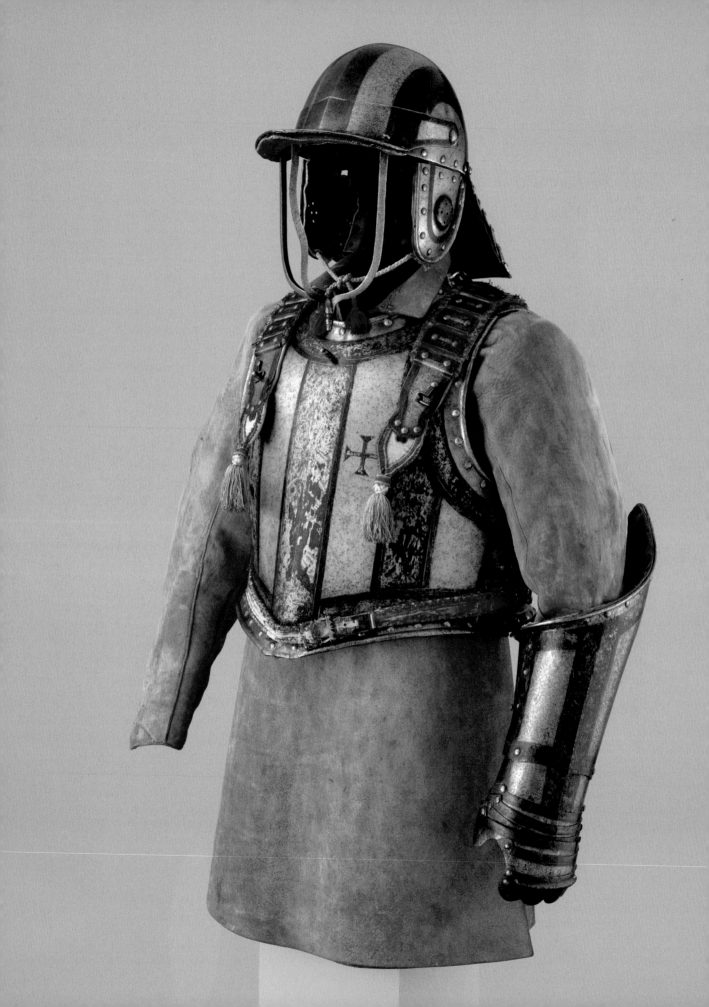

CENTERS OF ARMOR PRODUCTION

Armor of good to average quality was made in many cities throughout Europe from the Middle Ages to the early seventeenth century (fig. 28). However, the creation of the highest quality custom armor for an international clientele of rulers and noblemen, as well as the production of large quantities of standardized armor, called munitions armor, occurred in only a few cities or court workshops, which were famous for the skill of their armorers. The works of many armorers and production centers are recognizable thanks to surviving pieces stamped with identifiable maker's marks and city marks (fig. 29). Unfortunately, there are far more individual craftsmen and active places of production that are only known through period documents and for which no surviving examples of actual armor can be identified.

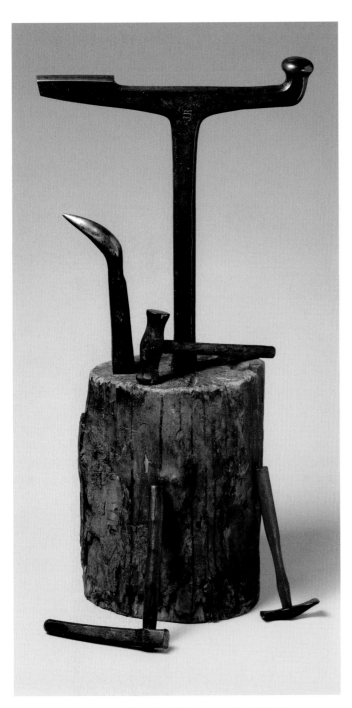

Fig. 28. Hammers and Stakes of the armorer Daniel Tachaux (1857–1928), German or French, 18th to 19th century. Iron and wood. Rogers Fund, 1912 (12.230.2, .32, .98, .129, .179)

Fig. 29. Armorer's mark of Lorenz Helmschmid and the city mark of Augsburg, detail of a Pair of Tournament Pauldrons (Shoulder Defenses). German, Augsburg, ca. 1500. Steel and copper alloy. Bashford Dean Memorial Collection, Gift of Edward S. Harkness, 1929 (29.156.67h, i)

Opposite: Fig. 27. Harquebusier's Armor of Pedro II, King of Portugal (reigned 1683–1706) with leather Buff Coat. Armor attributed to Richard Holden (British, London, recorded 1658–1708), ca. 1683. Steel, gold, leather, and textile, wt. 43 lb. 5 oz. (19.6 kg); buff coat, 17th–18th century. Armor: Rogers Fund, 1915 (15.113.1–.5); buff coat: Bashford Dean Memorial Collection, Funds from various donors, 1929 (29.158.885). The armor was restored and its shoulder straps made by Daniel Tachaux in 1915, see fig. 28

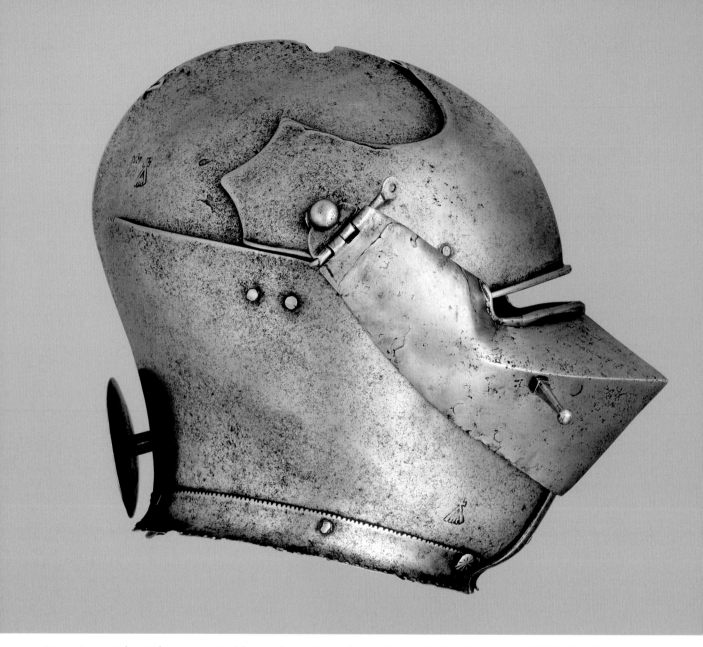

Fig. 30. Armet, Italian, Milan, ca. 1475. Steel, h. 10 in. (25.4 cm); wt. 7 lb. 7 oz. (3374 g). Bashford Dean Memorial Collection, Funds from various donors, 1929 (29.158.51)

Milan was a leading center of the international armor trade from as early as the thirteenth century until the sixteenth century. Not just armor, but also the armorers were exported, and Milanese armorers established workshops in several Italian cities, including Brescia, Venice, Florence, Rome, and Naples, and even on the Dalmatian coast. They were equally sought after abroad and founded

Fig. 31. Detail of Missaglia mark on Italian Armet, fig. 30

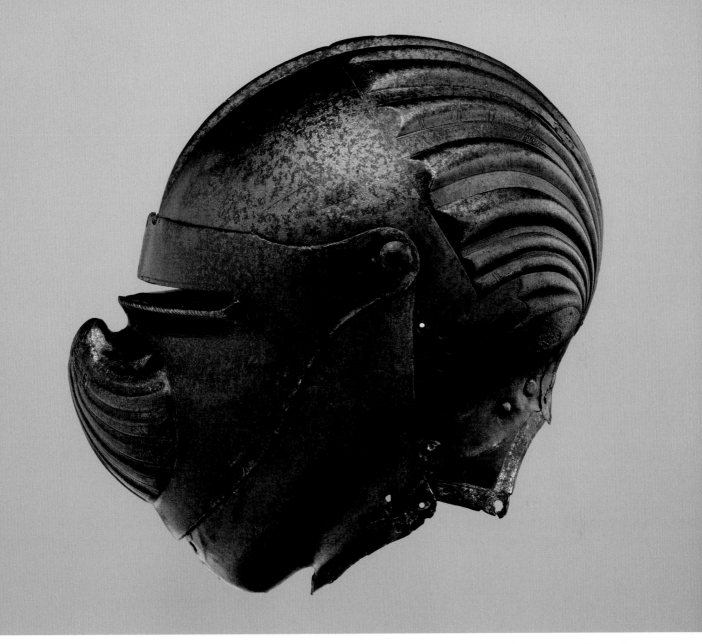

Fig. 32. Close Helmet, Gian Giacomo Negroli (Italian, Milan, 1463–1543), Italian, Milan, ca. 1510–20. Steel and gold, h. 13⅛ in. (33.3 cm); wt. 3 lb. 6 oz. (1530 g). Purchase, Arthur Ochs Sulzberger Gift, 2014 (2014.282)

Fig. 33. Detail of mark on Negroli close helmet, fig. 32

or were employed in workshops in the Netherlands, France, and England. The most famous of the Milanese armor-making families were the Missaglia (figs. 30 and 31) and the Negroli (figs. 32 and 33).

In Germany, the imperial cities of Nuremberg and Augsburg rivaled and eventually surpassed Milan in the international market during the course of the sixteenth

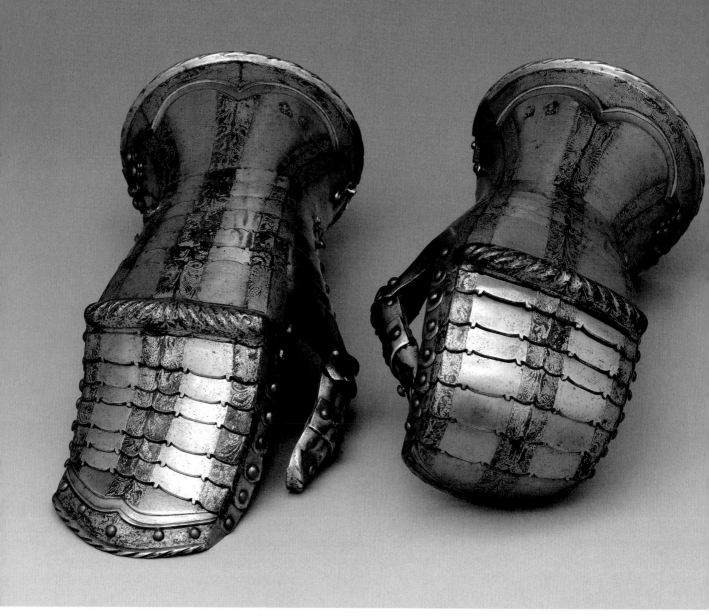

Fig. 34. Pair of Mitten Gauntlets, Valentin Siebenbürger (German, Nuremberg, ca. 1510–1564, master in 1531), German, Nuremberg, ca. 1535. Steel and gold, l. of each 11 ½ in. (29.2 cm). Fletcher Fund, 1922 (22.145.1, .2)

Fig. 35. Detail of marks on Siebenbürger gauntlets, fig. 34

century. Nuremberg specialized in munitions armor but also had a handful of armorers famous for their individual skills, such as Hans Grünwalt (ca. 1440–1503), Valentin Siebenbürger (ca. 1510–64) (figs. 34 and, 35), and Kunz Lochner (1510–67) (see fig. 120). Augsburg produced armor of the finest quality for elite patrons from the late fifteenth century through the late sixteenth century. Among its many famous armorers were several generations of the Helmschmid family, active from about 1475 to 1575,

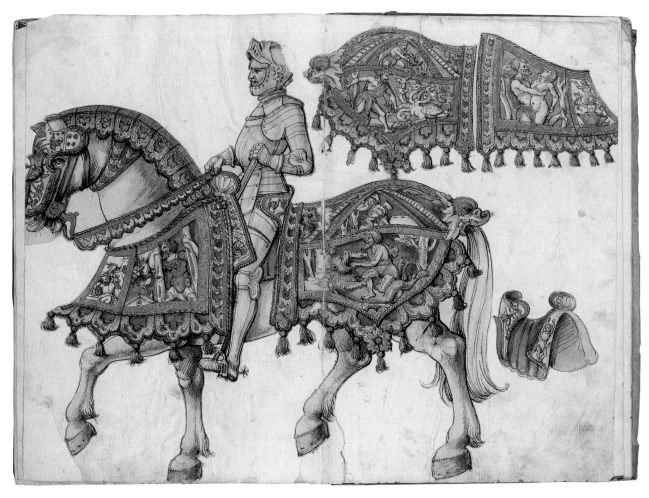

Fig. 36. Armored man and horse, from the *Thun Sketchbooks*, ca. 1517. Uměleckoprůmsylové Museum v Praze (Museum of Decorative Arts, Prague), inv. no. GK 11.557-A, folio 111v-112r. The horse armor is preserved in the Royal Armory, Madrid (inv. A149)

Mattheus Frauenpreis the elder (1510–49), and Anton Peffenhauser (1525–1603). Our knowledge of armor-making in Augsburg from the late fifteenth to the early seventeenth century, particularly the work of the Helmschmids, is greatly enriched by two unique and fascinating manuscripts called the *Thun Sketchbooks* (fig. 36). Previously known to historians chiefly through a selection of black-and-white photographs taken in the 1930s, the sketchbooks were considered lost or destroyed during World War II, but they were rediscovered in about 2010 and have since been fully researched and published. They include hundreds of highly informative drawings of armor garnitures and armor for field, ceremonial, and tournament use, several pieces of which can be identified in museum collections today. Proximity to the court of the dukes of Bavaria allowed armor-making to thrive in the city of Landshut for several generations. It reached a high point in the mid-sixteenth century with the work

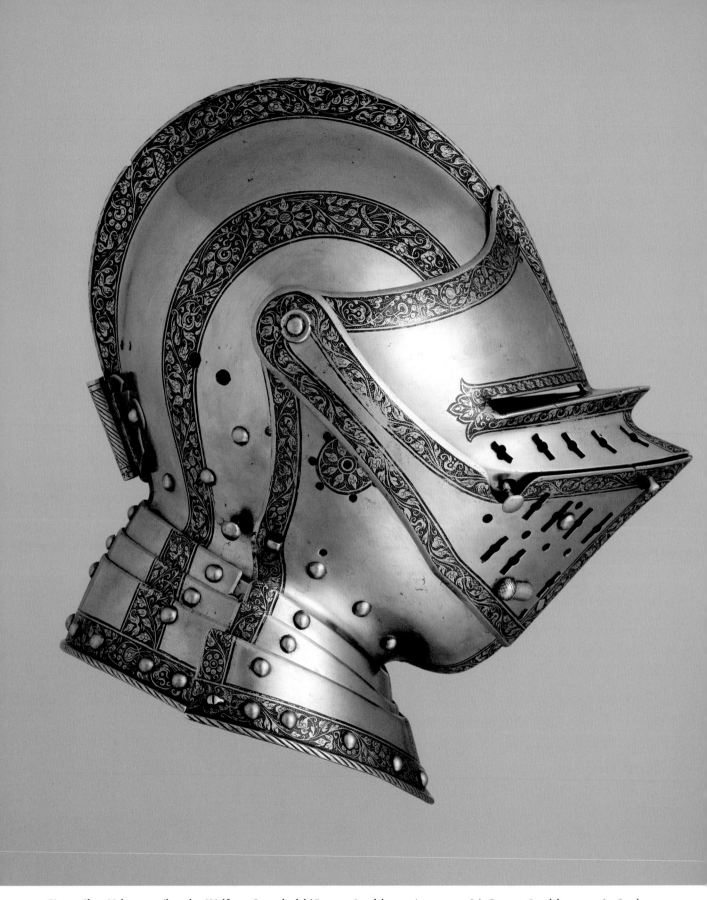

Fig. 37. Close Helmet, attributed to Wolfgang Grosschedel (German, Landshut, active ca. 1517–62). German, Landshut, ca. 1560. Steel, leather, and copper alloy, h. 14¾ in. (37.5 cm); wt. 11 lb. 3.1 oz (5077.4 g). Rogers Fund, 1904 (04.3.267a)

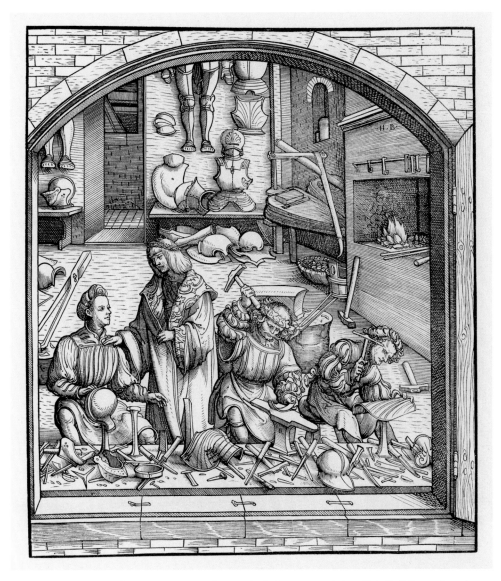

Fig. 38. Emperor Maximilian I visiting Konrad Seusenhofer in court workshop (*Die Hoffplatnerei*, 1514), from facsimile edition of *Der Weisskunig*, fictionalized biography of Maximilian. Watson Library, The Metropolitan Museum of Art

of Wolfgang Grosschedel (active ca. 1517–62) (figs. 37 and 41). His patrons included King Philip II of Spain and emperors Ferdinand I and Maximilian II.

Some of the most beautiful armor in the late Gothic and early Renaissance styles was made in the Austrian town of Innsbruck and neighboring Mühlau, where Emperor Maximilian I, one of the greatest patrons of the armorer's art, established his court workshop in the early sixteenth century (fig. 38). Innsbruck gained an international reputation for the strength of its steel and the skill of its armorers, and continued to produce armor of high quality for the Habsburg emperors and members of their court into the early seventeenth century.

About 1511, perhaps emulating Emperor Maximilian I, King Henry VIII established the royal workshops at Greenwich, near London, and staffed them with armorers imported from Flanders, Italy, and Germany. The workshops made armor only for the sovereign and members

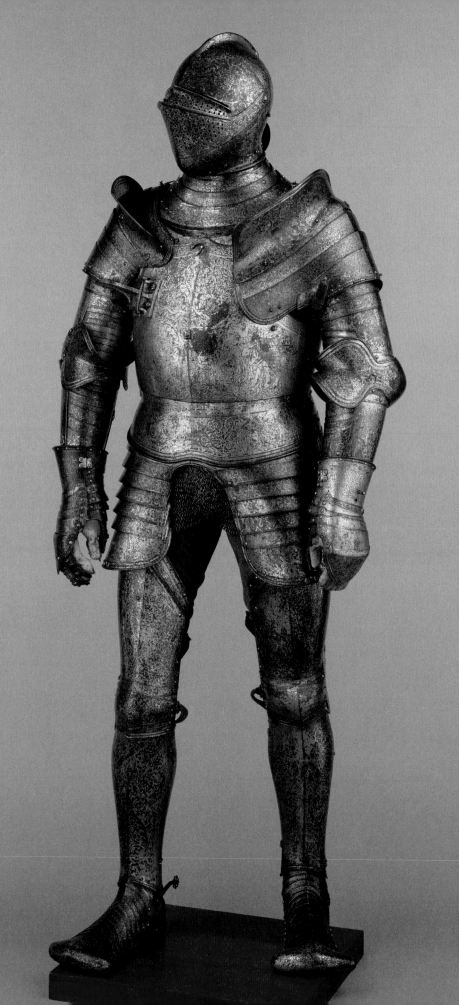

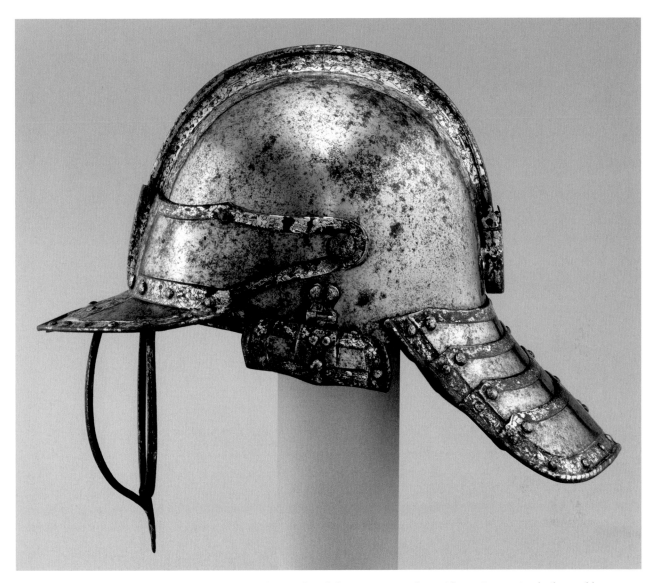

Fig. 40. Helmet for a Harquebusier, made in London or the Royal workshops at Greenwich, British, ca. 1630–40. Steel, silver, gold, copper alloy, and textile, h. 13 7/8 (35.3 cm); wt. 4 lb. 7 oz. (2010 g). Purchase, Arthur Ochs Sulzberger Gift, 2012 (2012.15)

of the court by royal warrant. The earliest surviving dated armor from Greenwich is the gilt garniture almost certainly made for Henry VIII himself in 1527 (fig. 39). Among the last of the luxurious armors produced there is a garniture made as a gift for Duke Friedrich Ulrich of Brunswick about 1610. However, the workshops remained active until the 1640s. Separate from the royal workshops, the Armourer's Company of London was chartered in the mid-fifteenth century and continued making armor of good quality until late in the seventeenth century (fig. 40).

Opposite: Fig. 39. Armor Garniture, probably of King Henry VIII of England (reigned 1509–47), British, Greenwich, dated 1527. Steel, gold, leather, and copper alloys, h. 73 in. (185.4 cm); wt. 62 lb. 12 oz. (28.45 kg). Purchase, William H. Riggs Gift and Rogers Fund, 1919 (19.131.1a-r, t-w)

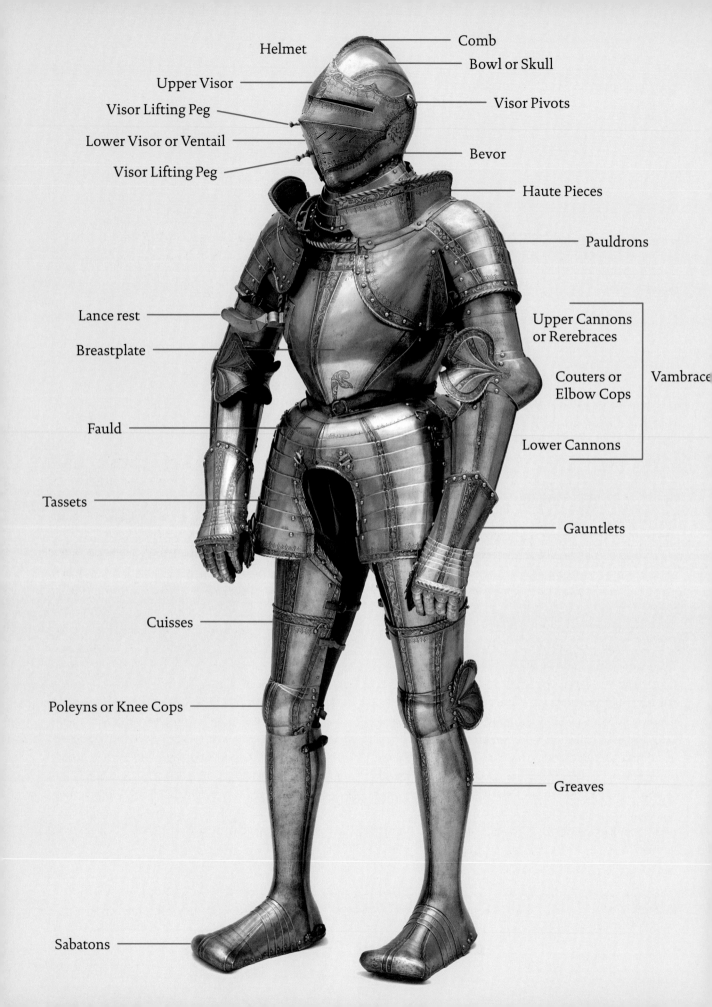

Helmet

Comb

Bowl or Skull

Upper Visor

Visor Pivots

Visor Lifting Peg

Lower Visor or Ventail

Bevor

Visor Lifting Peg

Haute Pieces

Pauldrons

Lance rest

Upper Cannons or Rerebraces

Breastplate

Couters or Elbow Cops

Vambrace

Lower Cannons

Fauld

Tassets

Gauntlets

Cuisses

Poleyns or Knee Cops

Greaves

Sabatons

THE SUM OF ITS PARTS
ARMOR FROM HEAD TO TOE

Now that we have outlined the development of European armor from the fifteenth to the seventeenth century and where it was made, we will examine the individual parts of plate armor from that period one by one. As we will see, while there are many variations, a complete armor of this period usually consists of the following components (fig. 41): a helmet to cover the head; a gorget over the neck and collarbones; a cuirass with tassets and fauld defending the torso, hips, and upper thighs; a pair of pauldrons for the shoulders; a pair of vambraces over the arms; a gauntlet for each hand; cuisses covering the thighs to the knees; poleyns or knee cops for the knees; greaves, which cover the shins and calves from the base of the knee to the ankles; and a pair of sabatons covering the feet from the instep to the toes. Narrow plates called lames often join larger plates together and fill the gaps between them, while all the parts are connected and articulated by a combination of external straps and buckles, rivets, internal leather straps, hinges, and other fittings.

The armor that will act as the template throughout our exploration is called the Dos Aguas garniture (fig. 42a and b). It is a complete armor equipped with twenty-three additional parts, also known as pieces of exchange, which can be used to adapt it for at least two different types of tournament and for infantry or light cavalry. This particular armor garniture is an ideal model; in many ways, it is a typical suit of plate armor from the mid-sixteenth century, but it is also the most complete, complex, and extensive garniture in any collection outside continental Europe. In fact, relatively few garnitures as large as this still exist in a single collection anywhere. It was made about 1550 to 1575 in Milan, which as noted above was a renowned center for the production of armor since the fifteenth century. Like many Milanese armors of this period, it is not signed or stamped with an armorer's mark, so we don't know the name of the armorer who made it. And while only a nobleman would have commissioned such an extensive garniture, we don't know who that nobleman was either. We can be fairly certain, however, that its original owner was a member of the Dos Aguas family, or someone closely allied to them, because the garniture was acquired by the Metropolitan Museum in 1927 from that family's ancestral armory in Valencia, Spain, where the armor had been kept for generations (fig. 43).

While it is well made and the configuration of its parts is extremely rare, the Dos Aguas garniture could never be considered among the most beautiful or artistic armors of its time. In fact, except for its unique aspects as a large Italian garniture, this armor is solidly average in craftsmanship and decoration. Rather than a drawback,

Opposite: Fig. 41. Diagram of the parts of a complete European plate armor of the 16th century. Armor, Wolfgang Grosschedel (German, Landshut, active ca. 1517–62); German, Landshut, ca. 1534–40. Steel, leather, and copper alloy, wt. 55 lb. 11 oz. (25.25 kg). Fletcher Fund, 1923 (23.261)

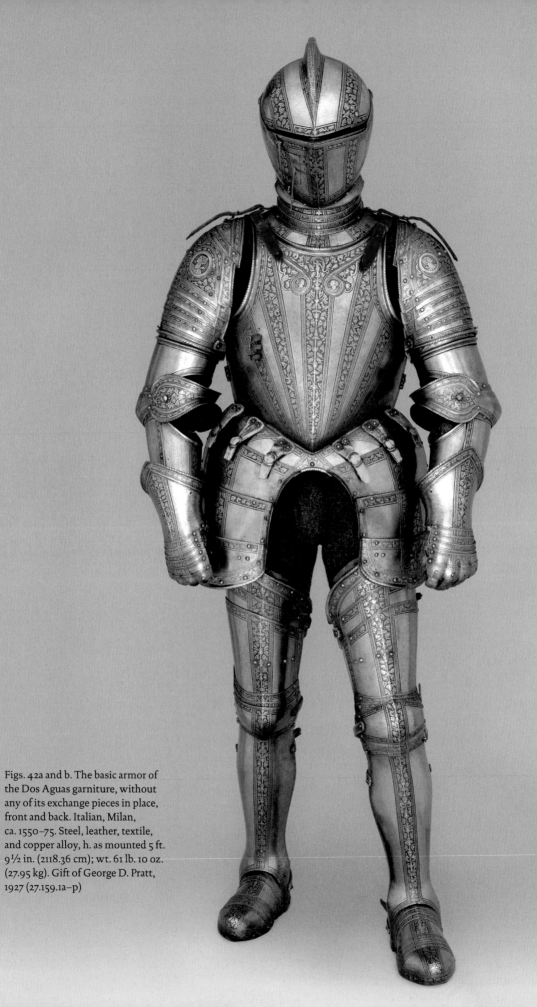

Figs. 42a and b. The basic armor of
the Dos Aguas garniture, without
any of its exchange pieces in place,
front and back. Italian, Milan,
ca. 1550–75. Steel, leather, textile,
and copper alloy, h. as mounted 5 ft.
9½ in. (2118.36 cm); wt. 61 lb. 10 oz.
(27.95 kg). Gift of George D. Pratt,
1927 (27.159.1a–p)

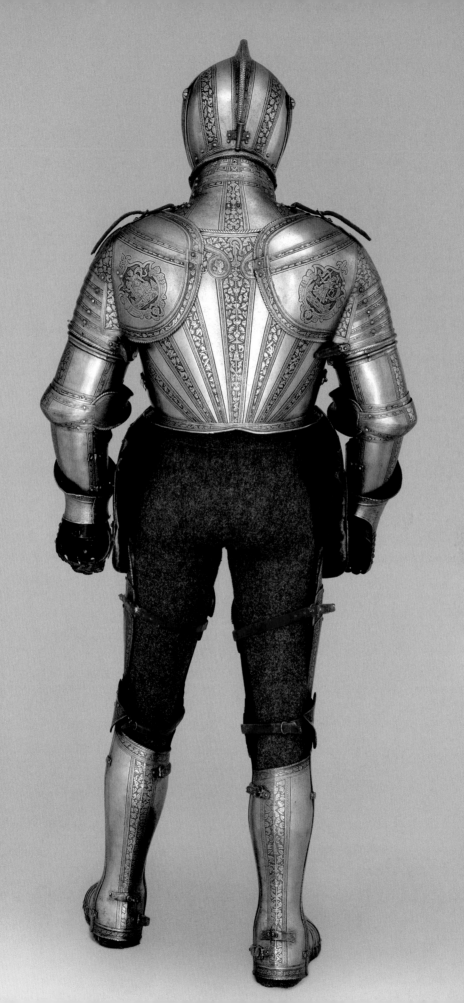

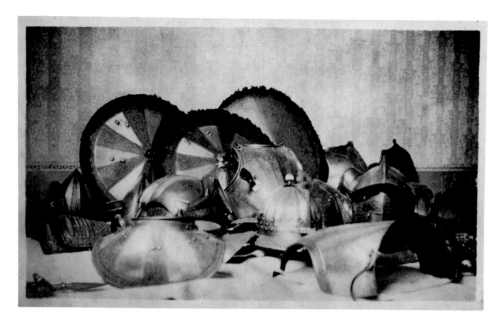

Fig. 43. Elements of the Dos Aguas garniture scattered among other pieces of arms and armor in the Dos Aguas Palace, Valencia, Spain, 1927. Photograph probably taken by Anita Reinhard (1887–1986), staff member in the Department of Arms and Armor, The Metropolitan Museum of Art, who negotiated the purchase of the collection

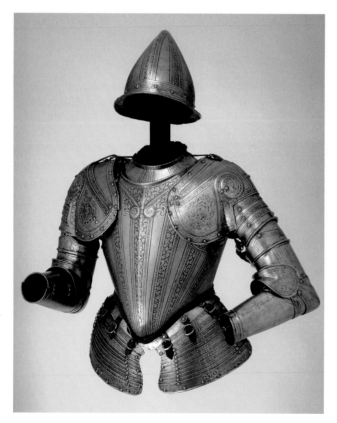

Fig. 44. Armor for the Amsterdam Civic Guard, Italian, Milan, ca. 1580. National Military Museum, Soest, on loan from the City of Amsterdam

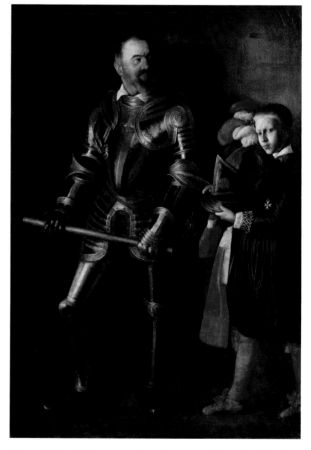

Fig. 45. *Alof de Wignacourt, Grand Master of the Order of Malta, and His Page*, Caravaggio (Michelangelo Merisi) (Italian, Milan or Caravaggio 1571–1610 Porto Ercole), ca. 1607–08, detail. Oil on canvas, 76.4 x 52.8 in. (194 x 134 cm). Musée du Louvre, Paris (inv. 57)

Fig. 46. Detail of etched decoration on backplate of the Dos Aguas garniture, fig. 42b (27.159.1d)

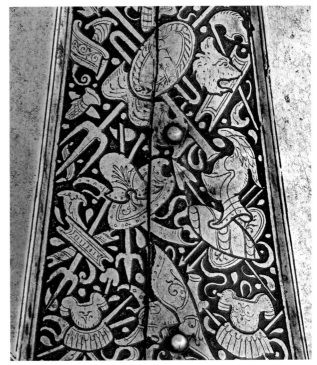

Fig. 47. Detail of etched decoration on a horse armor made for a member of the Collalto family, Italian, probably Milan, ca. 1560. Steel, gold, and leather. Fletcher Fund, 1921 (21.139.2a–h)

these attributes should be viewed as positive because the armor represents a popular type and a general level of quality that were used across the ranks of society, from militiamen to aristocrats, throughout Europe literally from Holland to Malta (figs. 44 and 45). In this sense, the Dos Aguas garniture is well suited to be our guide, a kind of armored Everyman with which we can see and appreciate most types of European armor from the sixteenth through the seventeenth century. Through it, we can look at all the individual pieces that make up a typical armor at a time when armor was prized as both a vital means of defense and an important art form.

Although the various styles and techniques for decorating armor will be discussed in detail later, before examining the pieces that make up the Dos Aguas garniture, a few comments should be made about its surface ornament. Every element of the Dos Aguas garniture has matching designs executed by etching, the most popular method of embellishing plate armor (fig. 46). The main feature of the Dos Aguas decoration consists of narrow vertical bands, which are arranged symmetrically and alternate with areas of plain polished steel. The bands are filled with clusters of small design motifs, known as trophies: symbols representing detached pieces of armor, masks, mythical animals, shields, and musical instruments. Like the trophies on many other Italian armors of this period and type, those on the Dos Aguas garniture are rendered in a fairly stylized and generic way, making the individual symbols hard to recognize at first. Comparison with the same designs etched more precisely, however, shows more clearly what they are intended to represent (fig. 47). The term trophies derives from the practice in the Classical world of publicly displaying war booty seized from defeated enemies as a visual and physical testament of victory. In the Renaissance, highly stylized designs of these ancient battle trophies became a popular decorative motif repeatedly found in architecture, sculpture, woodwork, prints, and particularly on Italian armor for most of the sixteenth century.

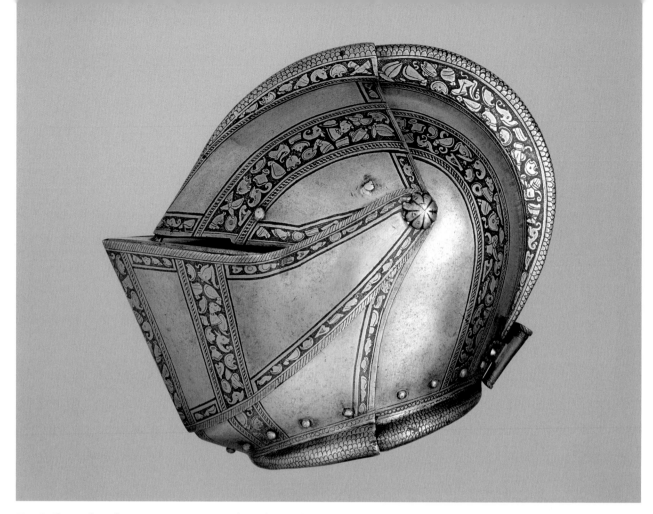

Fig. 48. Close Helmet from Dos Aguas garniture, fig. 42 (27.159.1a)

HELMETS

Because it is a garniture, the Dos Aguas armor includes two helmets. One is a type known as a close helmet, which completely encompasses the head and was designed for fully armored combat on horseback (fig. 48). The other is an open-faced helmet known as a cabasset, used for fighting on foot or horseback while wearing less armor (fig. 49).

A close helmet, as the name implies, fits closely around the entire head. All the main parts pivot on two rivets or bolts, one on either side of the head at about the height of the tops of the ears. The type was developed in the early 1500s, after more than two centuries of active experimentation and refinement of helmets with moveable visors (fig. 50). The main parts of a close helmet are the skull or helmet bowl, which usually follows the contours of the head from the forehead back to the nape area at the base of the skull and top of the neck; the upper visor, which overlaps the forehead area of the bowl and comes down to the vision slits, or sights, at eye level; the lower visor, covering the face from just below the eyes to the chin; and the bevor, which is overlapped by the lower visor and wraps around the cheeks and the chin down to the front of the top of the neck. The genius of this construction is that it permits the upper visor to be raised or lowered independently, providing increased vision or ventilation when needed (fig. 51b); for the upper and lower visors to be raised as single piece, exposing the entire face (fig. 51c); and for the whole front of the helmet, comprising the bevor and upper and lower visors, to be opened as a unit so that the helmet can be put on or taken off easily even though it fits very snugly around the head when

Opposite: Fig. 50. Diagram of the parts of a fully developed close helmet in The Metropolitan Museum of Art (14.25.689a). Drawing by Randolph Bullock, 1935. Archives of the Department of Arms and Armor

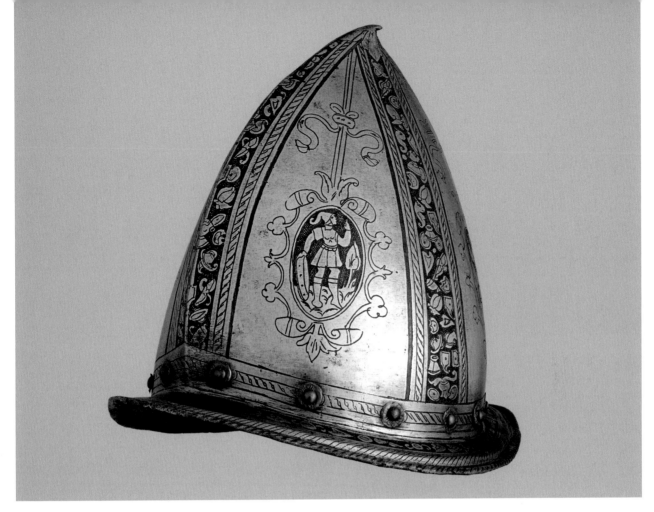

Fig. 49. Cabasset from the Dos Aguas garniture (27.159.12)

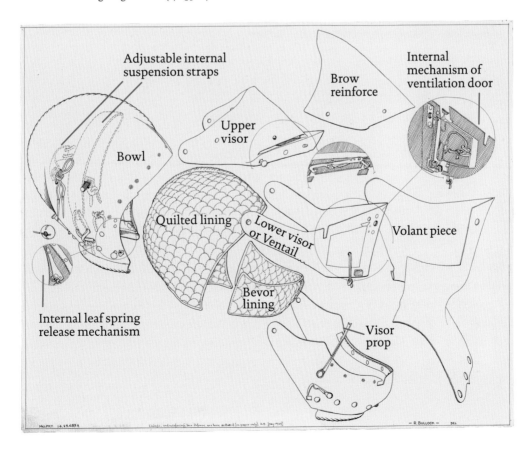

Adjustable internal
suspension straps

Brow
reinforce

Internal
mechanism of
ventilation door

Upper
visor

Bowl

Quilted lining

Lower visor
or Ventail

Volant piece

Bevor
lining

Internal leaf spring
release mechanism

Visor
prop

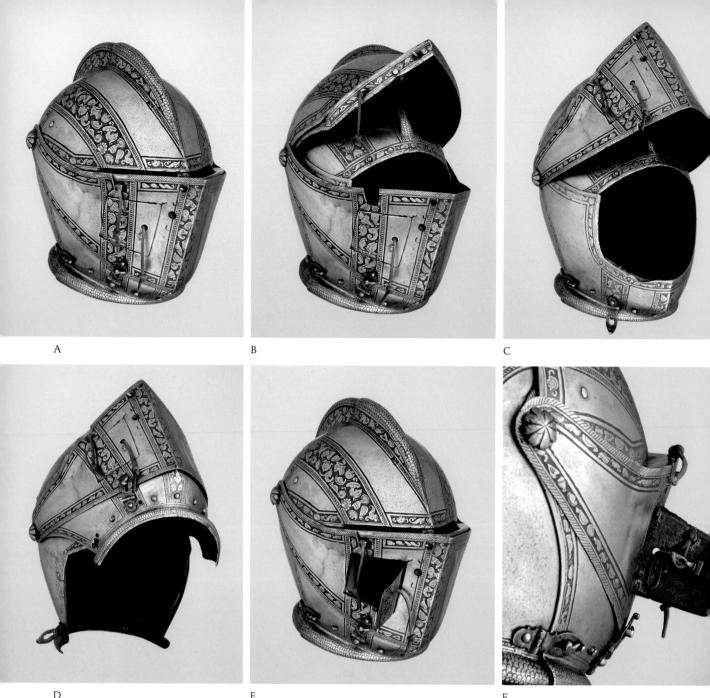

A

B

C

D

E

F

Above: Fig. 51. Close helmet from the Dos Aguas Garniture, fig. 42 (27.159.1a). A: closed; B: upper visor raised; C: upper and lower visors raised; D: upper visor, lower visor, and bevor raised as a unit to open front of helmet; E: right side with ventilation open; F: detail of ventilation door mechanism

closed (fig. 51d). There are many variations of close helmets, but they all follow these basic principles.

The Dos Aguas close helmet was not made for the battlefield but rather for jousting, a form of tournament fought on horseback with lances. The key feature signaling this fact is a nearly square hinged door on the right side of the lower visor, which could be opened quickly for ventilation or refreshment between rounds, called courses, of the joust (fig. 51e and f). Such a comparatively large opening would be too risky on a field helmet or even on a helmet designed for tournaments fought on foot, but it is typical of helmets employed in jousting, where only the

left side of the visor was exposed to hits from an opponent's lance. Other indicators that the helmet was made for tournament and not battle are its relatively heavy weight of 10 pounds 1 ounce (4564.3 g) as compared to about 5 to 7 pounds (2276.96 to 3175.15 g) for an average close helmet for field use of this period; the presence of an additional, form-fitting plate that has been riveted over the brow area of the upper visor for reinforcement, providing an extra layer of protection to the prime target area on a jousting helmet but impractical on a field helmet due to the weight it adds; and the presence of a threaded screw hole near the center of the lower visor and next to the hinged door, which secures the top of a reinforcing plate called a volant piece or *mezzo guardaviso*, used only on a jousting armor. It is likely that among its original exchange pieces, the Dos Aguas garniture also included a lighter close helmet for the field, with a visor that was perforated by a series of holes to provide adequate ventilation during active and prolonged use (fig. 52).

The second helmet that has survived with this garniture is called a cabasset (or *zuccotto* in Italian), also known as a Spanish morion or pointed morion, and was intended for infantry or light cavalry use (fig. 49). Generally, it was worn as part of a half armor, which reaches only to the waist or hips and comprises, in addition to the cabasset, a gorget, breastplate, and backplate, and either pauldrons with vambraces or simply full-length mail sleeves covering the shoulders and arms with or without gauntlets (see fig. 44). A cabasset covers the top of the head from just above the ears. It is characterized by a fully encircling brim that is horizontal or slopes down slightly and a bowl that narrows as it draws up, usually ending in a small point tipped toward the back. The cabasset is one of many forms of open-faced helmets with an encircling brim that were in use from the early middle ages through the seventeenth century. After being considered obsolete for more than two hundred years, open-faced steel helmets were reintroduced to the battlefields of Europe during World War I with the ubiquitous Brodie helmet, nicknamed the tin hat, worn by British and American troops, and the iconic German *Stahlhelm* (fig. 53), the latter a brilliant example of functional design rivaling the most efficient helmets of the fifteenth and sixteenth centuries.

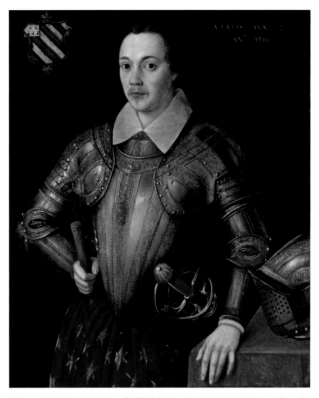

Fig. 52. *Sir John Shurley of Isfield (1565–1632)*, British Painter, dated 1588. Oil on wood, 35¾ x 29⅜ in. (90.8 x 74.6 cm). Gift of Kate T. Davison, in memory of her husband, Henry Pomeroy Davison, 1951 (51.194.2). He is wearing an Italian field armor of about the same period as the Dos Aguas armor

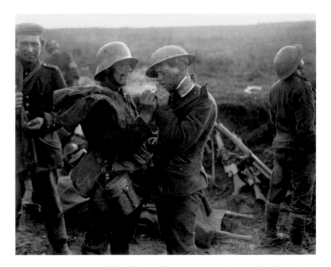

Fig. 53. A German soldier lights the cigarette of a wounded British soldier at a British field hospital during the Battle of Épehy, 1918 (Lt. Thomas K. Aitken, British Army Photographer, Imperial War Museums) © IWM (Q11538) *www.iwm.org.uk*

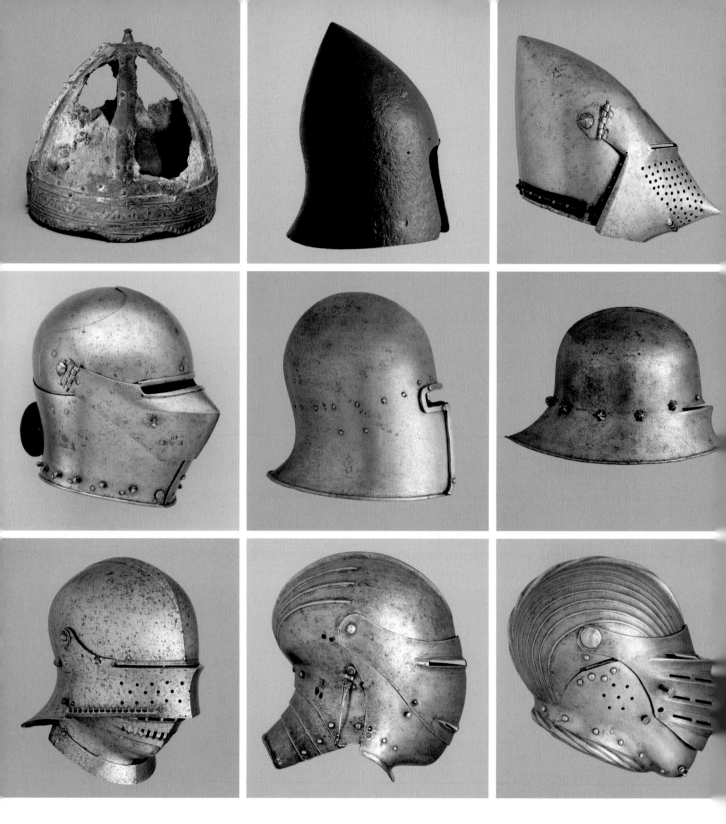

Fig. 54. Top row, left to right: Helmet, (*Spangenhelm*), Byzantine or Germanic, 6th–7th century. Gift of Stephen V. Grancsay, 1942 (42.50.1); Bascinet, Italian, ca. 1375–1400. Bashford Dean Memorial Collection, Funds from various donors, 1929 (29.158.45); Visored Bascinet, Western European, ca. 1375–1400. Rogers Fund, 1904 (04.3.235a, b). Middle row: Armet, Italian, probably Milan, ca. 1440. Gift of Stephen V. Grancsay, 1942 (42.50.2); Barbute, Italian, Milan, ca. 1460. Gift of Stephen V. Grancsay, 1942 (42.50.15); Sallet, Attributed to Adrian Treytz the Elder, Austrian, Innsbruck, ca. 1480. Rogers Fund, 1904 (04.3.229). Bottom row: Sallet of Emperor Maximilian I, German, Augsburg, ca. 1490–95. Bashford Dean Memorial Collection, Gift of Edward S. Harkness, 1929 (29.156.45); Close Helmet, Hans Maystetter, Austrian, Innsbruck, ca. 1505–10. Bashford Dean Memorial Collection, Funds from various donors, 1929 (29.158.35); Armet, German, Nuremberg, ca. 1520. Gift of Alan Rutherfurd Stuyvesant, 1949 (49.163.1a)

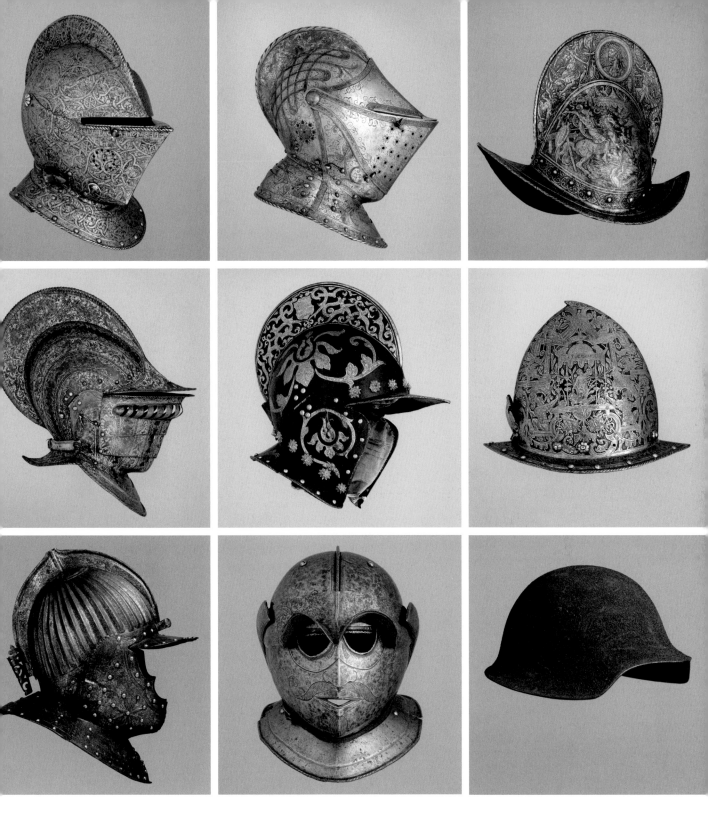

Fig. 55. Top row, left to right: Close Helmet of Claude Gouffier, French, ca. 1555–60. Gift of William H. Riggs, 1913 (14.25.596); Close Helmet from a Garniture Made for a Member of the d'Avalos Family, German, Augsburg, ca. 1560-70. Bashford Dean Memorial Collection, Gift of Mr. and Mrs. Alexander McMillan Welch, 1929 (29.153.3); Comb Morion, German, Brunswick, ca. 1560–65. Purchase, The Sulzberger Foundation Inc. and Ronald S. Lauder Gifts, 1999 (1999.62). Middle row: Burgonet with Buffe, Italian, ca. 1555–60. Gift of William H. Riggs, 1913 (14.25.613); Burgonet, German, Augsburg, 1575–1600. Gift of Clarence H. Mackay, 1922 (22.168); Cabasset, Flemish, possibly Antwerp, ca. 1580–90. Rogers Fund, 1904 (04.3.200). Bottom row: Burgonet, French, ca. 1610. Purchase Arthur Ochs Sulzberger Gift, 2013 (2013.95.3); Siege Helmet, Italian, ca. 1625. Bashford Dean Memorial Collection, Funds from various donors, 1929 (29.158.23); American Helmet Model No. 5, Hale & Kilburn Company, Philadelphia, 1918. Purchase, Gift of Bashford Dean, by exchange, 2013 (2013.582)

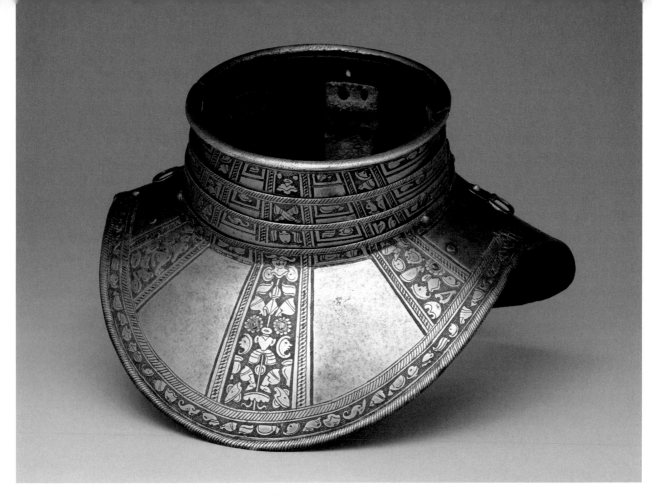

Fig. 56. Gorget from the Dos Aguas armor, fig. 42 (27.159.1b)

GORGETS

The primary purpose of a gorget is to protect the highly vulnerable areas of the throat and the base of the neck, front and back (fig. 56). Also very important, but often misunderstood or unrecognized, is the function of the gorget as a fulcrum for the cuirass and to support and distribute the weight of the breastplate and backplate. To accomplish this function, and to provide maximum protection, the gorget is worn underneath the breastplate and backplate, so that its bottom edges are overlapped by the top of the cuirass. Although exceptions occurred in the fifteenth and early sixteenth centuries, this arrangement was the norm, particularly for full plate armor. A typical gorget of this period consists of two large shaped plates at the front and back of the base of the throat and two or more ringlike lames encircling the neck. All these plates are hinged or articulated so that the gorget can be opened at one side and closed around the neck. The top lame usually has a lip, known as a turned edge. Some close-helmets, including the Dos Aguas example, were designed to lock onto the top ring of the gorget to form a kind of rotating joint. As armor gradually went out of use in the seventeenth century, gorgets were among the last elements of plate armor to be worn, often over a sturdy leather buff coat, or with civilian clothing (see fig. 173). Some gorgets, particularly in the seventeenth and eighteenth centuries, were also signs of status, more for ornament than protection. Small crescentic gorgets of silver or brass were worn as symbols of military rank until the end of the eighteenth century (fig. 57).

Opposite: Fig. 57. Top row, left to right: Gorget possibly from an Armor of Philip II, King of Spain, German, ca. 1550. Rogers Fund, 1939 (39.147.1); Gorget for the Bodyguard of Louis XIII, French, ca. 1610–17. Gift of William H. Riggs, 1913 (14.25.883a, b). Middle row: Painted Gorget, Western Europe, probably British or Dutch, ca. 1625–50. Purchase, Bashford Dean Memorial Collection, Funds from various donors, by exchange, 1992 (1992.137); Gorget, probably Dutch, ca. 1630. Gift of Joseph Duveen, 1916 (16.134a, b). Bottom row: Gorget for an Officer of the South Carolina Infantry Regiment, American, late 18th century. Rogers Fund, 1969 (69.138.3); Defense for the Neck and Shoulders (Necklet or Gorget), New England Enameling Company, Inc., Middletown, Connecticut, 1918. Purchase, Arthur Ochs Sulzberger Gift, 2015 (2015.458.3)

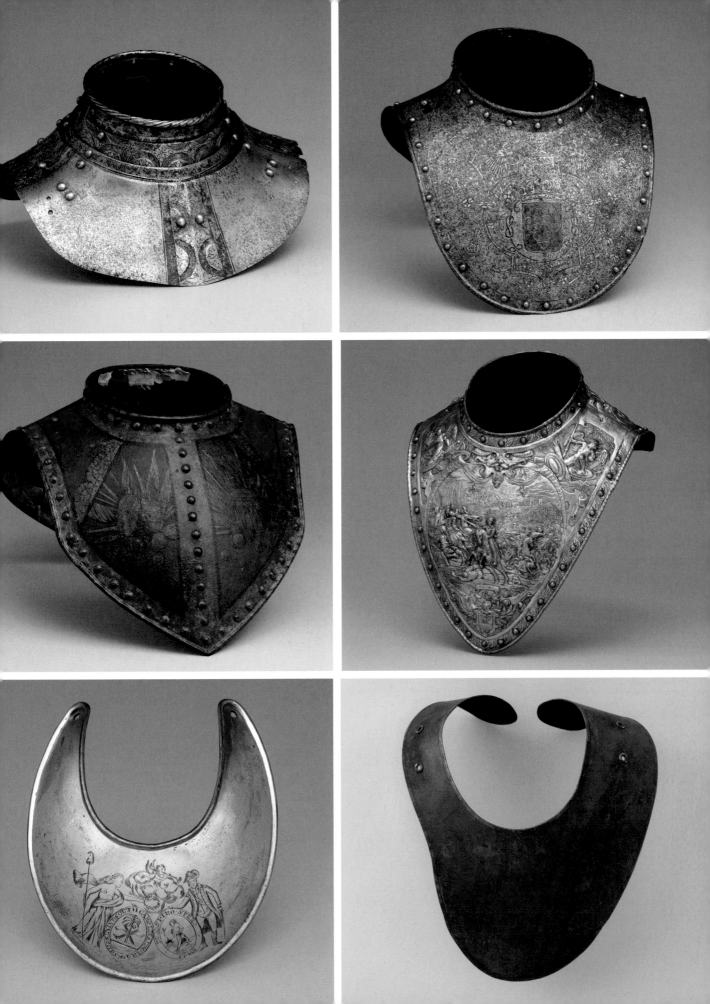

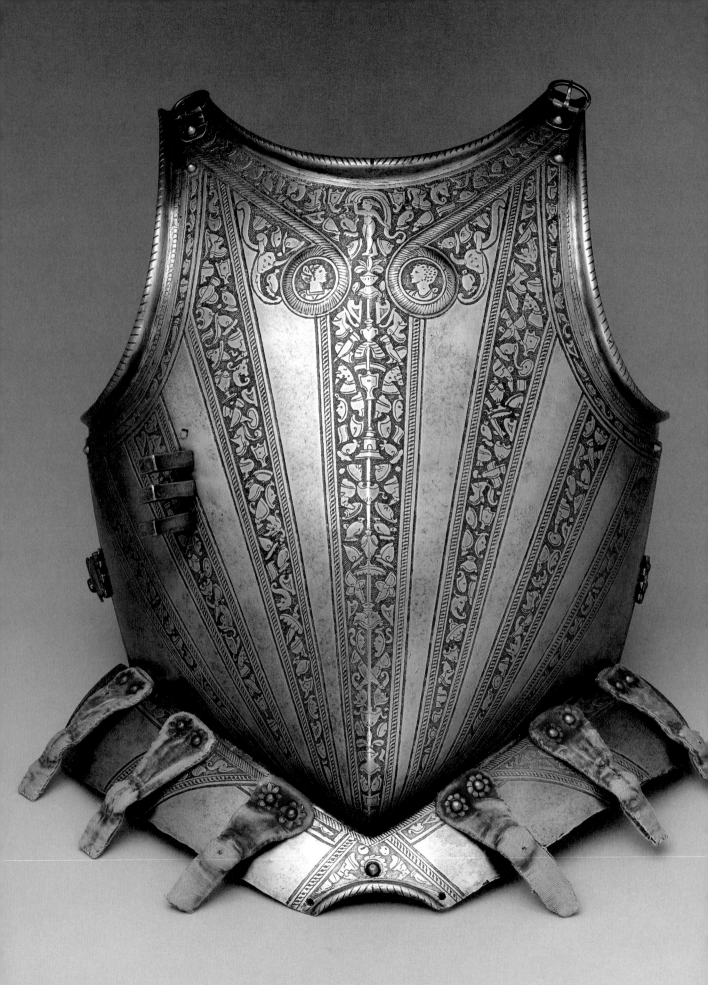

BREASTPLATES, TASSETS, AND BACKPLATES

In Europe, after generations of experimentation, a practical all-steel torso defense called a cuirass was created by about 1380 to 1400. A typical sixteenth-century cuirass comprises a breastplate, usually fitted with a pair of tassets, two pieces suspended from the bottom edge of the breastplate to cover the upper thighs, and a backplate. Often, for added flexibility, there are one to four narrow horizontal lames, called the fauld, between the bottom of the breastplate and the tops of the tassets. Mirroring the fauld, sometimes, are similar lames, called the culet, at the base of the backplate. The cuirass of the Dos Aguas garniture is a fine example of the general type used across Europe, with ongoing stylistic variations and refinements, for much of the sixteenth and well into the seventeenth century. The Dos Aguas breastplate has a one-piece main plate covering the front of the torso from about the level of the collarbones to the top of the hips (fig. 58). The center line of the plate rises to a gentle vertical ridge, which helped deflect the point of a weapon off to either side. At the waist, the center line drops to a rounded point called a peascod. Rather than protective or functional, the peascod is purely stylistic; it imitates the peascod waistline that was fashionable in men's clothing of the period (fig. 59).

At the neckline of the breastplate is a prominent turned border, jutting out at a ninety-degree angle. More than just a dramatic design feature, this border prevented the point of a weapon from sliding up the chest into the neck area. The small diagonal grooves, seen on this and on the borders of many pieces of armor, comprise a decorative feature called roping, which was probably derived from the trim used to finish the seams of male clothing. The edges on both sides of the upper half of the breastplate curve inward in a wide arc to allow ample space for the arms to move across the body. The range of that motion is increased by an innovative feature called sliding gussets, which are movable flanges set into the curved edge of each arc and forming the borders of the armholes. The gussets are riveted in such a way that they can slide in toward the center slightly, providing a bit more flexibility.

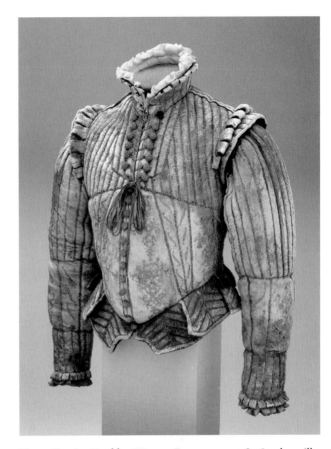

Fig. 59. Fencing Doublet, Western European, ca. 1580. Leather, silk, linen, and cotton. Bashford Dean Memorial Collection, Funds from various donors, 1929 (29.158.175)

Sliding gussets first appeared on breastplates near the end of the fifteenth century, and some more elaborate later examples have an internal V-shaped spring to move them back into a fully extended position after they slide inward.

The bracket that protrudes on the right side of the breastplate (from the perspective of the person wearing it) is called a lance rest (see fig. 41). An armored cavalryman, when riding, generally held his lance vertically, or leaned it back on his right shoulder, with about three-quarters of the lance above or in front of his right hand and about one-quarter beneath it. When charging an opponent, the rider couched the lance, lowering it into a nearly horizontal position, pointing at his target, with the back quarter of the lance cradled under his right

Opposite: Fig. 58. Breastplate from the Dos Aguas armor (27.159.1c). The straps are for attaching the tassets (fig. 61)

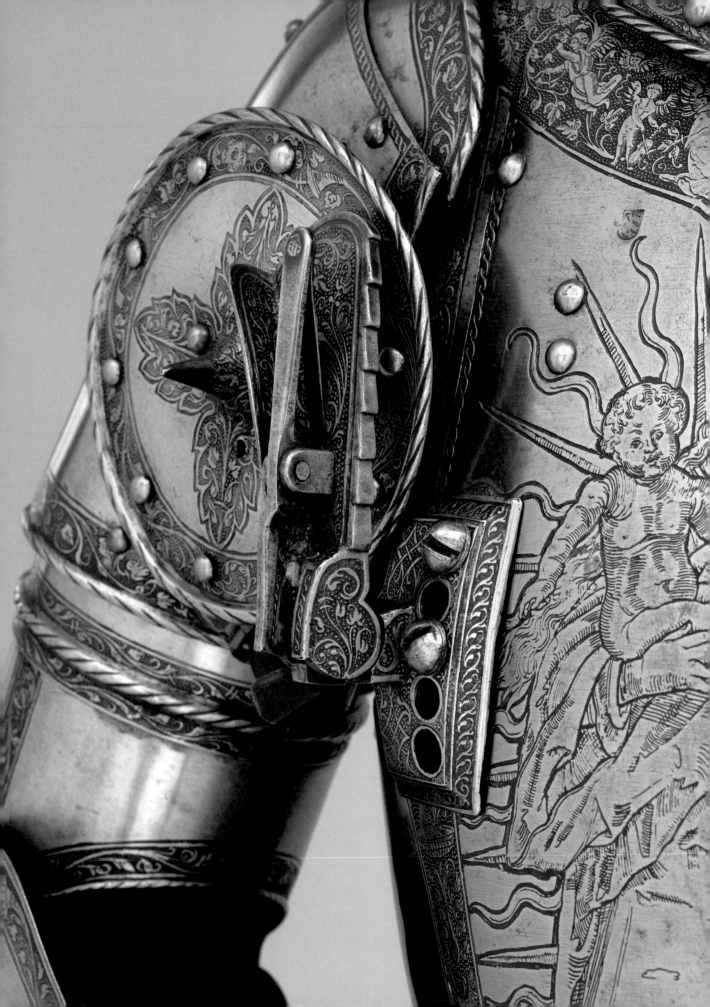

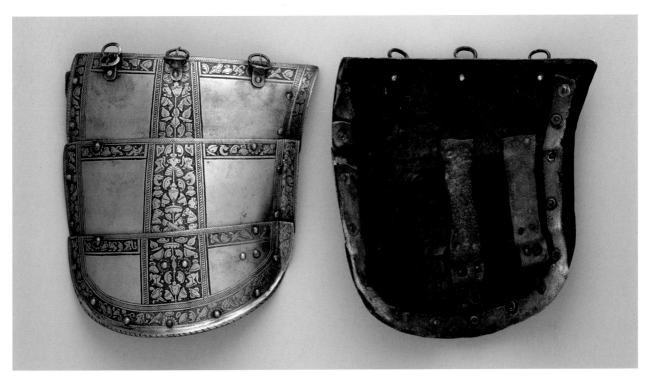

Fig. 61. Tassets (interior and exterior) of the Dos Aguas armor, fig. 42 (27.159.1k, l)

armpit. In this position, the lance sits on the lance rest just behind the rider's right hand. The lance rest supported much of the lance's weight and helped steady the rider's aim. Also, when the point of the lance hit its target, the lance rest transferred some of the shock of the impact through the torso, so that all of it was not borne by the rider's arm and shoulder. In fact, shoulder and wrist strains on the right arm were common jousting injuries. The lance rest on the Dos Aguas armor is fixed in horizontal position, which is common on jousting armors (see fig. 83). On armor made for battle, however, often the lance rest had a hinge and could be folded up against the chest so it would not get in the way of swinging a sword after the lance was broken or discarded (fig. 60).

Usually, the breastplate and backplate are held together securely by a pair of straps and buckles at the top, going over the shoulders, and a belt that is riveted to the backplate and buckles in the front at the waist. Often, as on the Dos Aguas armor, there is also a very sturdy hinged steel hasp on each side, about halfway between the bottom of the arm opening and the waist. Here, each hasp,

which is riveted to the side edge of the breastplate, has three slots to engage a turning pin on the backplate. The slots allow some adjustment to tighten or loosen the fit of the cuirass on the torso.

The bottom edge of the Dos Aguas breastplate, just below the curve of the peascod, flares out slightly to form a small flange, to which a single fauld lame is loosely riveted, giving it added flexibility. The tops of the tassets are attached to the fauld by straps and buckles. Some tassets are made of a single plate, but more often, they consist of three to four horizontal overlapping lames (fig. 61). The individual lames are joined by rivets and internal leather straps to provide flexibility. Some types of tassets in the late sixteenth and seventeenth centuries were even made of one plate that was embossed with horizontal lines to simulate the appearance of separate lames. Each of the tassets of the Dos Aguas armor consists of three large lames. They are unusual because the inner edge of each lame is turned out at a right angle, forming a strong continuous flange in the shape of an arch. Like the border at the top of the breastplate, this prevented the point of a weapon

Opposite: Fig. 60. Detail of lance rest of armor of Emperor Ferdinand I, Kunz Lochner (German, Nuremberg, 1510–1567), fig. 120. The spring loaded release lever is visible on the underside

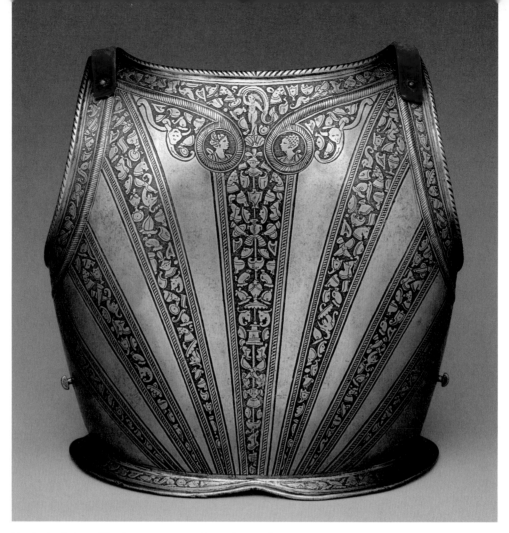

Fig. 62. Backplate of the Dos Aguas armor, fig. 42 (27.159.1d)

from sliding off the adjacent plates and into a vulnerable area. This type of border is found only on tassets that are part of tournament armor, and usually only on the left tasset, which is the side most exposed to an opponent's lance. They were part of the specialized equipment used in a different form of jousting, including an Italian joust known as *a campo aperto*, literally translated in the open field, in which there was no lengthwise barrier between the charging contestants.

The backplate of the Dos Aguas armor is made in one piece, shaped to follow the contours of the body (fig. 62). When assembled as part of the cuirass, the side edges of the backplate are overlapped by the corresponding edges

of the breastplate, which is typical for virtually all plate armor of this type. Because most attacks come from the front, backplates are usually made of slightly thinner metal than breastplates and are therefore lighter, which cuts down on the overall weight of the complete armor. On the Dos Aguas armor, for example, the breastplate, at 6 pounds 10 ounces (2999.4 g), weighs nearly twice as much as the backplate, at only 3 pounds 6 ounces (1536.5 g). A look at different types of breastplates and backplates shows how dramatically their forms evolved from the fifteenth to the seventeenth century in response to changing technology, stylistic considerations, and military tactics (fig. 63).

Opposite: Fig. 63. Top row: Breastplate with applied stop-ribs, Italian, ca. 1420–40. Bashford Dean Memorial Collection, Bequest of Bashford Dean, 1928 (29.150.87); Breastplate (*Kastenbrust*), German, ca. 1450. Bashford Dean Memorial Collection, Bequest of Bashford Dean, 1928 (29.150.79). Middle row: Breastplate, German or Austrian, ca. 1475–85. Bashford Dean Memorial Collection, Bequest of Bashford Dean, 1928 (29.150.77); Backplate, German, ca. 1475, Rogers Fund (53.138.4). Bottom row: Cuirass, Italian or Flemish, ca. 1490–1500. Gift of William H. Riggs, 1913 (14.25.927a-c); Cuirass, German, late 17th century. Gift of George D. Pratt, 1926 (26.261.12)

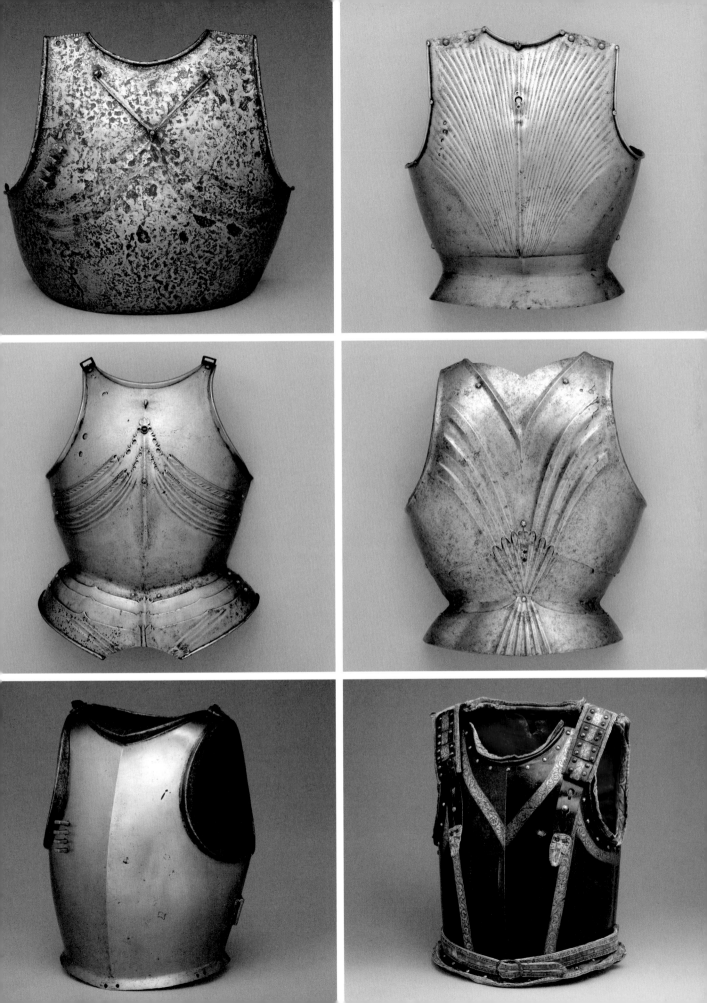

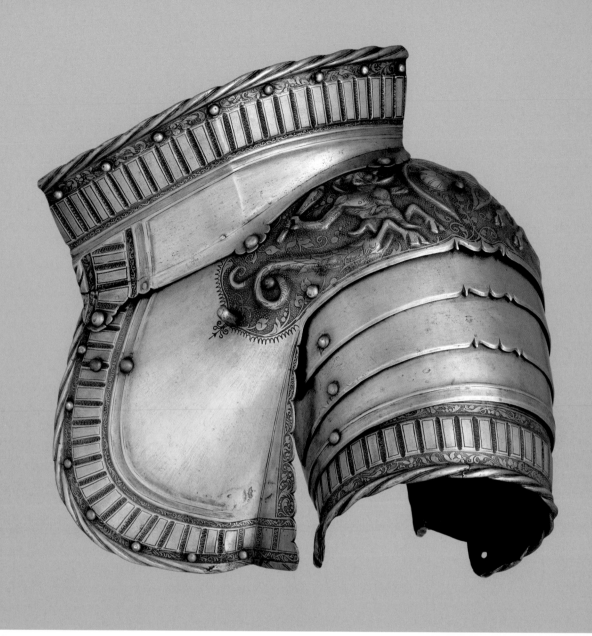

A. three-quarter front view

Fig. 64a and b. Two views of Left Shoulder Defense (Pauldron), Kolman Helmschmid (German, Augsburg 1471–1532), German, Augsburg, ca. 1525. Steel, copper alloy, and leather, h. 10¼ in. (26 cm). Gift of William H. Riggs, 1913 (14.25.828)

PAULDRONS

Because the shoulders need a great degree of flexibility and mobility, in addition to protection, pauldrons must have multiple moving parts and, after the helmet, can be the most complex elements of a suit of armor. Most pauldrons have a large main plate that covers the shoulder blade in the back, overlapping the backplate, and wraps around the shoulder to the front where the shoulder meets the chest (fig. 64a, b). Above the main plate, there are usually two to three crescentic lames to cover the area between the point of the shoulder and base of the neck. Below the main plate, there are three to five hooplike lames that

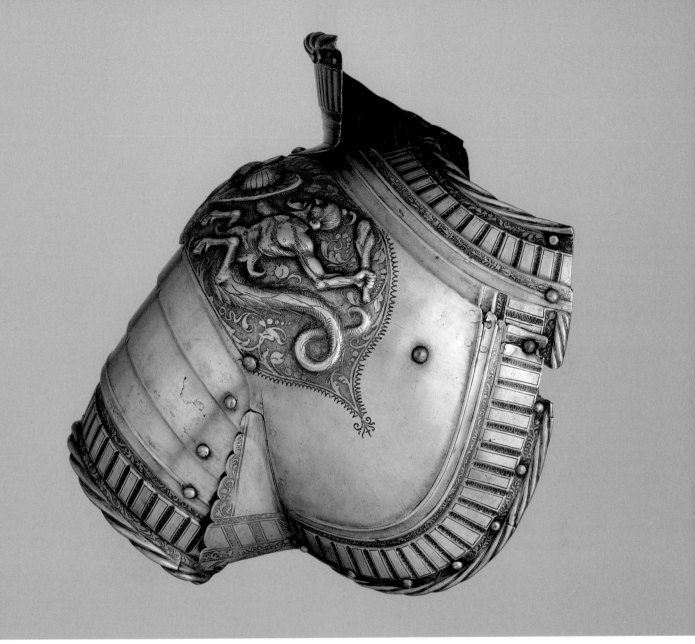

B. back view

wrap the upper arm. On many pauldrons designed for heavy cavalry armor, the front edge of the main plate is equipped with an upright flange called a haute piece, which is intended to keep the point of a weapon from sliding up the pauldron toward the neck area. This basic and ingenious construction of pauldrons originated in Italy in the first third of the fifteenth century and remained in use, with various refinements and developments, until pauldrons ceased to be worn around the middle of the seventeenth century. Many pairs of pauldrons, particularly those made for cavalry armors, are asymmetrical, with the front of the left pauldron extending farther

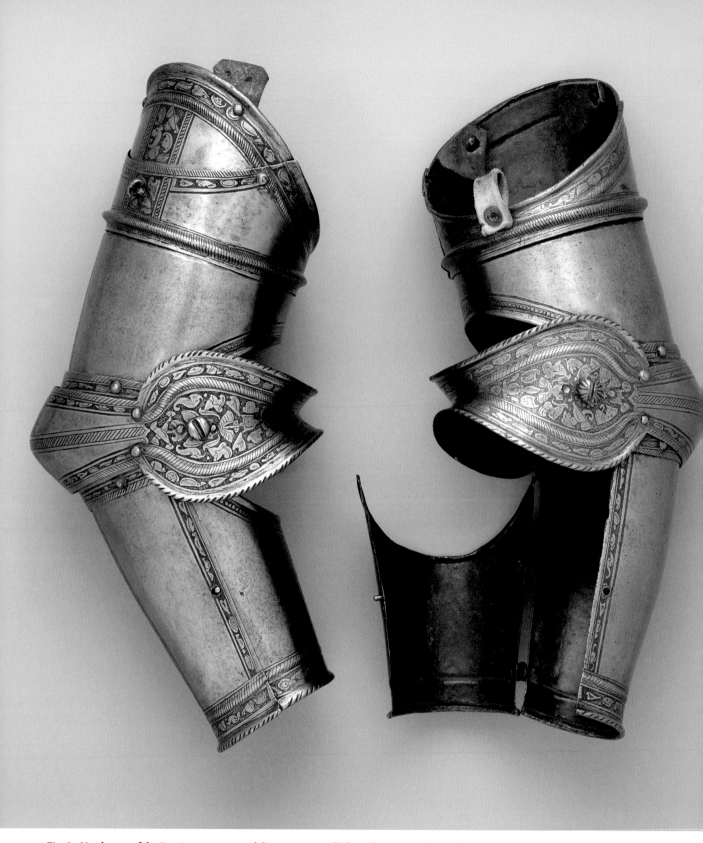

Fig. 65. Vambraces of the Dos Aguas armor with lower cannon of left vambrace open, fig. 42 (27.159.1g, h)

and overlapping the breastplate, while the right pauldron is cut back in the front to allow a lance to be couched under the arm and a sword to be wielded more easily. The pauldrons of the Dos Aguas armor are symmetrical, with neither the left nor the right one extending very far in the front. This type was usually intended for use with a light cavalry or infantry armor, suggesting that the Dos Aguas garniture originally included an additional pair of asymmetrical heavy cavalry pauldrons.

VAMBRACES

Vambraces are designed to defend the arms from the bottom of the pauldrons to the wrists while still permitting the arms to bend and rotate freely from the shoulder and elbow joints. The essential parts of a vambrace are a tube, called a cannon, for the upper arm; a couter, also called an elbow cop, covering the elbow; and a cannon sheathing the forearm from the elbow to the wrist. In some types, particularly on German armor, the upper and lower cannons connect to the couter by leather straps, but on the Dos Aguas armor, and many others, these elements are riveted together with small articulating lames in between (fig. 65). The elbow is protected by a cuplike plate over the point of the elbow, with a heart shaped wing or fan that extends to protect the crook of the inner elbow. In some instances, as in this one, the wing arches over from front to back in one continuous piece. For seamless protection of the upper arm, the top of the upper cannon is joined to the bottom of the pauldron by a fastening device called a turning pin. To prevent this from impeding mobility, the top of the upper cannon is fitted with a type of rotating cuff that allows the upper arm to turn or rotate from the shoulder without creating a gap between the plates. To allow the lower cannon to fit snugly, it is made in two halves hinged together so that it can be opened for the arm to be inserted and then closed securely over the forearm. This construction is typical for its time and represents vambraces at their fullest form of development. The Dos Aguas vambraces have the additional feature of a slotted screw in a threaded hole in the center of each elbow wing. These screws enabled the attachment of reinforcing

pieces over both elbows for use in tournaments, another indication that this armor is part of a large garniture.

GAUNTLETS

The primary challenge facing armorers in making gauntlets was to fully protect the hands while not impeding the ability to hold weapons securely and maneuver them with as much dexterity as possible. A process of experimentation and development, beginning with the first plate gauntlets in the early fourteenth century, culminated about two centuries later with light, flexible, strong, and effective designs that display both elegant form and ingenious construction (fig. 66). The key elements are a one-piece cuff covering the wrist and the areas immediately above and below it, a series of flexible metacarpal lames covering the back of the hand, a shaped plate over the knuckles, protection for each finger in the form of small overlapping plates individually riveted to underlying strips of leather, and a similar covering over the thumb. Usually, within the steel gauntlet is a leather glove, to which the fingerplates and the thumb-piece were attached. In addition to gauntlets with fingers, mitten gauntlets were also popular. Well-made gauntlets are incredibly supple and bend easily with a hand's movements. The flaring cuff allows the wrist to rotate freely in all directions. The most refined type of gauntlet from the period of the Dos Aguas armor is represented by a beautifully decorated example made for another Spanish nobleman, Don Alonzo Pérez de Guzman el Bueno (1550–1619), commander of the Spanish armada, the fleet sent to attack England in 1588 (fig. 67). The great variety of gauntlet types and their development can be seen in examples from the fourteenth to the seventeenth century (fig. 68).

LEG DEFENSES: POLEYNS, CUISSES, GREAVES, AND SABATONS

A horseman's legs were vulnerable to attack, particularly by infantrymen, who would be about level with a rider's legs in the press of battle. Therefore, from the early thirteenth century onward, various types of rigid or reinforced defenses for the legs of cavalrymen were

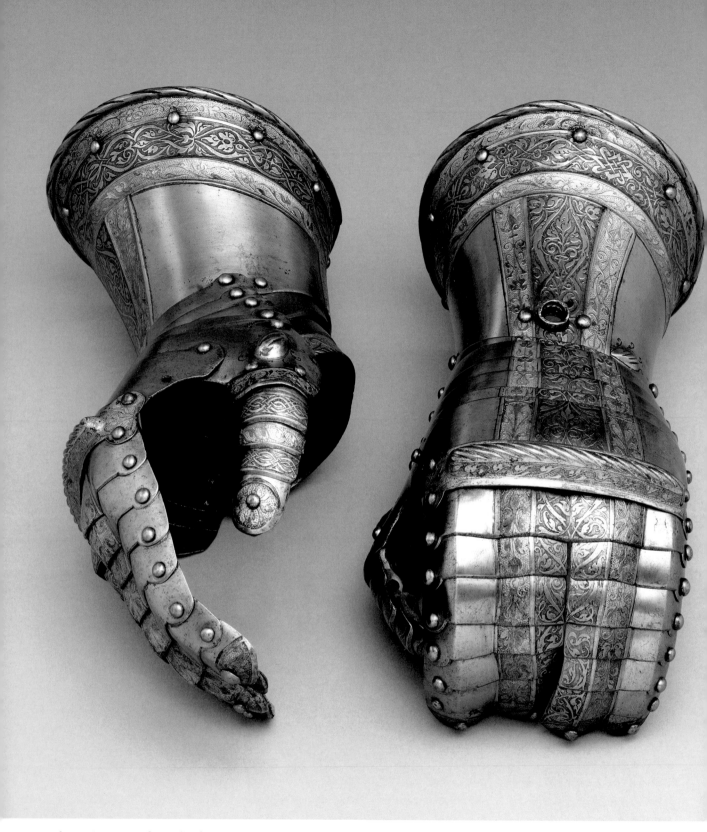

Above: Fig. 66. Pair of Gauntlets from a Garniture of Armor of Philip II of Spain (reigned 1554–58), Armorer: Desiderius Helmschmid (German, Augsburg, 1513–1579); Etcher: Ulrich Holzmann (German, Augsburg, recorded 1535–62), German, Augsburg, 1546. Steel, leather, and gold. Gift of William H. Riggs, 1913 (14.25.901a, b)

Opposite: Fig. 67. Gauntlet for the Right Hand, Belonging to the Armor of Don Alonzo Pérez de Guzman el Bueno, Count of Niebla and Duke of Medina-Sidonia, Italian, Milan, ca. 1580. Steel, silver, gold, textile, and leather. Gift of Bernice and Jerome Zwanger, 2002 (2002.507)

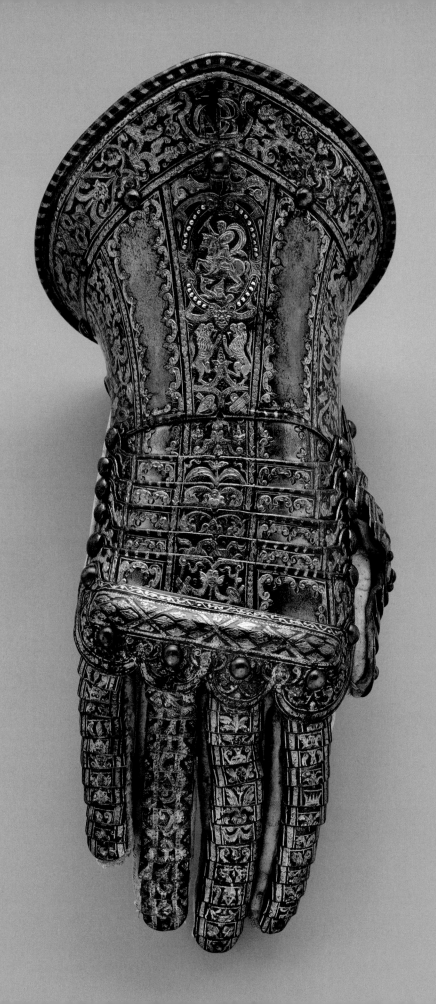

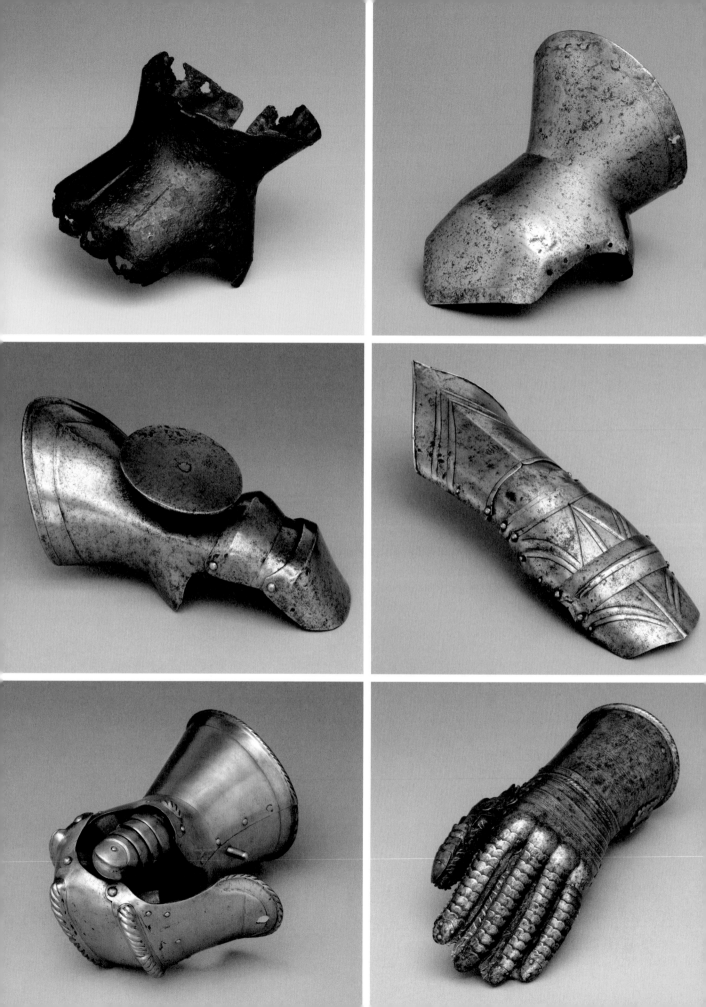

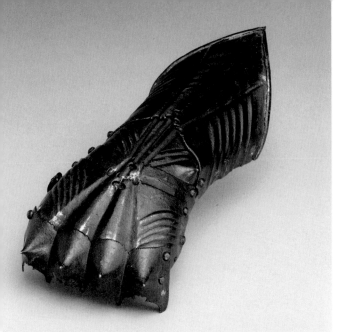

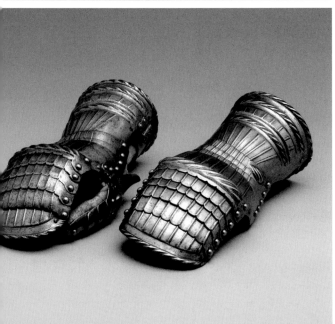

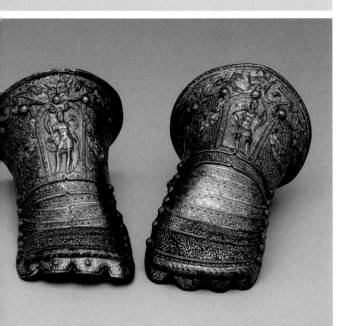

developed, at first covering only the knees but then extending the areas of enhanced protection to the thighs, shins, and feet. These early forms of leg armor include poleyns of hardened and molded leather to cover the knees and padded textile cuisses reinforced with leather or small steel plates for the thighs. Continuous thigh to toe, fully articulated, multipart steel leg armor existed by about the mid-fourteenth century (see fig. 16) and was refined over the next two centuries into the highly effective style we see on the Dos Aguas armor.

The cuisses of the Dos Aguas armor wrap around the front and sides of the thighs, leaving the backs uncovered so that a rider could grip and guide his horse with his legs (fig. 69). Each cuisse has one main plate covering the thigh and two large articulated plates above it reaching to the hip. The plates are connected by sliding rivets and internal leathers, which allow the plate to flex sufficiently when the knee was raised. Similar in form and function to couters that protect the elbows, the poleyns cover the knees and have a shaped cuplike plate, or knee cop, with a wing or fanlike extension at the outer edge to protect the tendons at the back of the knee while still allowing the knee to bend completely. The poleyns are connected to the cuisses above and the greaves below them by narrow articulating lames that ensure both flexibility and complete coverage of the joints. As is often the case, the

Fig. 68. Top row, left to right: Gauntlet for the Right Hand, from Tannenberg Castle, German, ca. 1380. Bashford Dean Memorial Collection, Bequest of Bashford Dean, 1928 (29.150.108); Gauntlet for the Right Hand, Italian, ca. 1420. Bashford Dean Memorial Collection, Bequest of Bashford Dean, 1928 (29.150.91h); Gauntlet for the Left Hand, South German or Austrian, ca. 1480. Gift of William H. Riggs, 1913 (14.25.909). Middle row: Mitten Gauntlet for the Left Hand with Rondel (Manifer), Italian, ca. 1480–1500. Bashford Dean Memorial Collection, Funds from various donors, 1929 (29.158.241); Mitten Gauntlet for the left hand. German or Austrian, ca. 1500. Bashford Dean Memorial Collection, funds from various donors, 1929 (29.158.256). Pair of Mitten Gauntlets in the Maximilian style, German, Augsburg, ca. 1525. Bashford Dean Memorial Collection, Gift of Mrs. Bashford Dean, 1929 (29.151.3p, q); Bottom row: Locking Gauntlet for the Tournament, German, possibly Augsburg, ca. 1525–50. Gift of William H. Riggs, 1913 (14.25.896); Left-Hand Dueling Gauntlet, Italian, ca. 1550–75. Gift of William H. Riggs, 1913 (14.25.911); Pair of Gauntlets for a Child, Lucio Piccinino, Italian, Milan, ca. 1585. Rogers Fund, 1919 (19.128.1, .2)

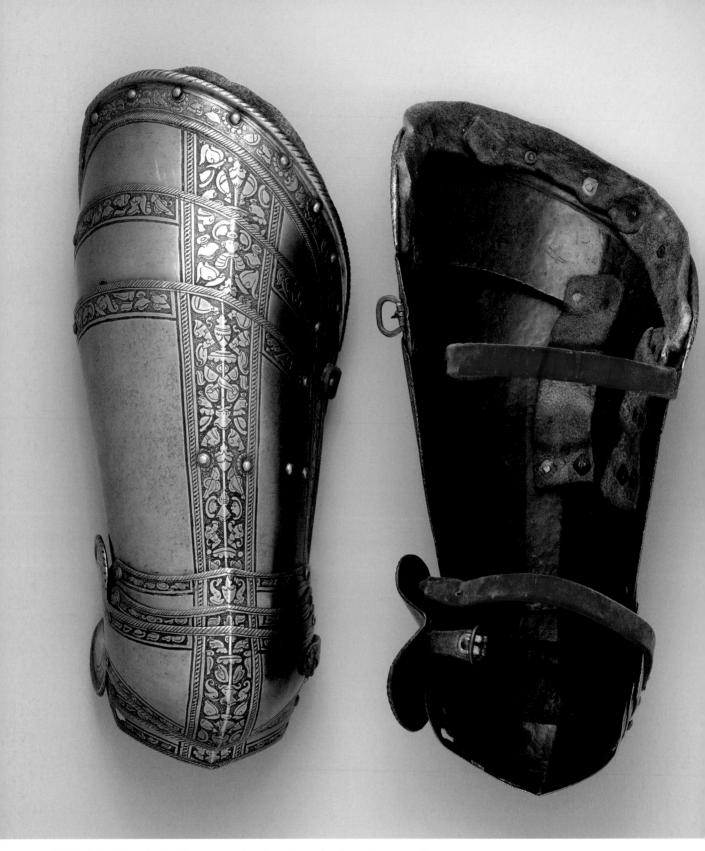

Fig. 69. Cuisses from the Dos Aguas armor, interior and exterior, fig. 42 (27.159.1m, n)

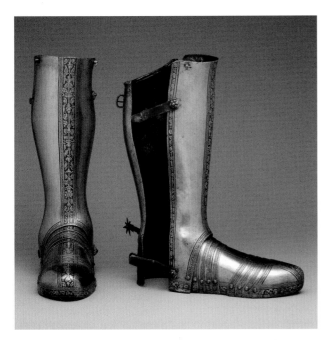

Fig. 70. Greaves and sabatons from the Dos Aguas armor, fig. 42 (27.159.10, p) with left greave open

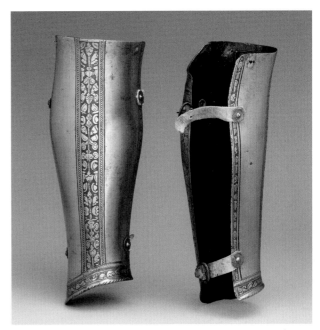

Fig. 71. Exchange greaves from the Dos Aguas garniture (27.159.10, .11)

lowest lame below each poleyn has two keyhole slots in it, which connect to the top of the front plate of the greaves by two turning pins. This makes it easy to detach the greaves from the rest of the leg armor. Three-quarter armor, covering the wearer from the lower thighs or knees to the head, without greaves, was a popular form of slightly lighter armor for both infantry and cavalry throughout the sixteenth century.

Each greave consists of a front and a back half, shaped to closely follow the contours of the lower leg (fig. 70). Usually, the halves are hinged on the outer edge and secured at the overlap on the inner edge by two small studs on the edge of the calf plate that engage corresponding holes on the edge of the shin plate. Sometimes, they are fastened by a pair of straps and buckles, as on the Dos Aguas armor. Frequently at the base of the back half, in the area over the heel, there is a vertical slot that accommodated the stem of the rider's spurs. Slightly more unusual is the arrangement on the Dos Aguas greaves, which are fitted with short spurs made to be attached directly to the greaves.

The greaves on any genuine armor of the fifteenth or sixteenth century have a reasonably accurate anatomical shape and follow the natural contours of a lower leg from the base of the knee to the instep. Really well made greaves have great elegance, and their lines flow with a sculptural quality that accentuates the graceful curve of the shin and the swell of the calf muscle. This naturalistic form must have been very difficult to make because awkward or clumsy looking greaves can be one of the first things to give away a fake or reproduction armor.

The Dos Aguas sabatons have a shaped toecap and a larger plate over the center of the instep. These are connected to each other and to the base of the front plate of the greaves by a series of narrow lames, all of which are riveted together so the foot can bend and flex in a natural walking motion.

The Dos Aguas armor is also furnished with an alternate pair of lighter greaves (fig. 71). Rather than entirely enclosing the legs below the knees, these greaves are open on about one-third of their inner aspect and have no armor for the foot. In addition to reducing weight, they allowed a horseman more ankle flexion and therefore must have improved his ability to mount and dismount a horse or to move about on foot and would have been more comfortable to wear for long periods of time.

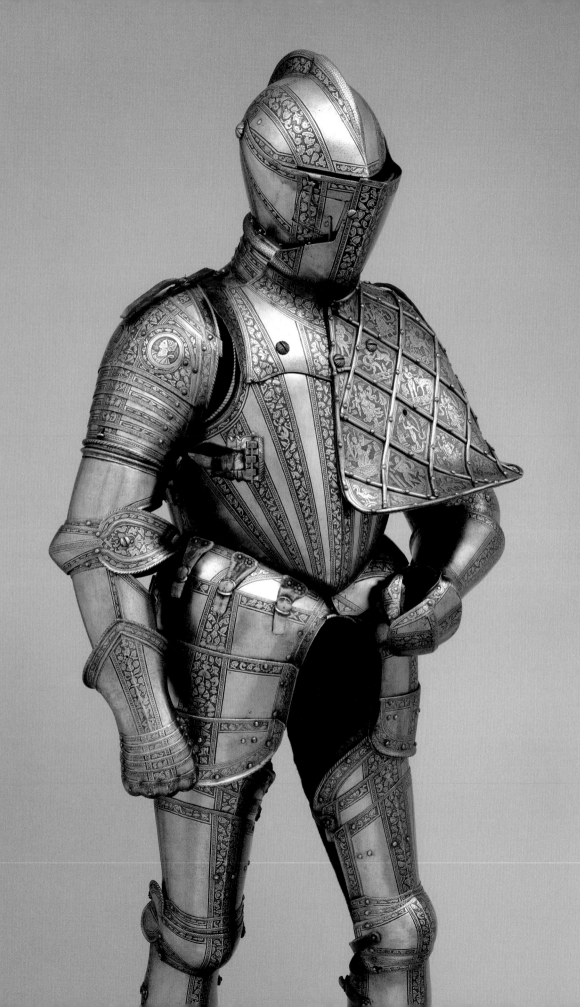

THE DOS AGUAS ARMOR AS A GARNITURE

The alternate greaves, along with the cabasset previously mentioned, number among the exchange pieces that tell us the Dos Aguas armor is a garniture rather than a single armor (fig. 72). The concept of armor garnitures developed in Germany late in the fifteenth century and at the start of the sixteenth century. Among the earliest surviving examples is a set of exchange pieces in The Metropolitan Museum of Art, made in Augsburg about 1510–15 by Kolman Helmschmid, one of the most talented and innovative armorers of his generation (fig. 73). This set comprises a reinforcing breastplate, a grandguard covering the chin, chest, and left shoulder, a left elbow reinforce, a plate called a manifer to cover the left gauntlet, an extra-long left tasset, and a vamplate, which was fitted on the lance to protect the right hand (fig. 74). All the elements are decorated with bands of etching that simulate elaborately patterned cut-velvet silk brocade. Also, in a playful touch, the etching on the top of the grandguard represents a man's face framed by long hair and wearing a ringed collar. The armor to which these pieces belonged no longer exists, but they were designed to equip it for the tourney, or *Freiturnier* (German for free tournament). The tourney was fought in an enclosed field by groups or teams of contestants on horseback and armed with lances and blunted swords. As woodcut prints from the period demonstrate,

the tourney closely approximated the action, and the chaos, of a full-scale cavalry battle (fig. 75).

Most of what we have seen of the Dos Aguas armor as a garniture so far points to its adaptability as a field armor for light and heavy cavalry and as an infantry armor. Now, we will look at the other more specialized garniture parts, which equip and convert the armor for two kinds of tournaments with lances, known as the tilt in the Italian style and the tilt in the German style. The type, number, and variety of its surviving pieces clearly show that the Dos Aguas garniture was modeled after the large and elaborate field and tournament garnitures made from about 1550 to about 1575 for the upper echelons of German, Italian, and Spanish noblemen in the circle of the Habsburg court (fig. 76). Most garnitures of this type were created by German armorers in the city of Augsburg beginning late

Fig. 73. Medal of Kolman Helmschmid (1471–1532), after a model by Hans Kels the Younger (German, 1508/10–1565), German, Augsburg, dated 1532. Lead, diam. 1¹⁵⁄₁₆ in. (50 mm). Purchase, Kenneth and Vivian Lam Gift, 2015 (2015.597)

Opposite: Fig. 72. The Dos Aguas armor (fig. 42) equipped for the German tilt (27.159.1–.3,.5–.7)

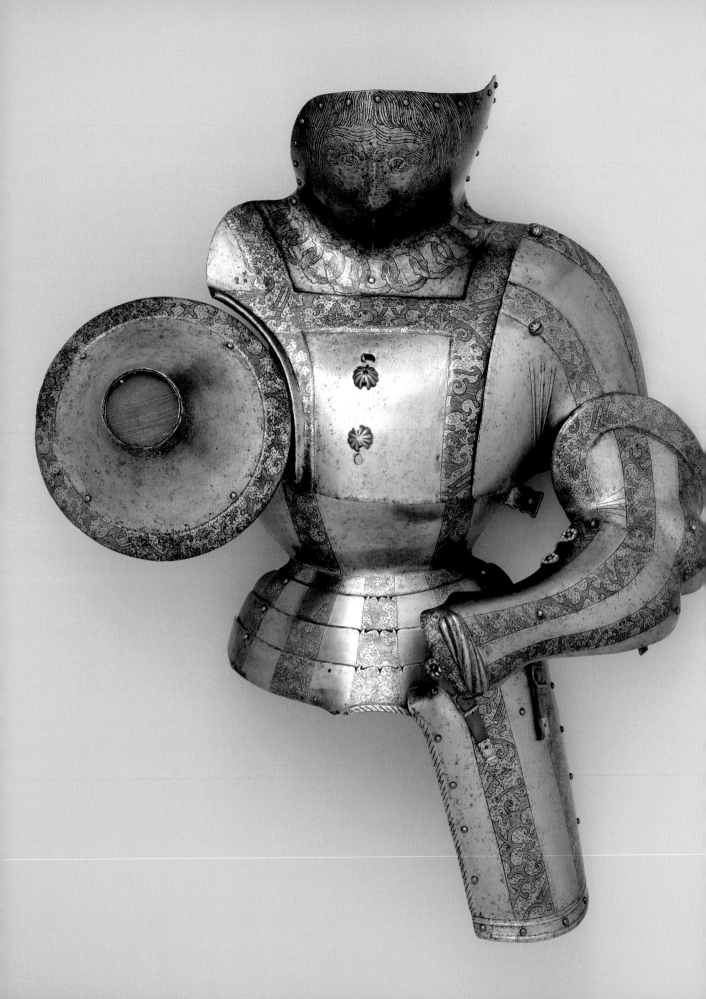

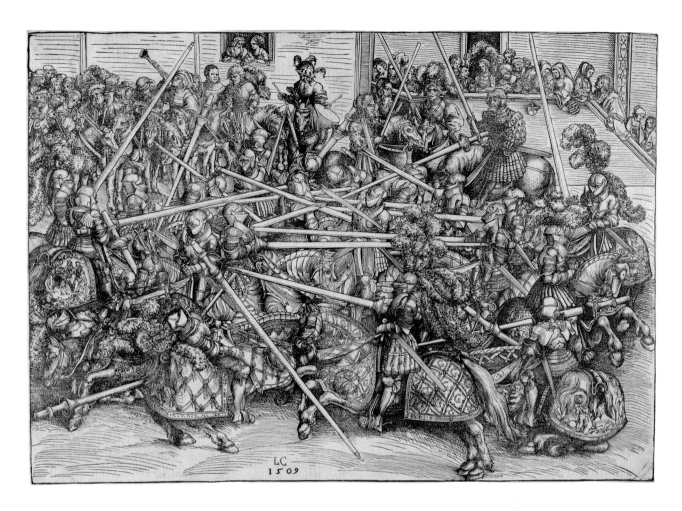

Opposite: Fig. 74. Reinforcing Pieces for the Tourney, Kolman Helmschmid (German, Augsburg 1471–1532), ca. 1510–15. Steel, copper alloy, and gold. Bashford Dean Memorial Collection, Bequest of Bashford Dean, 1928 (29.150.6d, f, m-p)

Above: Fig. 75. *The Third Tournament*, Lucas Cranach the Elder (German, Kronach 1472–1533 Weimar), 1509. Woodcut, 11¼ x 16¼ in. (28.6 x 41.3 cm). Harris Brisbane Dick Fund, 1927 (27.54.26)

Right: Fig. 76. Parts of an armor garniture made for a member of the Spinola family, possibly Marc Antonio Spinola, first count of Tassarolo (d. 1578), from the *Thun Sketchbooks*, Uměleckoprůmsylové Museum v Praze (Museum of Decorative Arts, Prague), inv. no. GK 11.557-A, folio 27v-28r

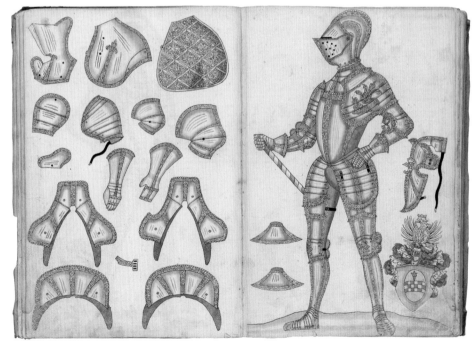

Fig. 77. Two vamplates from the Dos Aguas garniture (27.159.8, .9)

in the reign of Emperor Charles V (r. 1519–56) and continuing throughout the reigns of his two successors, Ferdinand I (r. 1558–64) and Maximilian II (r. 1564–76). There are several documented examples of Augsburg garnitures commissioned by Spanish courtiers, but the Dos Aguas garniture is the only one known of this type that was made in Italy rather than Germany.

Like others in this category, the Dos Aguas garniture has a single complete field armor for mounted combat as its core component (see fig. 42), which could be reconfigured, with various exchange pieces added or subtracted, to outfit it for its various purposes. As was typical, some elements were used in more than one ensemble. For instance, the gorget, pauldrons, and gauntlets could work for cavalry or infantry use. Missing pieces of this garniture probably include at least a close helmet for the field, an alternate pair of heavy cavalry pauldrons, an alternate pair of vambraces, a folding lance rest, a shorter pair of tassets for cavalry or infantry, and a round steel shield for infantry use. In addition to the alternate pair of light greaves and the cabasset, the surviving elements of the Dos Aguas garniture include two complete sets of saddle steels, plates that cover an armored saddle; two vamplates, a conical guard that fits over the shaft of a lance to protect the rider's hand in field or tournament (fig. 77); and eight exchange pieces for the Italian and German forms of the tilt. The term tilt refers to a barrier placed down the middle of a tournament field, which was called the lists. Contestants, armed with lances, started at opposite ends of the lists and rode toward each other along opposite sides of the tilt, allowing them to charge past their opponent as closely as possible without any danger of their horses colliding. Tournaments of this type were called tilts or tilting, and by extension, armor designed to be used in them was called tilting armor or armor for the tilt.

The foundation for all the tournament pieces of the Dos Aguas garniture is a reinforcing breastplate, called a plackart in English and *sovrapetto* in Italian (fig. 78). Essentially, it is a complete second breastplate that fits snugly over the underlying breastplate of the cuirass and is attached to it by the sturdy staples and pin that hold the lance rest in place. Next, screwed securely to the top of the plackart and the front of the helmet is the volant piece, or *mezzo guardaviso*, which doubles the amount of protection of the left side of the helmet, chin, and throat areas (fig. 79). In addition, the volant piece locks the helmet in place, turning the helmet and breastplate into a single unit, to minimize the danger of a broken neck or whiplash. It also has a slightly upturned flange on its right side, which protects the gap between the breastplate and the right shoulder. It is possible that the plackart and volant piece may have been used, in conjunction with other now-missing pieces, to outfit the garniture for the *campo aperto*, or joust in the open field, a variation of the tournament popular in Italy and fought with lances but with no tilt or other barrier separating the contestants.

With the plackart and volant piece in place, the armor can be equipped for the Italian or German tilt. For the Italian tilt, the grandguard, or *mezzo sovrapetto*, is bolted on next (fig. 80). The grandguard is a single form-fitting piece that covers the entire left half of the plackart and the front of the left shoulder, giving a triple layer of

Right: Fig. 78. Plackart (*sovrapetto*) from the Dos Aguas garniture (27.159.2a)

Below left: Fig. 79. Volant Piece (*mezzo guardaviso*) from the Dos Aguas garniture (27.159.2b)

Below right: Fig. 80. Grandguard (*mezzo sovrapetto*) from the Dos Aguas garniture (27.159.2c)

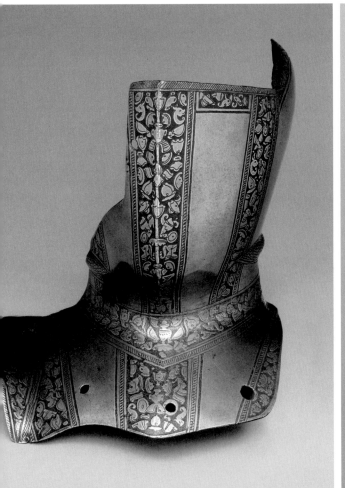

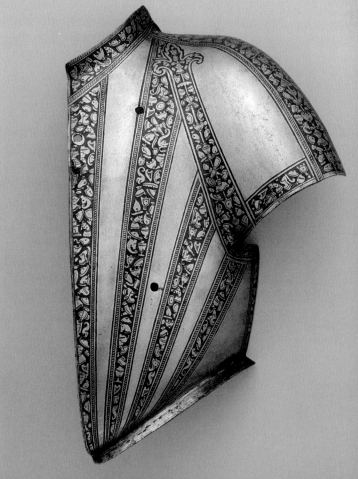

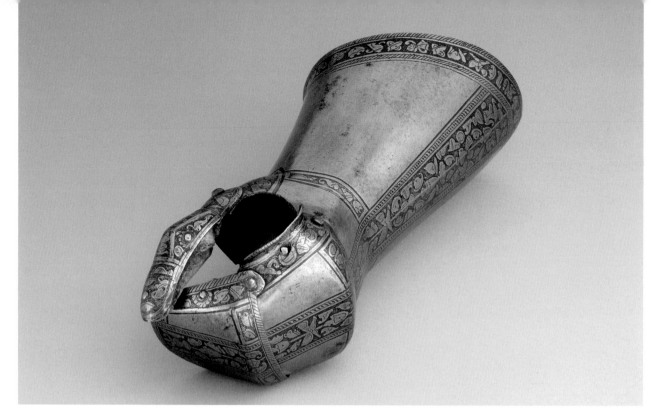

Fig. 82. Manifer (*manopola da lancia*) from the Dos Aguas garniture (27.159.6)

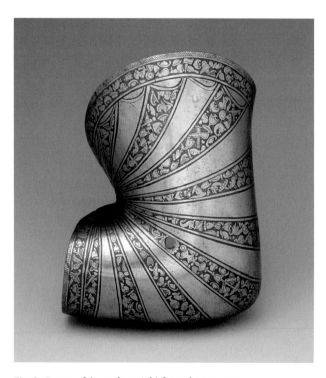

Fig. 81. Pasguard (*soprabracciale*) from the Dos Aguas garniture (27.159.4)

protection to the left half of the chest and a double layer to the left shoulder. To reinforce the left arm from the shoulder to the wrist, a large L-shaped plate called a pasguard, or *soprabracciale*, is screwed to the threaded socket in the left elbow of the vambrace (fig. 81). The pasguard overlaps the grandguard at the shoulder and keeps the left arm in a bent position. The fingered gauntlet of the field armor is replaced by a longer, heavier mitten gauntlet called a manifer or *manopola da lancia* (fig. 82), completing the ensemble for the Italian tilt (fig. 83). In conjunction with the plackart and volant piece, the combination of grandguard, pasguard, and manifer protected the rider's left side, where lance blows in a tilt were most likely to hit, while still allowing a certain amount of mobility for the left shoulder and arm. Some sixteenth century writers referred to this form of the garniture as equipped for the joust of war, because it was more similar to field armor than other types of tournament armor.

Starting again with just the plackart and volant piece as a foundation, for the German tilt, the exchange piece called a trellised targe, or *targetta*, is screwed securely in

Opposite: Fig. 83. Dos Aguas armor (fig. 42) equipped for the Italian tilt (27.159.1, .2, .4, .6)

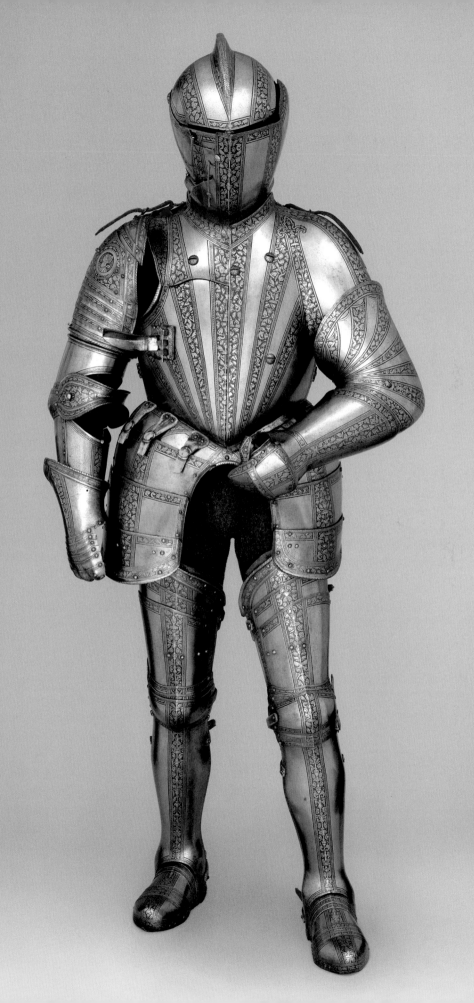

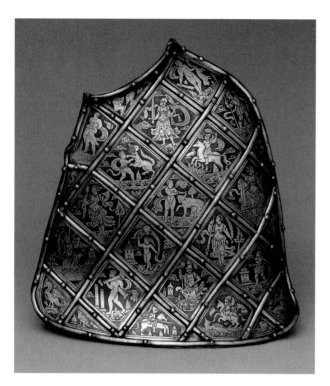

Fig. 84. Trellised Targe (*targetta*) from the Dos Aguas garniture (27.159.7)

Fig. 85. Reinforcing Piece for the Elbow (*gran guardabraccio*) from the Dos Aguas garniture (27.159.5)

Fig. 86. Reinforcing Piece for the Stomach (*mezza panziera*) from the Dos Aguas garniture (27.159.3)

place over the plackart and volant piece (fig. 84). The trellised targe is fixed in one position, providing a rigid steel cape protecting the left shoulder, upper arm, and chest from the impact of a lance. Its raised trellis pattern, made of crisscrossing steel ridges, was designed to catch the tip of an opponent's lance and ensure a solid hit, exactly the opposite goal of field armor, which was designed to have weapons glance off its surfaces. Since the left elbow was sheltered mostly by the scooped bottom edge of the trellised targe, a large pasguard was unnecessary. Instead, a small elbow piece called a *gran guardabraccio* was added (fig. 85). The area of the plackart that was exposed below the trellised targe is covered by the addition of a small stomach plate, or *mezza panziera* (fig. 86). With the left hand protected by the same manifer, the conversion of the garniture for the German tilt is complete (fig. 87). In this configuration, the garniture was equipped for what some sixteenth-century authorities on the tournament referred to as the joust of peace, because the restrictive nature of the targe was suitable for tournament use only.

The two vamplates of the Dos Aguas garniture (fig. 77) were designed for lances a full inch different in diameter: the opening of one measures 1¾ inches (4.5 cm) across, and the other is 2¾ inches (7 cm). It seems likely that the narrower lance was intended for the Italian tilt and the wider lance for the German tilt, but it is also possible that the different lance widths were simply a matter of personal preference on the part of the jouster.

Opposite: Fig. 87. Dos Aguas armor (fig. 42) equipped for the German tilt (27.159.1-.3, .5-.7)

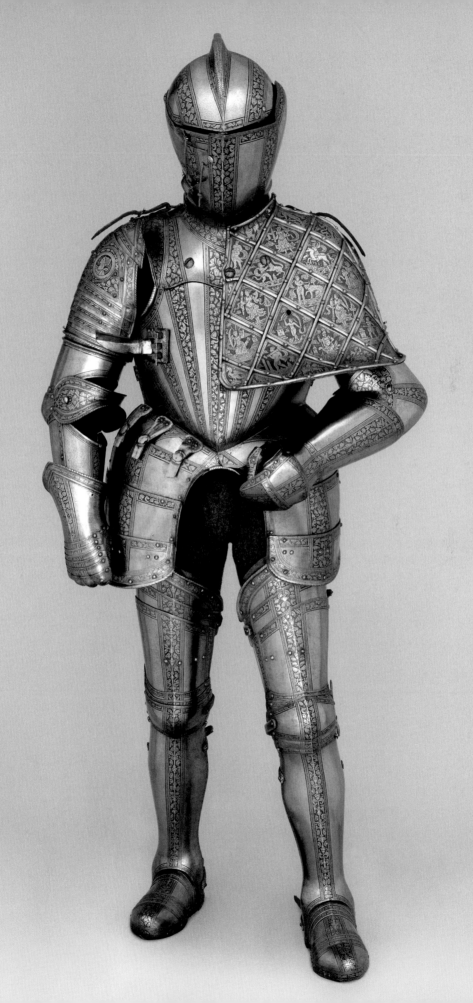

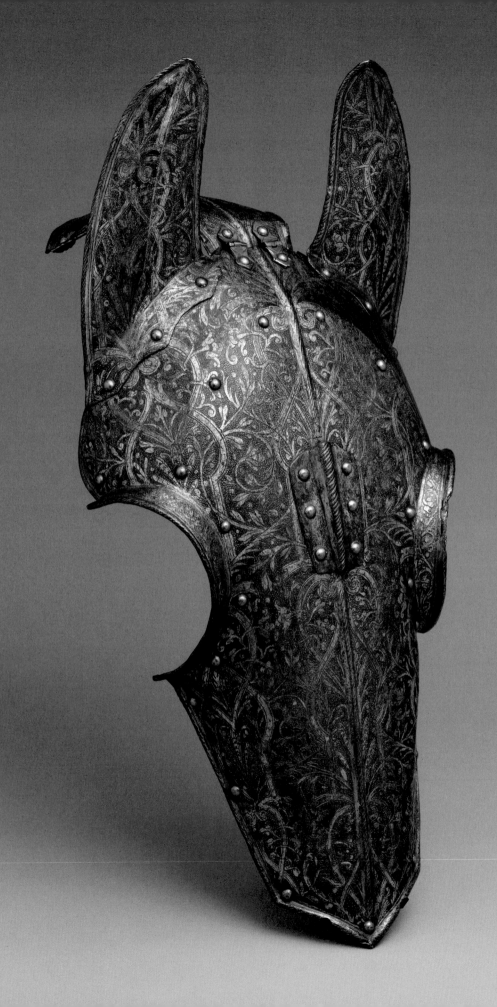

ARMORED SADDLES AND HORSE ARMOR

Armored saddles were used in Europe from at least the early fifteenth century until the early seventeenth century. Their armor consists of plates called saddle steels, which are shaped to cover the pommel (front arch) and cantle (rear arch) of a saddle. The steels are attached to the pommel and cantle of a saddle tree, the frame making up the saddle itself, which is composed predominantly of wood, often with components of iron, leather, and textile. Armoring a saddle with steels makes it an integral part of a horse and rider's protective equipment. In addition, saddle steels offer large surfaces for decoration, which, in the case of more elaborate armor or armor garnitures, matched the decorative scheme of the armor to which they belonged.

The two complete sets of saddle steels that belong to the Dos Aguas garniture are decorated with the same configuration of borders and bands of trophies as the rest of the armor and its exchange pieces (figs. 89 and 90). The construction of the steels of both sets is typical for the period. Each of the pommel plates has three pieces, a central plate to cover the pommel itself and two side plates extending downward to cover each arm of the front arch. The only distinct difference between the sets is that the outer edge of the right side plate of one has a distinct step or notch, where the butt of the lance could be rested

(fig. 90). Both cantle plates are two-piece, divided into roughly symmetrical halves, although some cantle plates were made in a single piece. As the two sets of saddle steels shown here indicate, the Dos Aguas garniture was intended to have two fully equipped saddles, perhaps one for the field and the other for tournament, or both to be ready for two different forms of tournament. Originally,

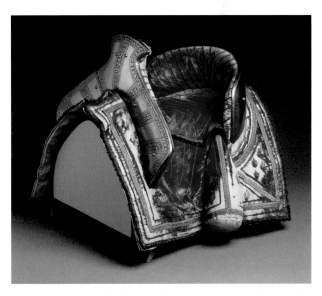

Fig. 89. Armored saddle from the Dos Aguas garniture (27.159.14)

Opposite: Fig. 88. Shaffron (Horse's Head Defense), French, ca. 1600. Steel, gold, and textile, h. 22 in. (55.9 cm), wt. 2 lb. 14 oz. (1304 lg). Rogers Fund, 1927 (27.177.2)

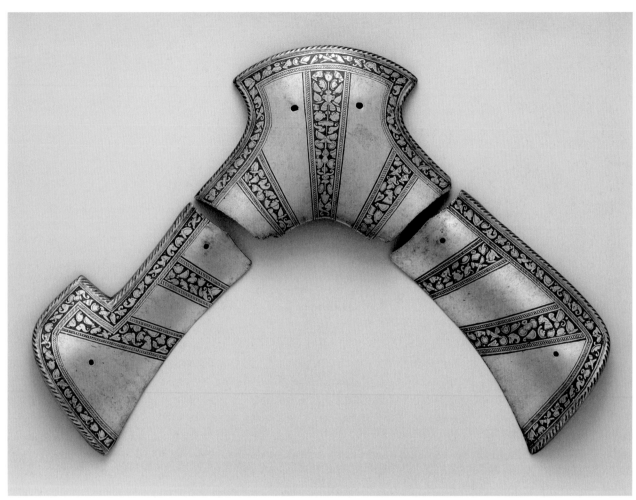

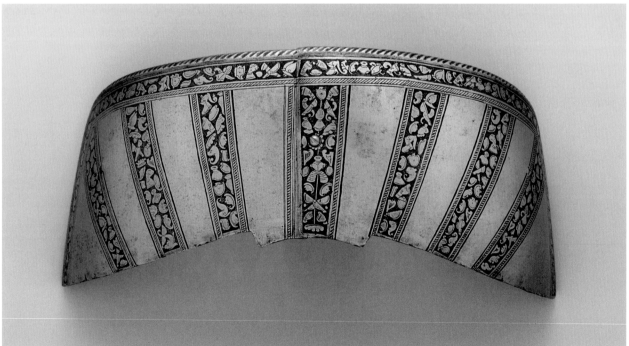

Fig. 90. Alternate of saddle steels from the Dos Aguas garniture (27.159.13)

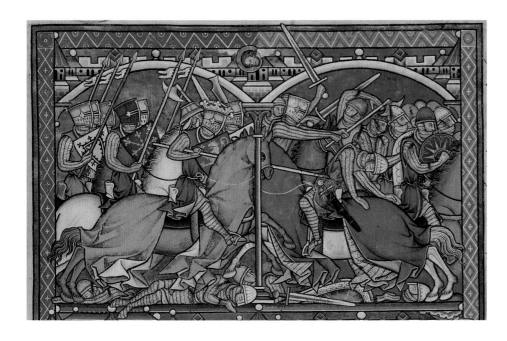

Fig. 91. Horse wearing a mail trapper, detail from *Old Testament Miniatures*, France, ca. 1244–54. The Morgan Library and Museum, New York, MS M.638 fol. 39r

the Dos Aguas garniture probably included one or even two matching shaffrons (horse's head defenses).

Armored saddles were often included in large garnitures during the sixteenth century, along with partial or sometimes complete horse armors. Horse armor has a long history. Many different forms were in use by the first millennium B.C. from China to Greece. Horse armor was brought to Western Europe by Roman heavy cavalry troops in the third or fourth century A.D. and may have been known there even earlier. After the fifth century and the dissolution of the Roman Empire, horse armor seems to have been used only sporadically, if at all, in Europe until the Middle Ages. Documented by the late eleventh century, it remained relatively rare until the late twelfth to thirteenth century, when it took the form of a complete covering of mail, also called a trapper (fig. 91). Mail trappers reinforced with rigid panels of hardened leather, and possibly steel, are documented by the mid-thirteenth century and became more common from the fourteenth century on (fig. 92). Complete plate horse armor, often referred to as a bard or barding, was developed in Italy by the mid-fifteenth century and was used throughout Europe over the next 150 years.

Like armor for men, armor for horses comprises a series of carefully shaped and articulated plates, the form and design of which became increasingly sophisticated,

reaching the peak of refinement by the mid-sixteenth century. The elements of such a fully developed bard include a shaffron for the horse's head; a crinet covering the top of the neck (crest) from the poll to the withers; a crupper over the horse's croup, buttocks, and hips; a peytral to protect the breast and shoulders; and flanchards, which are rectangular plates suspended horizontally from either side below the saddle to cover the ribs in the area between the peytral and the crupper (fig. 93). A saddle, usually an armored one, would protect the horse's back. The most extensive examples of horse armor have a

Fig. 92. Chess Piece in the Form of a Knight, Western European, possibly British, ca. 1350–75. Ivory (elephant), h. 2¹³⁄₃₂ in. (6.1 cm). Pfeiffer Fund, 1968 (68.95)

Following pages: Fig. 93. Horse Armor Probably Made for Count Antonio IV Collalto (1548–1620), Italian, probably Brescia, ca. 1580–90. Steel, leather, copper alloy, and textile, wt. including saddle 93 lb. 1 oz. (42.2 kg). Fletcher Fund, 1921 (21.139.1a-x)

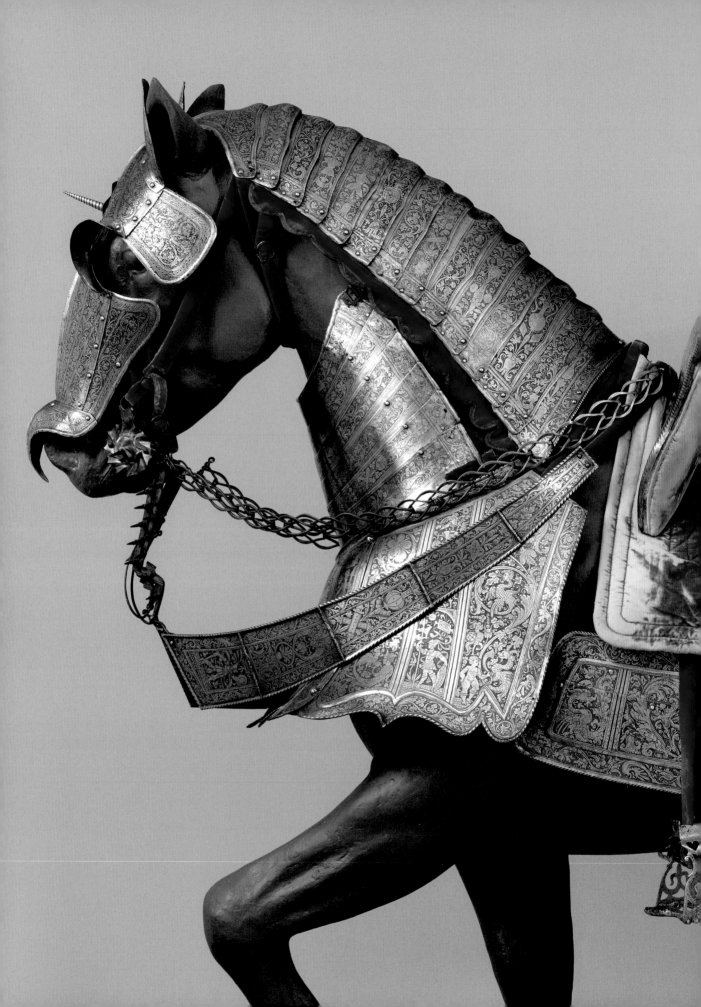

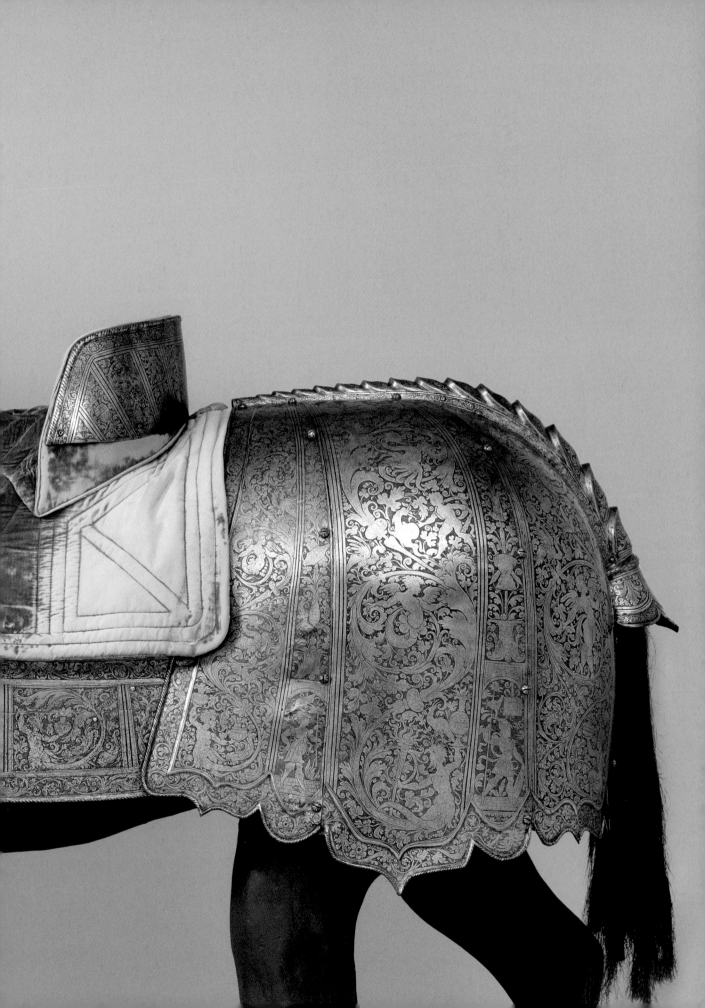

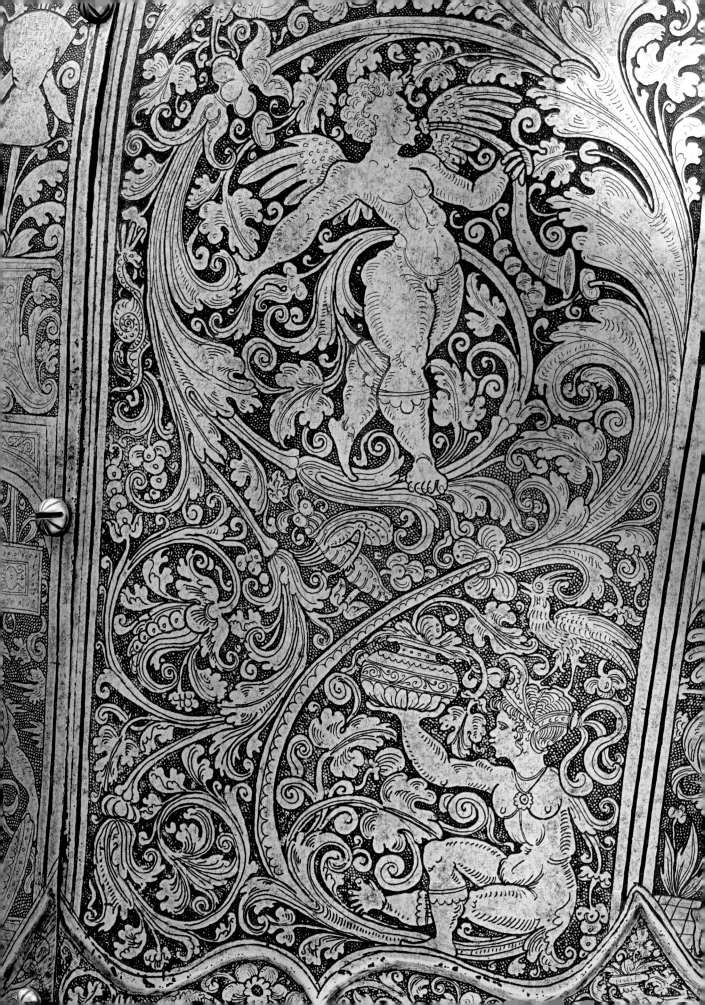

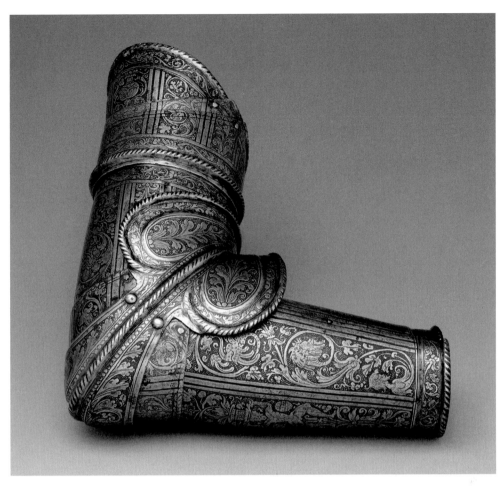

Fig. 95. Vambrace from an armor probably made for Count Antonio IV Collalto (1548–1620), Italian, probably Brescia, ca. 1580–90. Steel. Fletcher Fund, 1921 (21.139.11)

closed crinet, which, in addition to the top of the neck, covers the throat area either with a shaped panel of mail or a series of articulated plates. War horses in this period almost invariably were fitted with curb bits, which have long arms on each side that enable the rider to exert great pressure on the horse's mouth. Curb bits have two sets of reins; upper or snaffle reins set at the sides of the horse's mouth, and lower reins, called curb reins, set at the end of the arms. Often on a complete bard, the curb reins are faced with armor plates so they could not be cut in battle. The snaffle reins can also be made of an iron chain, rather than leather straps. Just as they have for a man's armor, the plates comprising a top quality horse armor have matching decoration. All these factors coalesce perfectly

in a superb Italian horse armor made about 1580–90 for a member of the Collalto family, probably Count Antonio IV Collalto. This armor is distinctive for its completeness and fine condition, for the excellence of its form, and for the beauty of its dense and lavish etched decoration (see figs. 93 and 94). The style of the etching indicates that the armor was made in the Northern Italian city of Brescia, a noted center of armor production for the Republic of Venice. Count Antonio was appointed commander of the Venetian army in 1589, and this horse armor may have been commissioned in conjunction with that event. Originally, it was part of a complete set for man and horse. Unfortunately, only a single piece, a vambrace, from the man's armor remains (fig. 95).

Opposite: Fig. 94. Detail of etched decoration on crupper of horse armor, fig. 93 (21.139.1a-x)

TOURNAMENT ARMOR

As early as the thirteenth century, there is evidence that reinforcing pieces were added to otherwise standard battle armor to give extra protection in tournaments. The process of making specialized tournament helmets and other pieces developed steadily through the fourteenth century, and by the mid-fifteenth, there were forms of complete armor designed to be used only in tournaments. Some types of sixteenth-century tournaments and tournament armor have been mentioned already in the context of the Dos Aguas garniture. The examples that follow show other specialized and distinctive varieties of tournament armor.

Among the rarest types of surviving tournament helmets is a large basketlike construction called a *Kolbenturnierhelm,* literally, club tournament helmet (fig. 97). Dating from about 1450 to 1500, it was used in a contest fought by groups of mounted men armed with clubs (*Kolben*) or blunted swords (fig. 98). A large iron grill over the front half of the head provides protection, ventilation, and a wide field of vision. The rest is an iron framework covered with fabric, over which is a layer of gesso, a material similar to plaster. The gesso has been molded with floral patterns derived from designs found on luxury silk fabrics of the period. At the back of the helmet, the decoration also includes the coat of arms of the original owner, a member of the von Stein (or vom Stain) family from Swabia in southwestern Germany. Because of the relative fragility of gesso and textile, and the hard use these helmets endured, very few of them still exist today. In contrast to its rather muted appearance now, when this helmet was new, it would have been topped with a large elaborate crest and draped with bright fabrics, in keeping with the colorful and festive nature of tournaments.

The most recognizable and iconic type of tournament helmet is the *Stechhelm* (fig. 99), worn as part of a particular form of armor developed in the late fifteenth and early sixteenth centuries for the German joust, or *Gestech* (fig. 100). It is epitomized in works by Albrecht Dürer (1471–1528) and many other Renaissance artists (fig. 101), and is also highly familiar as a type because of its use in heraldic representations to support the crest above a coat of arms. To minimize the chances of head or neck injuries during the joust, the helmet was intentionally heavy—this example weighs nearly 18 pounds (8.1 kg)—and was bolted to the cuirass front and back. For further protection, it was worn in conjunction with an internal suspension system consisting of a padded cap outfitted with straps and laces to keep the wearer's head from hitting the inside

Opposite: Fig. 96. *Combat à la barrière,* part of the Valois Tapestries series, showing the tournament fought on foot, Flemish, Brussels, ca. 1575. Wool, silk, gold, and silver, 151¹⁵/₁₆ x 129⅛ in. (386 x 328 cm). Gallerie degli Uffizi, Ministeri dei Beni e le Attività Culturali, Florence. In the center, two combatants fight with spears over a waist-high railing; two more, fully equipped for foot tournament, stand in the foreground at either side

Fig. 97. Tournament Helm (*Kolbenturnierhelm*), German, ca. 1450–1500. Steel, textile, leather, gesso, and polychromy, h. 19 ⅝ in. (49.8 cm). Gift of Christian A. Zabriskie, 1940 (40.135.3)

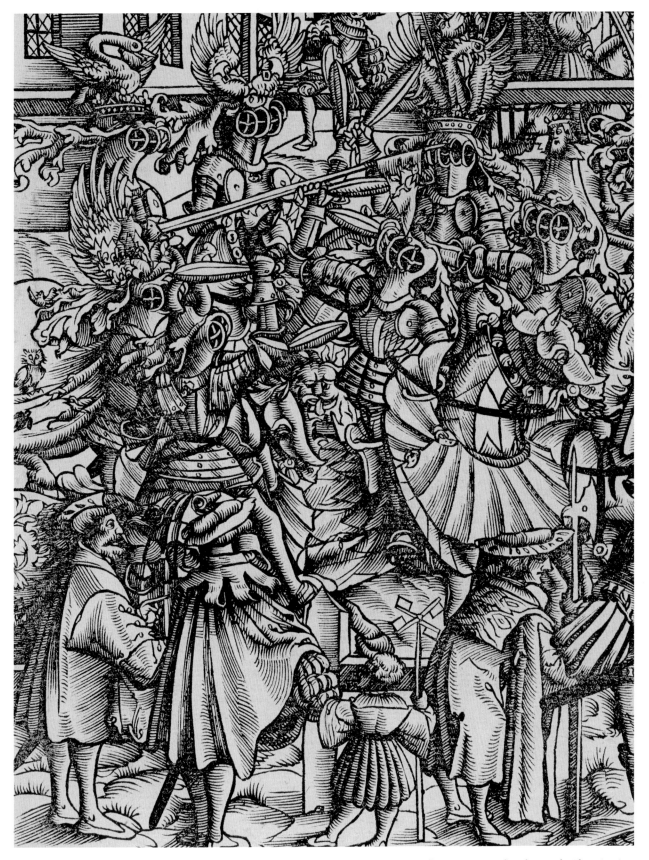

Fig. 98. Detail of the tournament fought with clubs (*Kolbenturnier*), from George Rüxner, *Anfang, Ursprüg und Herkomen des Thurniers im teutscher Nation* ... Siemern, 1532. Library of the Department of Arms and Armor

Fig. 99. Helm for the Joust of Peace (*Stechhelm*), German, probably Nuremberg, ca. 1500. Steel and copper alloy, h. 17¾ in. (45 cm); wt. 17 lb. 14 oz. (8097 g). Bashford Dean Memorial Collection, Gift of Edward S. Harkness, 1929 (29.156.67a)

Fig. 100. Detail of jousters in *Gesellenstechen auf dem Grossen Markt von Nürnberg*, Jost Ammann, 1561. Bavarian National Museum, Munich, Inv.-Nr. 49/43

Fig. 101. *Three Studies of a Helmet*, Albrecht Dürer (German, Nuremburg, 1471–1528). Watercolor and ink on prepared paper, 16⅝ x 10½ in. (42.1 x 26.6 cm). Musée du Louvre, Paris, RF5640

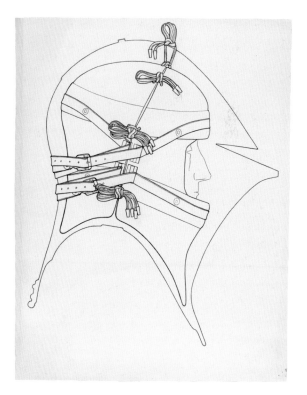

Fig. 102. Cutaway view showing the suspension system inside a *Stechhelm*. Archives of the Department of Arms and Armor

was a natural part of many tournaments. Fighting on foot was also important for trial by combat, or judicial duels, in which opponents, armored from head to toe and armed with swords or poleaxes, settled legal disputes or other serious issues by fighting before judges in the lists (figs. 8 and 103). Like other tournament armor, foot combat armor became very specialized in the fifteenth and sixteenth centuries. One type of helmet unique to foot combat in the lists, either sporting or judicial, has a smooth rounded form and was bolted securely to the breastplate and backplate (fig. 104). Rather than the usual horizontal sights or vision slits, its large, hemispherical visor is perforated with multiple rows of small slots, so there would be no large gaps for the blade of a weapon to penetrate. The helmet shown here was made in England or Flanders in the early sixteenth century and is one of the finest surviving examples of its kind. It belonged to Sir Giles Capel, an English nobleman, and appears to be the one he described in his will as his "beste Helmett," which was to be hung above his tomb after his death in 1556. In 1520, Sir Giles was part of the entourage accompanying King Henry VIII to France for the Field of the Cloth of Gold, a summit meeting with King Francis I. The monarchs and their retinues competed in tournaments, including foot combats in which Sir Giles may have worn this helmet.

In another type of foot combat tournament popular from the mid-sixteenth to the early seventeenth century, the contestants wore no armor on their legs because they were separated by a waist-high railing and striking below the belt was prohibited (see fig. 96). The railing also eliminated some of the dangers of close hand-to-hand fighting, including grappling and wrestling holds and throws that were otherwise a regular part of foot combat in the lists or on the battlefield. The participants were armed with blunted spears and rebated swords, meaning swords with rounded points and unsharpened edges, and unlike most tournaments, this event was sometimes held indoors. The German form of armor for these tournaments on foot is exemplified by a beautifully preserved blued and gilt armor made in 1591 by the renowned Augsburg armorer Anton Peffenhauser for Christian I, Duke of

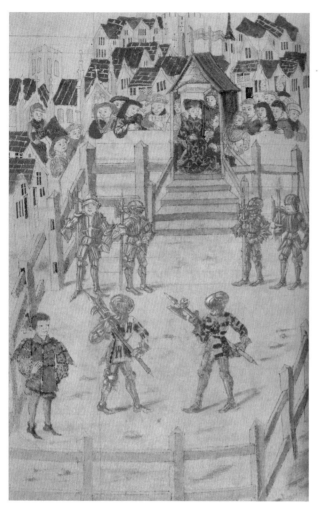

Fig. 103. Detail of a judicial combat, *Ordonances of Chivalry*, England, late 15th century. The Morgan Library and Museum, New York, MS M.775, fol. 277 verso

of the helmet (fig. 102). The plates at the front of the helmet are extra thick and curved to deflect the impact of the multi-pronged coronel lance heads that were used in the German joust. So while its dramatically sweeping lines and graceful form are immediately impressive and appealing, the *Stechhelm* is also a marvel of purposeful design uniquely suited to the specific needs of its event.

Because cavalrymen regularly faced the danger of being unhorsed in battle, the ability to fight effectively on foot in full armor was a vital skill. Therefore, foot combat

Opposite: Fig. 104. Foot-Combat Helm of Sir Giles Capel (1485–1556), English or Flemish, ca. 1510. Steel, h. 17½ in. (44.4 cm); wt. 13 lb. 8 oz. (6123 g). Rogers Fund, 1904 (04.3.274)

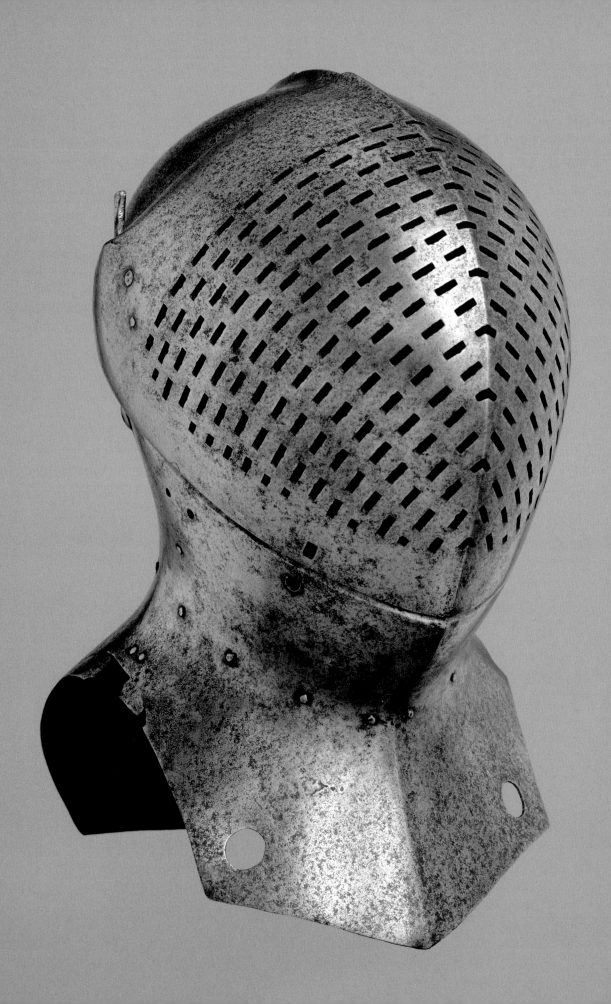

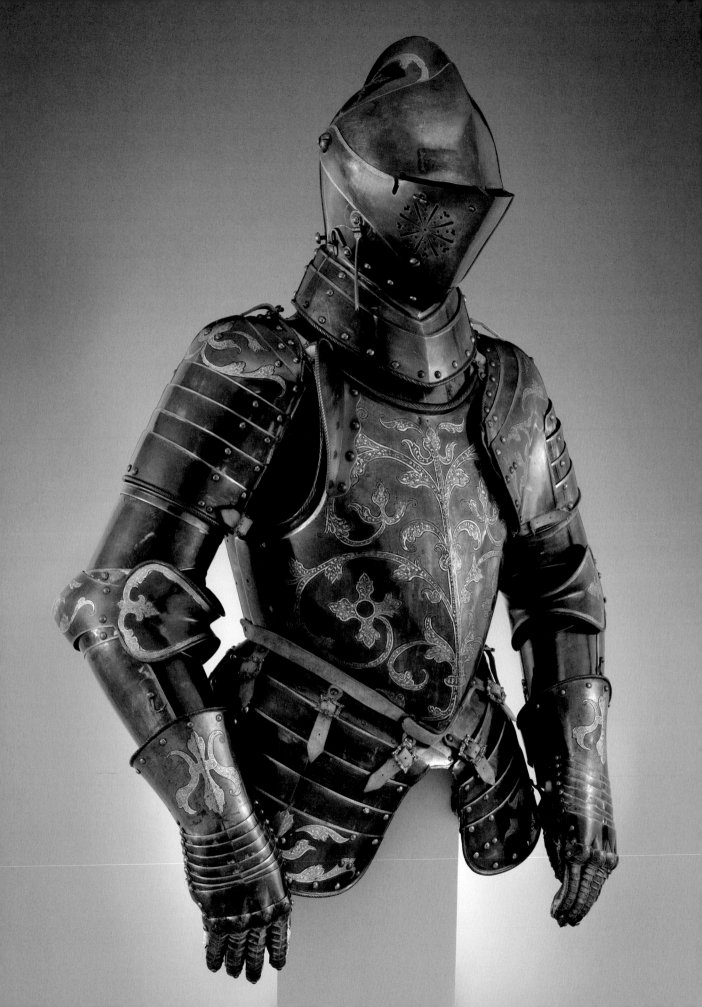

Fig. 106. Running at the Quintain, plate 47 from *L'instruction du roy en l'exercice de monter à cheval*, Antoine de Pluvinel, Amsterdam, 1666. Library of the Department of Arms and Armor

Saxony, in northern Germany (fig. 105). It was part of a set of twelve matching armors commissioned as a Christmas gift by Sophie of Brandenburg, Christian's wife. Unfortunately, Christian died suddenly in September 1591, and as a result, it appears that some of the armors were never used, which probably accounts for the remarkable condition of this one. In construction and form, it is very much like a field armor for cavalry. Other than having no leg defenses, the main features that identify it as an armor for foot tournament are the lack of a lance rest; the presence of a tournament visor on the helmet, with no openings on the left side; and the addition of a raised flange for extra protection at the gap between the right shoulder and the edge of the breastplate.

By the early seventeenth century, due to the steadily increasing use of firearms on the battlefield throughout the previous century, lances, and heavy cavalry in general, played a progressively decreasing role in warfare.

Partly as a result of this trend, by the late sixteenth century, full-contact tournaments in complete armor began to go out of fashion, all but disappearing by about the mid-seventeenth century. Nevertheless, accuracy with a lance on horseback was still considered part of a nobleman's training through the seventeenth century, but more as an aspect of overall skill in equitation (fig. 106). Rather than against a living opponent, it was more frequently practiced against an inanimate object such as a quintain (a target, often in human form, mounted on a post) or a ring suspended from ropes, in which case it was called "running at the ring." These feats were incorporated into carousels, elaborate equestrian pageants often with themes and costumes inspired by Greek and Roman mythology or ancient history, which replaced tournaments at courts throughout Europe during the seventeenth century and continued to be held occasionally until about the middle of the eighteenth century (fig. 107).

Opposite: Fig. 105. Foot-Combat Armor of Prince-Elector Christian I of Saxony (reigned 1586–91), Anton Peffenhauser (German, Augsburg, 1525–1603); decoration attributed to Jörg Sorg the Younger (German, Augsburg, ca. 1522–1603), 1591. Steel, gold, leather, and copper alloy, h. 38 11/16 in. (98.2 cm); wt. 46 lb. 3 oz. (20.96 kg). Gift of Henry Walters, 1927 (27.206a-l)

Fig. 107. *Ludi equestres, Das Thurnieren (The Tournament)*, Martin Engelbrecht (German, Augsburg, 1684–1756), ca. 1730. Engraving, paper, ink, and polychromy, 9½ x 15 3/16 in. (24.1 x 38.5 cm). Purchase, Kenneth and Vivian Lam Gift, 2014 (2014.434)

One place where fully armored jousting continued was Dresden, at the court of the dukes of Saxony, particularly in the form of the *Scharfrennen*, a mounted tournament fought with pointed lances. Combatants wore a specialized type of armor called *Rennzeug* (fig. 108); a large group of these were made in or near Dresden in the late sixteenth century. Like the Dos Aguas garniture, these Saxon tournament armors could be fitted with a cape-like targe over the left shoulder and a small reinforcing piece on the left elbow to equip them for the German joust, or with a more form-fitting grandguard and a pasguard (a large elbow reinforce) for the Italian joust. Their distinctive helmets are a purposely anachronistic form of German sallet, modeled after sallets from German field armors of the late fifteenth and early sixteenth centuries (see fig. 54). This later tournament version, however, is bolted securely to a reinforcing bevor that covers the lower face, which is

in turn bolted to the breastplate. The armors continued to be used periodically in Dresden in the eighteenth and nineteenth centuries; their last recorded use was in a historical revival tournament held in 1936. Over time, some interesting modifications were made to the armors to increase safety. The most distinctive alteration, probably made in the eighteenth century, was the addition of a steel brace from the back of the helmet to the backplate to protect against head and neck injuries such as whiplash. In some instances, we know who wore the armors in later tournaments because their names are painted inside them. The particular example seen here has "Herr von Breitenbauch" painted on the interior of the backplate, identifying it as used by Karl Christian von Breitenbauch, who, from 1694 to 1726, was an official at the court of Augustus the Strong, Duke of Saxony.

Opposite: Fig. 108. Jousting Armor (*Rennzeug*), German, probably Dresden or Annaberg, ca. 1580–90. Steel, copper alloy, and leather, wt. 91 lb. 6 oz. (41.45 kg). Gift of Henry G. Keasbey, 1926 (26.92.3a-w)

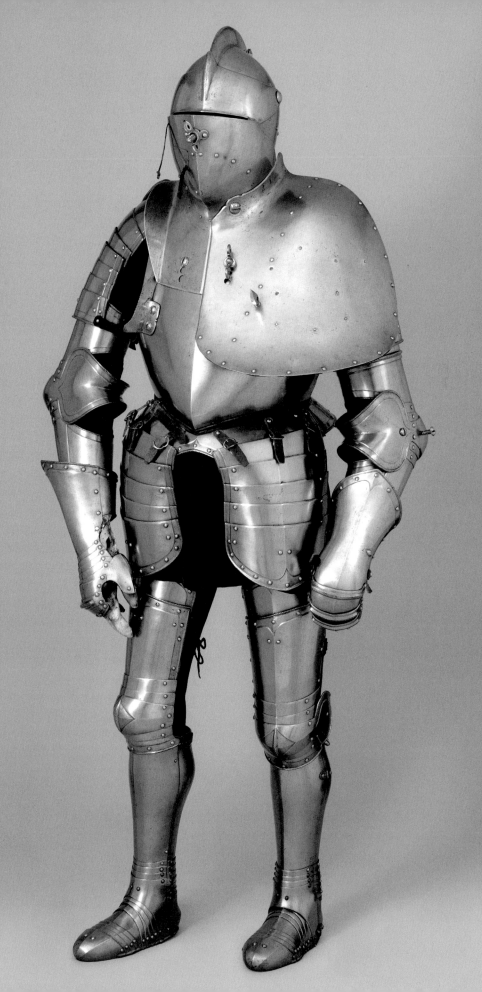

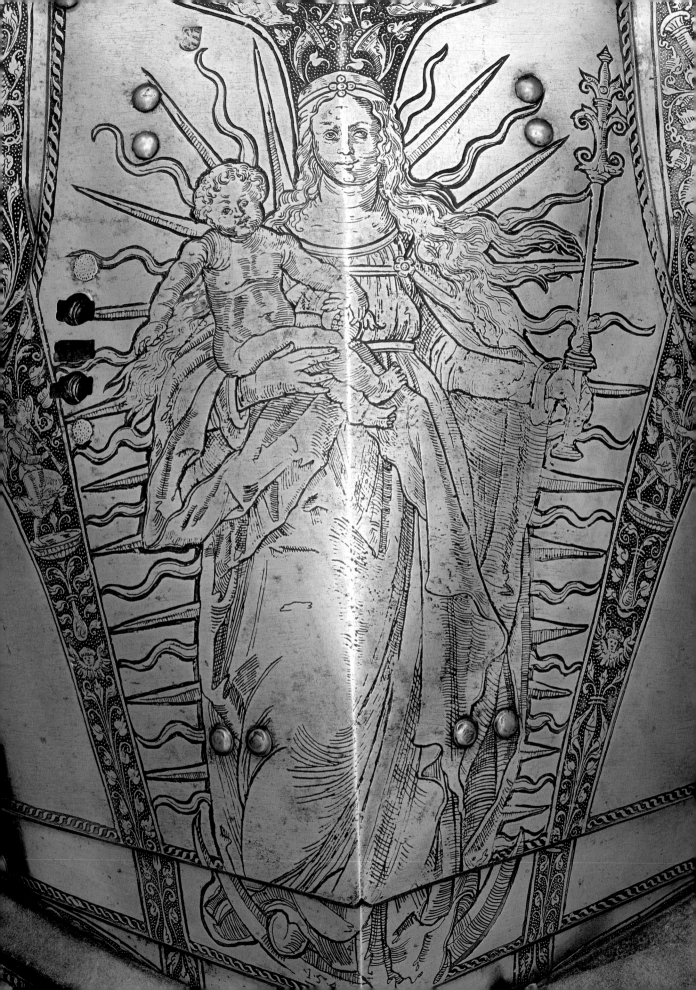

DECORATION

Although its overarching purpose is protection, armor is also a unique vehicle for personal adornment and display. Numerous examples from both Europe and Asia, dating from as early as the third millennium B.C., demonstrate that the desire to decorate armor is virtually as old as armor itself (fig. 110 and see figs. 1 and 2). The decoration of European armor from the fifteenth through the seventeenth century involves several techniques, which are found alone or in various combinations. They include etching, mercury gilding, heat bluing, engraving, inlay and damascening in gold or silver, raised ornament created on surfaces by embossing (also called repoussé), and the addition of applied borders or appliqués. How these techniques are utilized is a major factor in assessing and understanding the style, period, and quality of a particular piece of armor, and sometimes also its authenticity.

In addition to these methods of surface decoration, aesthetic form itself is often a key element indicative of quality and style. By about 1425 to 1450, armorers in Western Europe found solutions to the remaining problems of creating practical and fully articulated plate armor covering a man from head to toe. With this resolved, the next century brought steady technical improvements in functionality. Moreover, the most talented armorers now had the freedom to refine the form and design of armor,

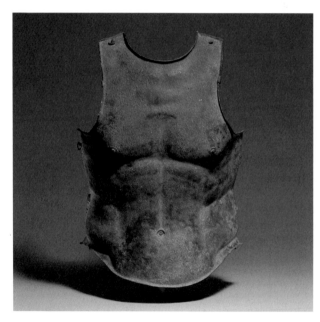

Fig. 110. Cuirass (body armor), Greek, Apulian, 4th century B.C. Bronze, h. 19⅝ in. (49.8 cm). Gift of Estée Lauder, Inc., 1992 (1992.180.3)

creating the potential for unprecedented degrees of beauty and elegance without compromising defensive capabilities. Compare, for example, two late fifteenth-century war hats. Both are very good examples of their kind and

Opposite: Fig. 109. Detail of Mary and the Christ Child, from the breastplate of the Armor of Emperor Ferdinand I (1503–1564), fig. 120

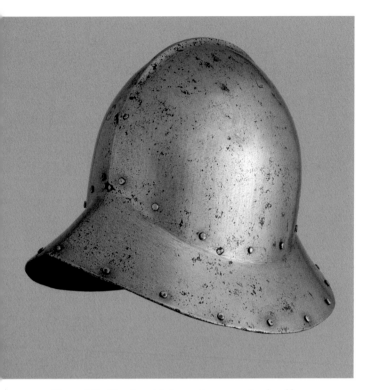

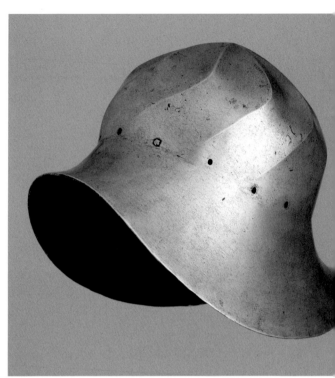

Fig. 111. War Hat, Spanish, late 15th century. Steel and brass, h. 9¾ in. (24.8 cm); wt. 3 lb.12 oz. (1696 g). Bashford Dean Memorial Collection, Bequest of Bashford Dean, 1928 (29.150.9a)

Fig. 112. War Hat, probably Burgundy or Flanders, ca. 1475. Steel, h. 10 3⁄16 in. (25.9 cm); wt. 6 lb. 7 oz. (2920 g). Rogers Fund, 1904 (04.3.228)

fully satisfy the requirements for effective protection. One has a characteristic shape for a Spanish war hat of this period, with a hemispherical bowl and a broad sloping brim (fig. 111). The other helmet, probably Burgundian or Franco-Flemish, has a bowl that features a swirl or spiral of facets and a brim that sweeps dramatically and asymmetrically to the back and front (fig. 112). Both helmets were probably prized by the men who originally wore them, and either would be treasured by a modern collector or museum. We can see, however, that although these two helmets are the same type from about the same period, their forms differ significantly. As with any armor, this is partially attributable to variations in national, regional, or even workshop styles. Beyond that, there is an expressive quality and dramatic use of form evident in the Burgundian helmet that is lacking in the Spanish war

hat, so that the latter looks tame and almost pedestrian in comparison. Assessing and appreciating less quantifiable qualities such as this can be an important aspect of distinguishing an example of good armor from a great one, or even a genuine piece from a fake.

ETCHING

Of all the techniques involved in the ornamentation of European plate armor, etching is the most important from several perspectives, ranging from technical and economic to art historical and aesthetic (see fig. 109). From the early years of the sixteenth century until the obsolescence of plate armor in the mid-seventeenth century, etching was used to decorate armor more than any other method. It is understandable to assume that elaborately etched armor must have been made for ceremonial use only, but most

often, that is not the case. Because the etching process does not weaken armor or otherwise adversely impact its protective capabilities, etching was employed frequently on armor intended for battle. In addition, since the technique was relatively inexpensive compared to other forms of embellishment, there was no economic reason to restrict its use to luxury armors for the upper nobility. Therefore, although the extent and artistic quality varies, etching is found on armor of almost all types and levels. It appears that etching was invented originally as a technique for the decoration of weapons and armor, but by the late fifteenth century, artists recognized the potential for producing prints on paper from etched metal plates, first steel and then copper plates, giving birth to one of the most prolific and influential genres of printmaking and the graphic arts. Because of the relative ease and flexibility of the process, etching presented armor decorators with more freedom for artistic expression and experimentation than any other technique. This resulted in a wide range of styles utilizing the full complement of Renaissance and Mannerist ornament, often derived from prints, including foliate scrollwork (fig. 113), strapwork patterns, geometric motifs, designs derived from textiles, and figural compositions depicting biblical stories, Classical history, myths and legends, and secular imagery. Thanks to this broad decorative and iconographic vocabulary, which was often combined on the same object, etching on armor is particularly fascinating for the way it can convey and invite different interpretations or levels of visual meaning.

The earliest surviving examples of etching on armor date from the late fifteenth and early sixteenth centuries and involve relatively simple figures and foliage. Within a few years, however, the potential of the medium was being explored more fully in Italy and Germany. The etching technique essentially involves creating permanent designs in the surface of a metal plate by means of an acid solution, or mordant. The plate is coated with an acid-resistant material, called the ground, traditionally a mixture of wax, pitch, and oil, or varnish. Then, using a needle or other pointed tool, the designs are drawn or

Fig. 113. Ornamental Fillet (Design for Armor Decoration), after Daniel Hopfer (German, Kaufbeuren 1471–1536 Augsburg), ca. 1525–30. Etching, 5³⁄₁₆ x 3¹⁄₄ in. (13.2 x 8.3 cm). Gift of Harry G. Friedman, 1962 (62.635.513)

incised through the ground, exposing bare metal. The designs can also be painted onto the plate using the resistant material like a pigment. The plate is bathed in the acidic solution, which etches, or bites, the plate where there are incised lines or uncoated areas. After the ground is removed, the etched lines could be blackened to provide contrast between the designs and the areas of bright steel. In another popular method, the etched design or its surrounding background are gilded rather than left bright.

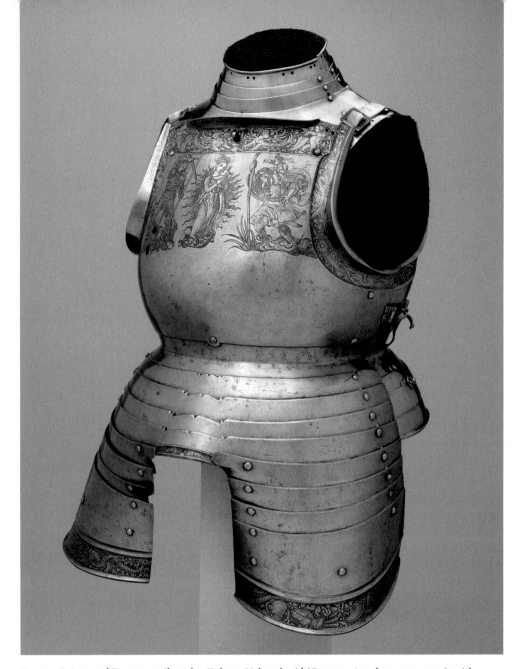

Fig. 114. Cuirass and Tassets, attributed to Kolman Helmschmid (German, Augsburg, 1471–1532), with etching attributed to Daniel Hopfer (German, Kaufbeuren, 1471–1536 Augsburg), ca. 1510–20. Steel and leather. Gift of Marshall Field, 1938 (38.143b-d)

Although seen less frequently, etching was also used to highlight embossed ornament.

Religious scenes and symbols are often prominent and offer some of the most dramatic and evocative examples of etching on armor. Depictions of Jesus, the Virgin Mary, Christian saints, and holy words or phrases were intended as a demonstration of faith and as a plea for protection by the person who wore the armor. One of the best examples of early German figural etching following a religious theme is found on the breastplate and backplate of an armor made in Augsburg about 1510 to 1520 (figs. 114–116). The breastplate features Mary and the baby

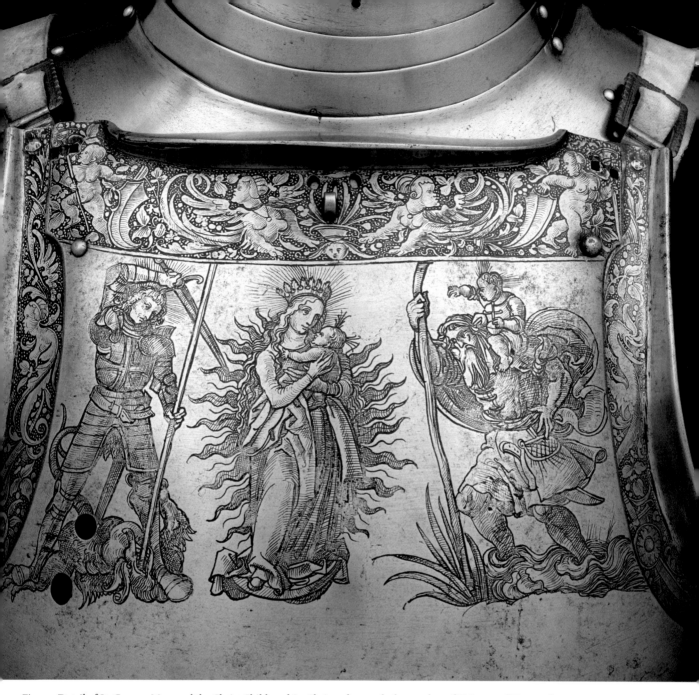

Fig. 115. Detail of St. George, Mary and the Christ Child, and St. Christopher on the breastplate of Cuirass and Tassets, fig. 114

Jesus in the center, flanked by saints George and Christopher (fig. 115). Across the top of the backplate are Saint Anne holding Mary and Jesus, and on either side saints James the Great and Sebastian (fig. 116). The close interplay between prints and armor etching in this fruitful period in the development of both art forms is demonstrated by the image of Saint Sebastian, which is modeled directly after a woodblock print from about 1507 by the Strasbourg artist Hans Baldung (figs. 116 and 117). The other figures probably derived from similar print sources. The etching is attributed to Daniel Hopfer, an Augsburg artist who is well known as a prolific and

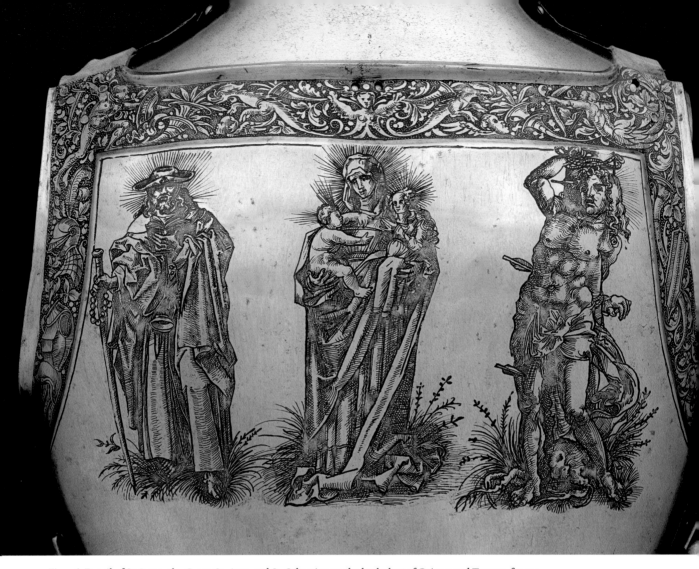

Fig. 116. Detail of St. James the Great, St. Ann, and St. Sebastian on the backplate of Cuirass and Tassets, fig. 114

influential printmaker and is also documented as an armor etcher. If he was not the very first artist to make prints from etched metal plates, Hopfer was certainly among the earliest artists to do so. The attribution of the etching to Hopfer does not derive from the human figures, however, but rather is based on the style of the decoration in the borders at the top of the breastplate and backplate, around the armholes, and at the base of the tassets. These include several motifs that appear regularly as elements of ornament in prints signed by Hopfer such as trophies of arms, cornucopia, putti, and harpies, the latter a mythical creature with a woman's head, bird's wings, and claws, here wearing a certain style of hairnet or cap (fig. 118).

This last motif is repeated by Hopfer many times in his signed prints and often appears in armor etching attributed to him. The armor itself, although unsigned, is attributed to the noted armorer Kolman Helmschmid, who was Hopfer's brother-in-law and neighbor.

We can compare the Augsburg style of etching with a nearly contemporary example from northern Italy by looking at a light cavalry armor from Milan that is decorated with similar imagery (fig. 119). The Italian etching is characterized by the sketchlike quality of its figures, the use of diagonally hatched backgrounds, and the generally dense compositions. Across the top of the breastplate is a frieze with three panels centering the Virgin and Christ

Fig. 117. *Martyrdom of St. Sebastian,* Hans Baldung (called Hans Baldung Grien) (German, Schwäbisch Gmünd (?) 1484/85–1545, Strasbourg) ca. 1507. Woodcut, 9⁵⁄₁₆ x 6⅜ in. (23.6 x 16.2 cm). Harris Brisbane Dick Fund, 1924 (24.28.25)

Child within an architectural setting, flanked by saints Paul and George. A Latin phrase in two rows below the panels translates: "Christ the King came in peace and God was made man." Another Latin phrase, quoting from the New Testament, Gospel of Luke (4:30), runs across the top of the backplate: "But Jesus passing through their midst went on his way." Other parts of the armor have vertical bands filled with scrolling foliage. The fact that the Latin words are as prominent as, or even more so than, the figures of Mary and the saints is very unusual in the genre of armor decoration and was probably a meaningful and highly personal choice on the part of the unidentified person who commissioned this armor.

An unparalleled expression of personalized and politicized Christian imagery on armor and also the apogee of large-scale figural etching, this time from Nuremberg, is seen on a field armor dated 1549 (fig. 120). Although unsigned, the armor is recognizable as the work of Kunz Lochner, Nuremberg's leading armorer. Additionally, the iconography of the armor's etched decoration was a key factor in identifying the original owner of the armor as Ferdinand I, a member of the house of Habsburg, younger brother of the Emperor Charles V and heir to the imperial throne. The front of the breastplate is covered almost

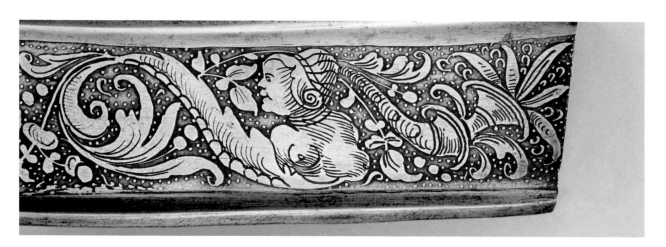

Fig. 118. Detail of etched decoration on the border of the left tasset of Cuirass and Tassets, fig. 114

Following pages: Fig. 119. Elements of a Light-Cavalry Armor, Italian, Milan, ca. 1510. Steel, gold, and copper alloy, wt. 19 lb. 13 oz. (8987 g). Gift of William H. Riggs, 1913 (14.25.716b–f)

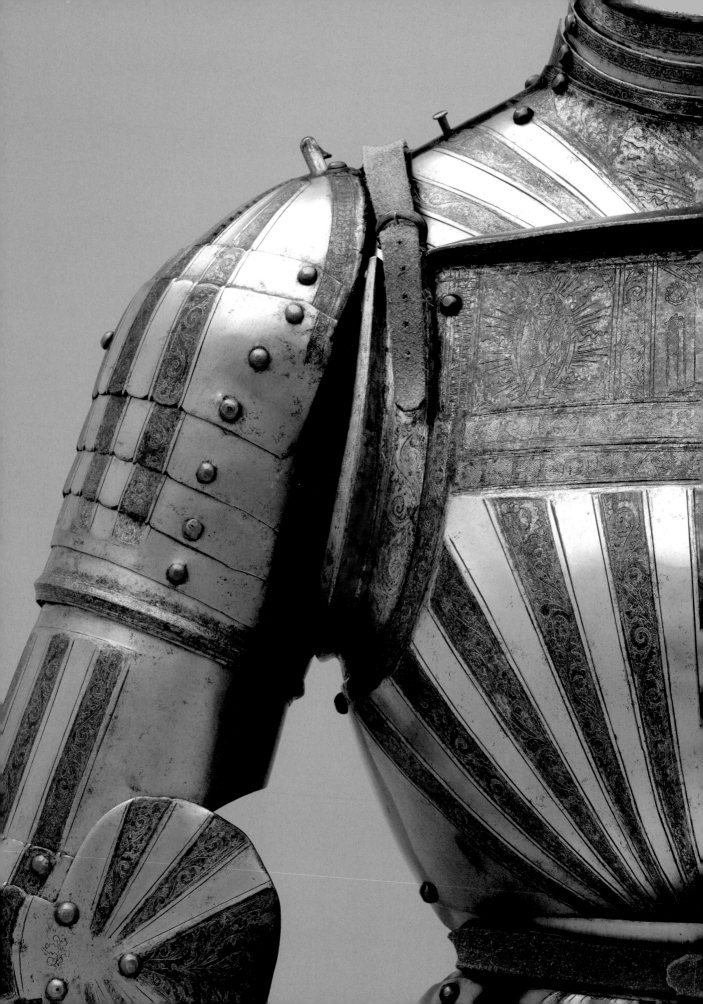

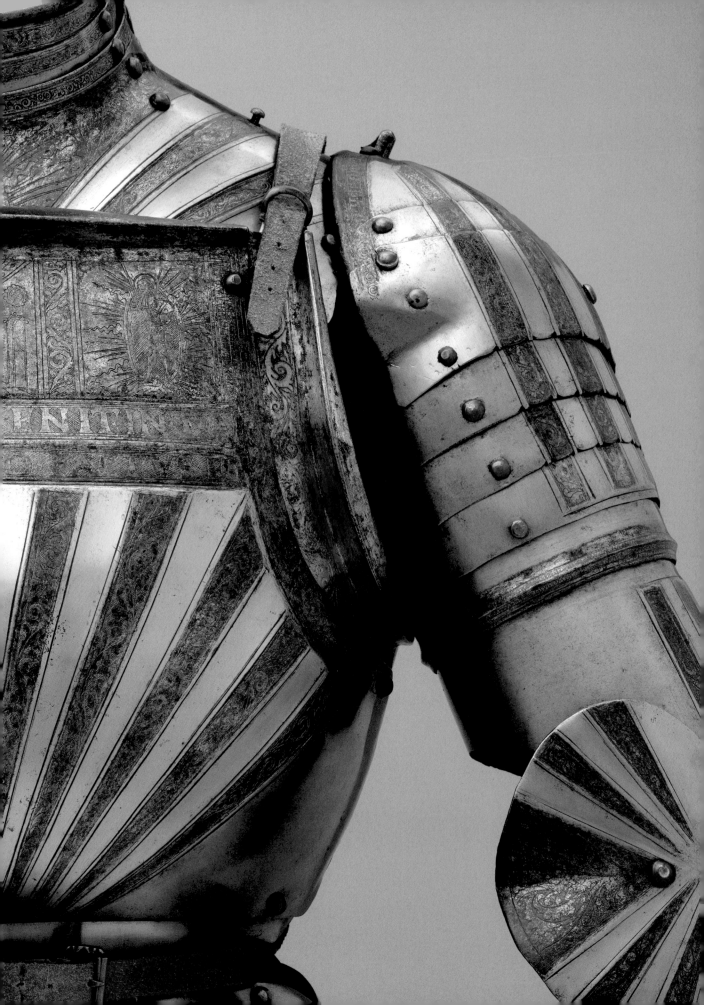

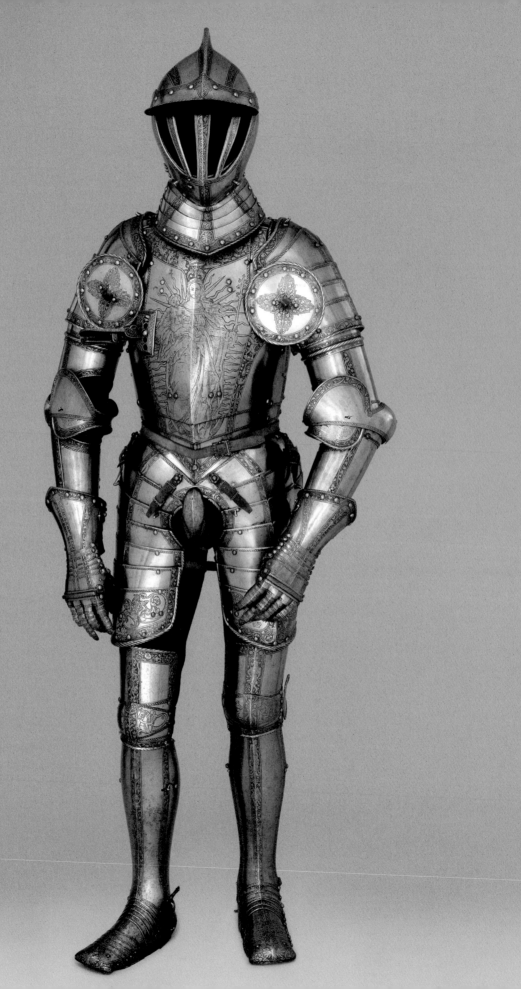

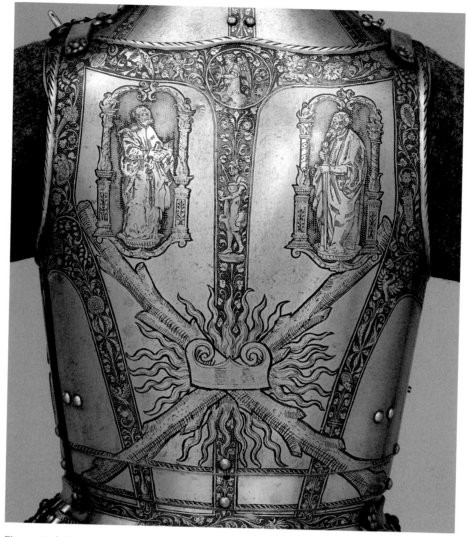

Fig. 121. Backplate of the Armor of Emperor Ferdinand I, fig. 120

entirely by a detailed image of the Virgin Mary holding the Christ Child in her right arm and a royal scepter in her left hand (see fig. 109). She stands on a crescent moon and is surrounded by an aureole of radiant beams of light. In the etched band at the top of the breastplate, two angels hold a royal crown above her head. In this guise, Mary represents The Woman of the Apocalypse, powerful imagery derived from the biblical Book of Revelation and its description of war in heaven between the angels and Satan. This is a clear visual reference to the fact that, when this armor was made, Ferdinand and Charles led the Roman Catholic cause in its religious, political, and military struggles with Protestantism. Moreover, the veneration of Mary was discouraged by Lutherans and other sects that sought to reform the Catholic Church. It was very likely that for these reasons, both Charles and Ferdinand adopted the image of Mary as a personal symbol, making a bold statement of belief and allegiance, both spiritual and temporal, through the decoration of their armor. The message is reinforced by the equally well-rendered figures of saints Peter and Paul, dual pillars of the Roman Catholic Church, who are shown in two large cartouches in the area of the shoulder blades near the top of the backplate of the armor (fig. 121).

Opposite: Fig. 120. Armor of Emperor Ferdinand I (1503–1564), Kunz Lochner (German, Nuremberg, 1510–1567), dated 1549. Steel, brass, and leather, h. 67 in. (170.2 cm); wt. 52 lb. 14 oz. (24 kg). Purchase, Rogers Fund and George D. Pratt Gift, 1933 (33.164a-x)

Fig. 122. Detail of etched decoration showing double-headed imperial eagle, on the toe cap of the Armor of Emperor Ferdinand I, fig. 120

This decoration is an outstanding example of how a single armor could provide a platform for the prominent display of both religious and political images. Two symbols etched on the lower half of the backplate, a blazing fire steel in the center of the Cross of Burgundy, represent the duchy of Burgundy. The prominent placement of these devices on the armor signifies the prestigious Burgundian lands and titles, which were claimed as an important part of their dynastic inheritance by the Habsburgs in the early sixteenth century. Variants of the fire steel and cross motif appear regularly in Habsburg imagery from this period on and symbolize the lineage, extent, and unity of the imperial titles. A more subtle but equally important feature of the decoration is the presence of a crowned double-headed eagle on each toe cap (fig. 122). Also known as the imperial eagle, it was the single most recognizable symbol of the Habsburg dynasty. The placement of a royal crown above the eagles signifies Ferdinand's position as heir to Charles V, whom he succeeded as emperor in 1558.

In a way that may be surprising to the modern eye but was the norm in sixteenth-century tastes, these potent religious and political symbols are set among an abundance of playful ornament included simply for its visual qualities to enliven the appearance and design. The borders and narrow bands that provide an overall framework for the larger motifs are filled with scrolling foliage, angels and putti playing musical instruments, and personifications of the virtues (such as Faith and Hope). Tritons, a popular motif in all types of Northern Renaissance ornament, appear no fewer than fourteen times and can be seen on the open areas of the shoulders, elbows, thighs, and knees (fig. 123 a, b).

Rich and distinct styles of armor etching also existed elsewhere in Germany, particularly in Landshut in the

Fig. 123a. Detail of etched decoration showing Tritons, on the right tasset of the Armor of Emperor Ferdinand I, fig. 120

123b. Ornament with Two Fighting Tritons, Sebald Beham (German, Nuremberg 1500–1550 Frankfurt), ca. 1525–50. Woodcut, 8⅝ x 17⅞ in. (21.9 x 45.4 cm). Rogers Fund, 1922 (22.67.54)

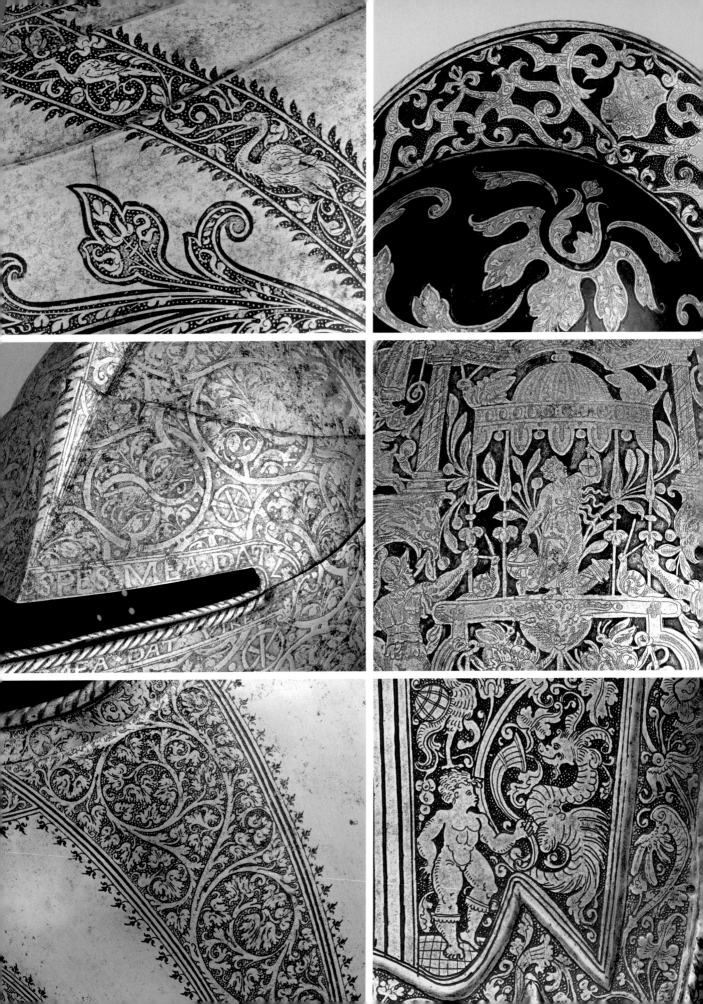

south and centered around the courts of the electors of Saxony and the dukes of Brunswick in the north; in France; in the Netherlands; in England at the royal workshops in Greenwich; and in Italy around Milan, Brescia, and Venice (fig. 124).

MERCURY GILDING AND HEAT BLUING

Mercury gilding permanently adheres a thin layer of gold over select areas of a metal object. It is also referred to as fire gilding because of the processes involved. Mercury gilding of objects made of silver or copper alloys (such as brass and bronze) was widely known in the ancient world and was practiced in parts of Europe by the Celts, Romans, Saxons, and others, remaining in use through the Middle Ages. Mercury gilding on iron or steel, however, requires a slightly different process and seems to have been unknown or at least seldom used in Europe until as late as the thirteenth or fourteenth century, if not later. It is seen regularly as a technique to decorate armor only from the late fifteenth to early sixteenth century on (see fig. 119). To gild an object made of silver or copper alloy, gold is dissolved into mercury to make a paste called an amalgam. The object is coated with the amalgam and then heated, causing the mercury to burn off (in the form of very toxic fumes) and the gold to fuse with the metal surfaces. The gold is then polished or burnished to give it a smooth and even finish. Unlike silver and copper alloys, however, iron does not form a natural amalgam with gold and mercury. Therefore, it is necessary first to coat the

Fig. 124. Details of etched decoration. Top row, left to right: Right Shoulder and Arm Defense, German, Landshut, ca. 1555–60. Rogers Fund, 1932 (32.109.1a); Burgonet, German, Augsburg, 1575–1600. Gift of Clarence H. Mackay, 1922 (22.168); Comb Morion, German, Brunswick, Purchase, The Sulzberger Foundation Inc. and Ronald S. Lauder Gifts, 1999 (1999.62). Middle row: Close Helmet of Claude Gouffier (1501–1570), French, ca. 1555–60. Gift of William H. Riggs, 1913 (14.25.596); Cabasset, Flemish, possibly Antwerp, ca. 1580–90. Rogers Fund, 1904 (04.3.200); Armor Garniture of George Clifford (1558–1605), Third Earl of Cumberland, breastplate, British, Greenwich, 1586. Munsey Fund, 1932 (32.130.6). Bottom row: Cuirass, Italian, ca. 1560. Gift of William H. Riggs, 1913 (14.25.800); Horse Armor Probably Made for Count Antonio IV Collalto (1548–1620), Italian, probably Brescia, ca. 1580–90. Fletcher Fund, 1921 (21.139.1); Burgonet with Buffe, Italian, ca. 1555–60. Gift of William H. Riggs, 1913 (14.25.613)

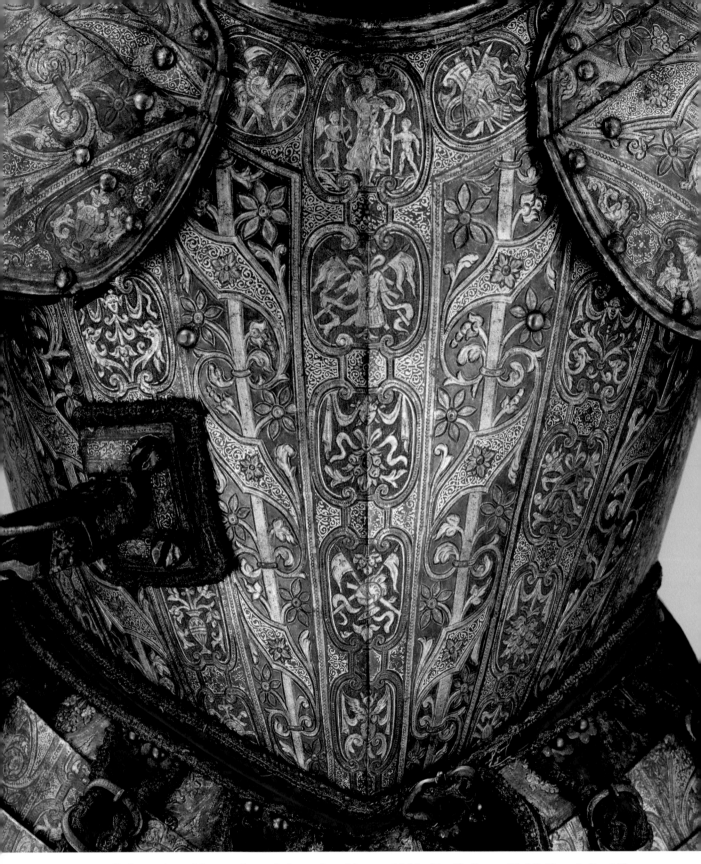

Fig. 125. Detail of engraving and damascening on the breastplate of Armor with Matching Shaffron and Saddle Plates, Italian, Milan, ca. 1600. Steel, copper alloy, silver, gold, leather, and textile, h. 62⅝ in. (159.1 cm). Fletcher Fund, 1938 (38.148.1a–n)

iron with a film of copper, usually by bathing it in a solution of copper sulphate, after which it can be coated with the amalgam and gilded. The heating process has to be carefully controlled not only for the gilding but also to ensure it will not adversely effect the tempering of plate armor. The term tempering refers to the controlled heating and cooling of iron and steel to produce desired degrees of hardness and flexibility. The decorative technique of heat bluing also uses controlled reheating to give steel a color ranging from brown to peacock blue. Modern experiments have shown that the highest heat was required for tempering, followed by gilding, and then bluing. Armor of above average quality frequently has gilded decoration, usually combined with etching or embossing. In general, only armor of the highest quality was gilded and blued.

ENGRAVING, INLAY, AND DAMASCENING

Engraving involves the use of small hammers and fine chisels, burins, needles, or other tools to cut, incise, and inscribe designs into the steel surfaces of plate armor. It can also be part of the chasing process, by which fine details are added to embossing (described below). On armor that is not embossed, it is found more often in the late sixteenth and early seventeenth centuries, frequently in conjunction with inlay or damascening (fig. 125). Inlaying utilizes similar tools to create designs by cutting fine lines or channels into the steel. Gold or silver wire is hammered or inlaid into the lines and burnished until it is even with the surrounding steel surfaces. Encrusting is a variant of inlaying, in which gold or silver is built up in the incised channels or larger recesses to raise a design higher than the adjacent surfaces rather than burnished flat. An object decorated using this method is said to be encrusted with gold or silver. In damascening, the surface to be decorated is crosshatched, meaning that it is scored or cut with a series of fine crisscrossing lines. This roughens the surface so that the gold or silver wire will adhere to it more easily. Fine lines of wire can be laid down and hammered into any shape or design. Wires can also be laid side-by-side and then burnished together to create the effect of a sheet of gold or silver.

EMBOSSING

Like mercury gilding, embossing has a long history as a goldsmith's technique and was well known in the Classical world as a way of working precious metals, bronze, and other copper alloys. It was employed for the creation of jewelry, vessels and other containers of various kinds, sculpture, and armor. In Renaissance Europe, it was used again to make armor after a lapse of perhaps a thousand years or more, and in steel rather than bronze, which was more common in antiquity. The process of embossing, or repoussé, turns the surfaces of armor into wearable compositions of low-relief sculpture (see fig. 131). However, as a consequence, embossing, unlike etching, gilding, or damascening, significantly compromises the defensive function of armor because it eliminates the carefully calculated thickness and the smooth glancing steel surfaces that are key factors in making plate armor effective in stopping or deflecting weapons. For that reason, embossed armor is almost always intended for ceremonial purposes and not for either battle or, with a few exceptions, the tournament.

To emboss steel armor, the individual elements are forged into their overall shapes, just as they would be for a plain piece with no embossing. Then, for each plate intended to have embossed decoration, the outlines of the intended designs are traced or incised on the plate's outer surface with a hammer and fine chisel. The plate is turned over and set into a bowl or tray filled with warm pitch, which is a strong but pliable material like tar, and the ornament is raised, or bossed out, from the inside with hammers, punches, and chisels. After the shapes have been raised sufficiently in relief, the designs are completed on the exterior in a process called chasing, by which the decoration is carefully refined using small chisels and punches to add definition and crisp details and to give the surface its final finished texture (figs. 126a–c). In the hands of master craftsmen, the resulting armor can look like sculpture cast in bronze or a goldsmith's work in precious metal.

Artistic representations emulating the embossed armor of ancient Greece and Rome began to appear

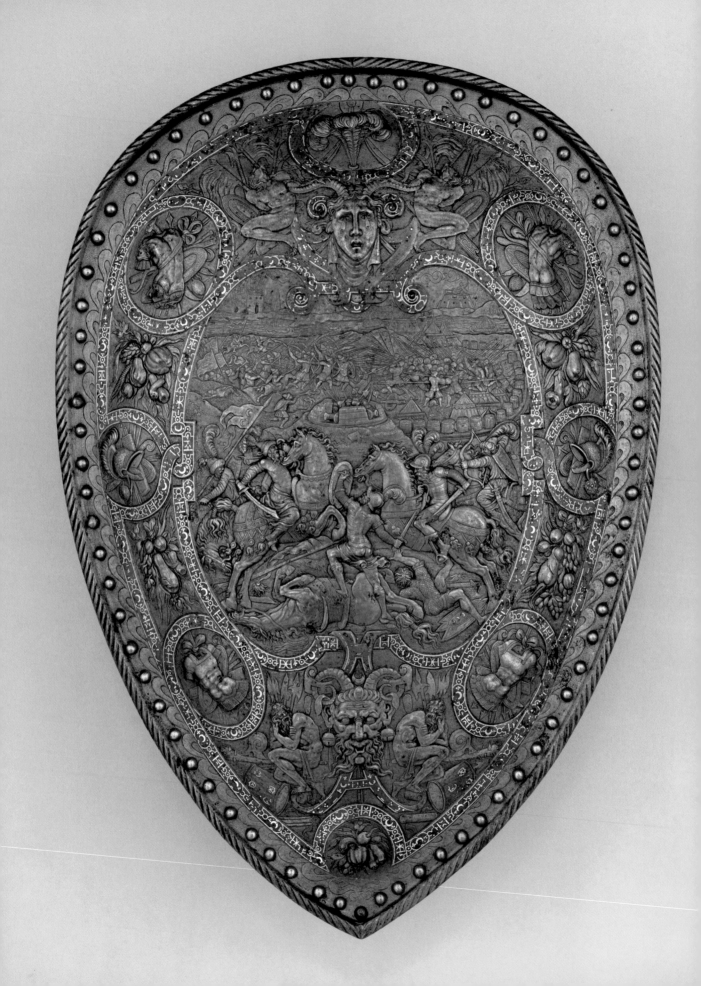

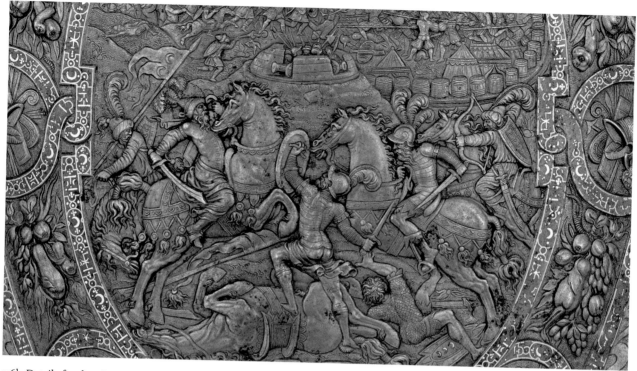

126b. Detail of embossing on exterior of fig. 126a

126c. Detail of same area as fig. 126b on the interior showing the reverse of the embossing

Opposite: Fig. 126a. Shield of Henry II of France (r. 1547–59), French, ca. 1555. Steel, gold, and silver, h. 25 in. (63.5 cm). Harris Brisbane Dick Fund, 1934 (34.85).

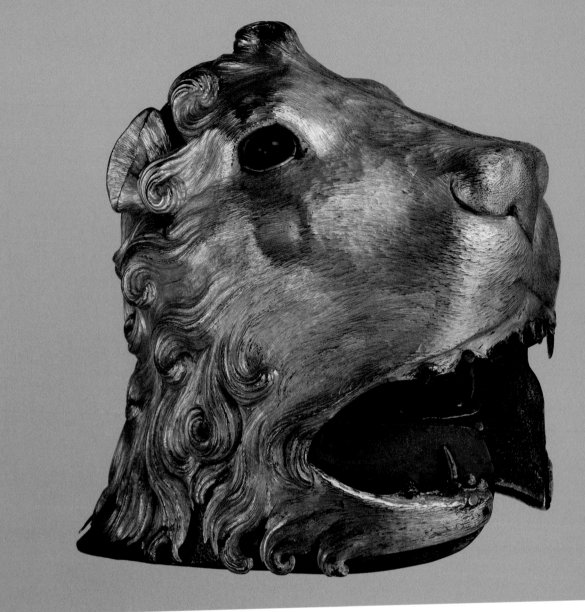

Fig. 127. Sallet in the Shape of a Lion's Head, Italian, ca. 1475–80. Steel, copper, gold, glass, pigment, and textile, h. 11¾ in. (29.8 cm); wt. 7 lb. 14 oz. (3574 g). Harris Brisbane Dick Fund, 1923 (23.141)

regularly in Italian Renaissance paintings, sculpture, and other works of art as early as the fourteenth century and by the fifteenth century were a standard part of the visual vocabulary of the Renaissance. The earliest surviving physical example of such armor *all'antica* (in the antique style), and a unique precursor to the embossed steel armor of the sixteenth century, is an Italian helmet in the form of a lion's head, made about 1475 (fig. 127). It is almost certainly intended to evoke the Classical hero Hercules and the story of the Nemean lion, a preternaturally powerful beast that Hercules slew as the first of his legendary twelve labors. Those labors were seemingly impossible tasks assigned to him by a jealous rival, King Eurystheus. After killing the lion, Hercules wore its impenetrable pelt

Fig. 128. Detail of *Hercules and the Hydra*, Cristofano di Michele Martini (Il Robetta) (Italian, Florence, 1462–after 1535), After Antonio Pollaiuolo (Italian, Florence ca. 1432–1498 Rome), ca. 1500–1520. Engraving, 9⁵⁄₁₆ x 3⅜ in. (23.7 x 8.5 cm). Harris Brisbane Dick Fund, 1927 (27.20.2)

for protection and as evidence of his great feat. Hercules is often shown in Renaissance and Mannerist art wearing the lion's head as a helmet with its skin over his shoulders, symbolizing his indomitable strength and courage (fig. 128). Imagine the allure this helmet would have had for an Italian prince or condottiere who desired to emulate the powers and virtues of Hercules. The helmet's construction is unique, consisting of an outer shell of embossed and gilt copper, fitted over an underlying helmet of plain steel. The copper shell, relatively thin and delicate, forms the lion's head and curling mane, with its open jaws revealing the sight aperture of the steel helmet below, so the wearer would appear to look out of the jaws of the lion skin just as Hercules did. The lion's sparkling

eyes are made of colored glass set in bezels of metal foil. The meticulous details of its fur and the naturalistic curls of its mane are the result of skillful embossing and fine chasing. The finished piece represents the strivings of an anonymous Renaissance armorer to capture and interpret one of the most famous legends of his time and express the courageous, even bold, aspiration of his unknown patron to embody that legend by wearing this helmet.

Artistically and technically, the greatest creations of embossed armor in the *all'antica* style were realized a generation later by the Milanese craftsman Filippo Negroli and his workshop, which was at the peak of its artistic output from about 1530 to about 1550. Ranked by his contemporaries as the equal of leading painters and sculptors, Negroli executed commissions for some of the highest

level noblemen and connoisseurs of the era, including Emperor Charles V, Dauphin Henry of France (later King Henry II), and Guidobaldo II della Rovere, Duke of Urbino (figs. 129 and 130). Among the small but stellar group of surviving pieces signed by Filippo, one helmet, a burgonet, is arguably his finest work. Signed and dated 1543, this burgonet presents a tour de force of Renaissance ornament rendered in high and low relief (fig. 131). The complexity of its design belies the fact that the helmet and all its decoration are forged from a single sheet of steel. A siren or mermaid with a tail of acanthus leaves lies back to arch fluidly along the top of the bowl, forming the helmet's crest. Her outstretched arms continue the arc of the crest down to the helmet's brim, and she grasps in her hands the flowing hair of the head of the Gorgon, Medusa,

Fig. 129. *Guidobaldo II della Rovere, Duke of Urbino (1514–1574), with his Armor by Filippo Negroli,* Italian, ca. 1580–85. Oil on copper, 5½ x 4 in. (14 x 10.2 cm). Purchase, Arthur Ochs Sulzberger Gift, 2009 (2009.224)

Fig. 130. *Study of a Bearded Man Wearing the Negroli Helmet of Guidobaldo II della Rovere, Duke of Urbino,* Anonymous, Venice, 1536–40. Charcoal or black chalk, highlighted with white chalk, on blue paper (faded to blue-gray), 10 3/16 x 8 7/16 in. (25.8 x 21.5 cm). Purchase, Rogers and Harris Brisbane Dick Funds, Gifts of Ernest Shapiro and family, Mrs. Henry J. Bernheim, and Mrs. Harry Payne Whitney, and Jacob H. Schiff Bequest, by exchange, and Gift of William H. Riggs, by exchange, 1998 (1998.345)

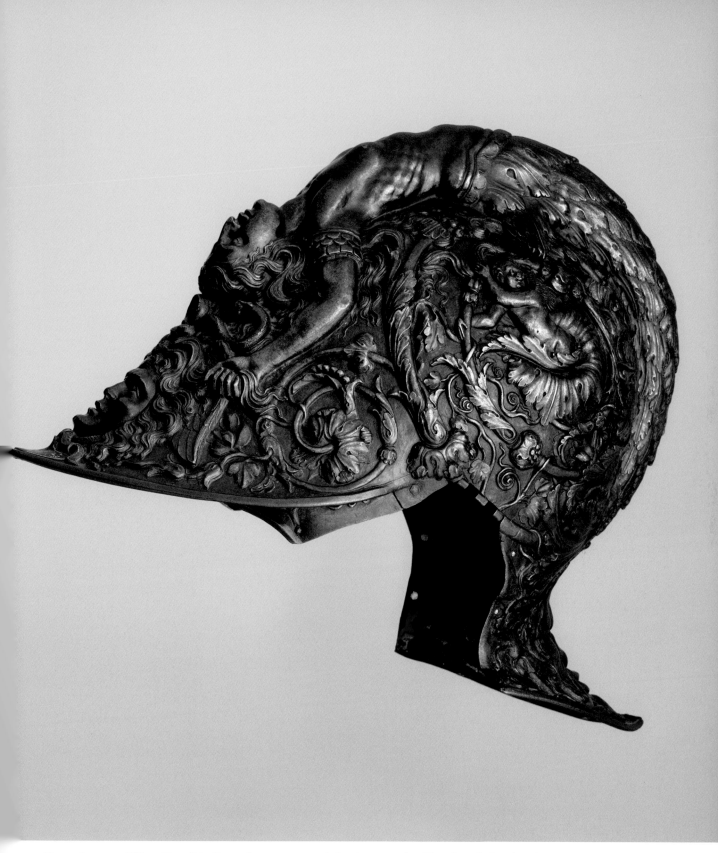

Fig. 131. Burgonet, Filippo Negroli (Italian, Milan, ca. 1510–1579), dated 1543. Steel, gold, and textile, h. 9½ in. (24.1 cm); wt. 4 lb. 2 oz. (1871 g). Gift of J. Pierpont Morgan, 1917 (17.190.1720)

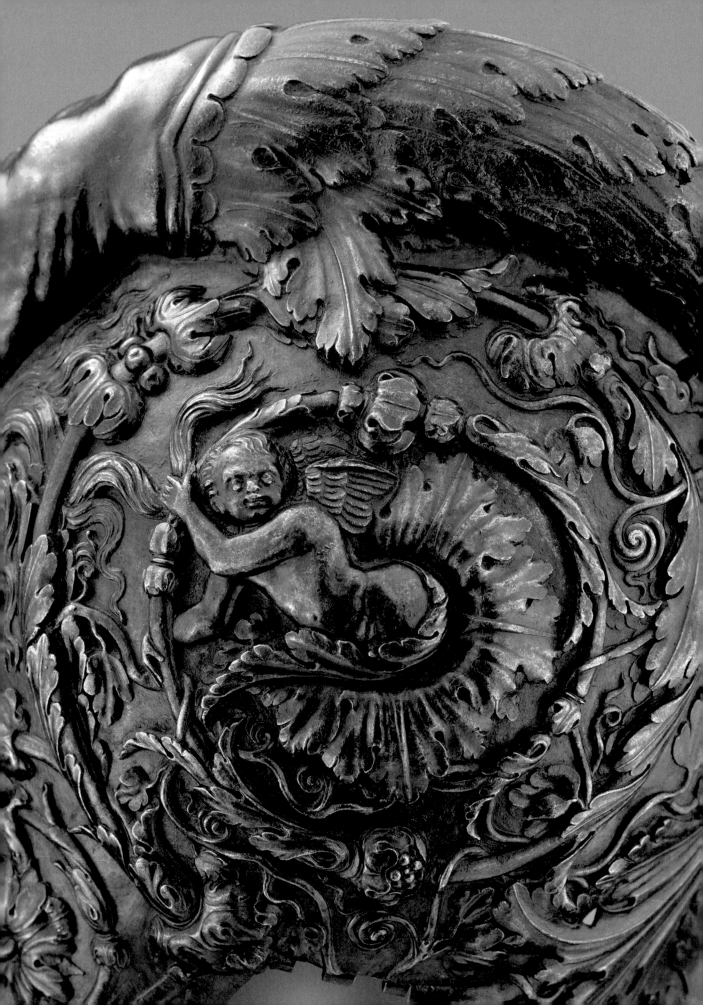

which is positioned prominently in the center of the brim. In Greek mythology, Medusa's gaze had the power to turn anyone who saw her into stone. According to legend, she was slain and beheaded by Perseus, one of the greatest Greek heroes. In the ancient world, representations of Medusa's head were used frequently as a protective symbol in architecture and the decorative arts. In Renaissance Europe, it was popular as one of many classicizing design elements. By evoking the legend of Perseus, the Medusa's head also symbolized the bravery and heroism of Perseus, a reference that likely was clearly understood and appreciated by the erudite owner of this helmet and his peers, and that probably explains why it is placed front and center in the helmet's decorative scheme.

In a further indication of the connoisseurship of both Negroli and his unknown patron, the sides of the helmet are decorated with large concentric designs of putti emerging from acanthus blossoms, which are derived directly from Classical sources that had been discovered in the early sixteenth century and were disseminated in Italy through the medium of ornament prints (figs. 132 and 133). This helmet has a fluidity, balance, grace, cohesion of composition, and technical excellence seldom combined so successfully in a single artistic endeavor, distinguishing it as a masterpiece. The helmet was a prized possession of the world famous early twentieth-century art collector J. Pierpont Morgan, and it was the only piece of armor in his vast collections. It was long coveted for The Metropolitan Museum of Art by Bashford Dean, the founding curator of the Department of Arms and Armor, and has been a highlight of the Museum's collection since it was donated to the Metropolitan in 1917.

While several armorers of the late Renaissance in addition to the Negroli produced many highly original and innovative examples of embossed armor, the majority of pieces that survive today, and that we are most likely to see in museum collections, date from about the 1550s to the 1580s and coincide, both in design and spirit, with the Mannerist movement in European art. In Italian armor, that usually entails not only embossing but also ample use of gold and silver damascening to highlight designs

Fig. 133. *A panel of ornament with a woman holding a vase in center,* Master of the Die (Italian, active Rome, ca. 1530–60), dated 1532. Engraving, 8⅞ x 6 in. (22.5 x 15.3 cm) (including text). Harris Brisbane Dick Fund, 1953 (53.600.62)

arranged so densely that, unlike earlier Renaissance examples, there is seldom a square inch of surface left blank. The results are often lavish in their elaboration and dazzling to the eye in their overall effect. The best examples display great technical proficiency, but in the hands of lesser craftsmen, they can begin to look repetitive. And this is a key difference between Italian embossed armor of the Renaissance and Mannerist periods; we must look longer and harder to see the individuality and originality

Opposite: Fig. 132. Detail of side of Burgonet by Filippo Negroli, fig. 131

Fig. 134. Cabasset, Italian, Milan, ca. 1575. Steel, gold, silver, and copper alloy, h. 9¼ in. (23.5 cm); wt. 3 lb. 7 oz. (1551 g). Gift of Stephen V. Grancsay, 1942 (42.50.4)

in these later designs, subsumed as they often are by the glamor of their overall appearances.

Much of what characterizes Italian armor embossed in the Mannerist style is demonstrated by a Milanese cabasset from about 1575 (fig. 134). Through it, we can gain a basic understanding and appreciation of the entire genre to which it belongs. It immediately accomplished its primary effect to impress and delight viewers with its richness, which it can still achieve in a museum display today. As a helmet, it is very well made. The execution of the decoration shows great skill and is laid out so that it covers every bit of its exterior surface with embossed, gilt, and damascened designs entirely in keeping with the tastes of the period (fig. 135). The majority of the ornament is purely decorative and includes a typical selection of classically inspired motifs, such as grotesque masks, bound prisoners, harpies, and acanthus leaves. The two elements of the decoration with definite symbolic meaning are featured in a large oval cartouche on each side, which frame quasi-legendary figures from Roman history, on the left, Marcus Curtius leaping into the fiery abyss, and on the right, Horatus Cocles defending the Sublicus Bridge. Both figures were recognized as paradigms of self-sacrificing heroism in the service of one's countrymen, and as such, they often appear in sixteenth- and seventeenth-century works of art. Their iconographic significance on this helmet may be obscure to us today, but it was clear to an educated viewer of the sixteenth century.

While this helmet demonstrates what to expect in a typical example of good Italian Mannerist embossed armor, the peak of the late Mannerist style is exemplified by a garniture for man and horse made between 1576 and 1580 for Alessandro Farnese (1545–1592), Duke of Parma and Piacenza (fig. 136). Its elaborate design scheme follows a series of intricate and beautifully rendered life-size drawings by Andrea Casalini (d. 1597), a goldsmith at the Farnese court (fig. 137). Unlike many examples of embossed armor from this period, its decoration remains lively and graceful throughout, and it covers the armor entirely in a coherent and balanced way. It must have been an immensely difficult task to successfully translate these designs into

Fig. 135. *La Vera Perfettione del Disegno di varie sorti di recami*, page 27 (verso), Giovanni Ostaus (Italian, active Venice, ca. 1554–91), 1567. Woodcut, 6⁵⁄₁₆ x 8⁷⁄₁₆ in. (16 x 21.5 cm). Rogers Fund, 1928 (21.15.3[53])

steel that was embossed, engraved, blued, and damascened in gold and silver, requiring the utmost skills of the armorers and goldsmiths who carried out the commission.

Although most extant embossed armor was created in Italy, important and distinct styles also occurred in France, Flanders, and Germany throughout the sixteenth century. Surviving design drawings for the ornament of armor are very rare. Rarer still are drawings, like the Casalini designs for the Farnese garniture, for which the finished armor survives. The only comparable examples are found in a series of approximately 175 drawings that represent the greatest achievements of French Mannerist armor embossing in the mid-sixteenth century (fig. 138).

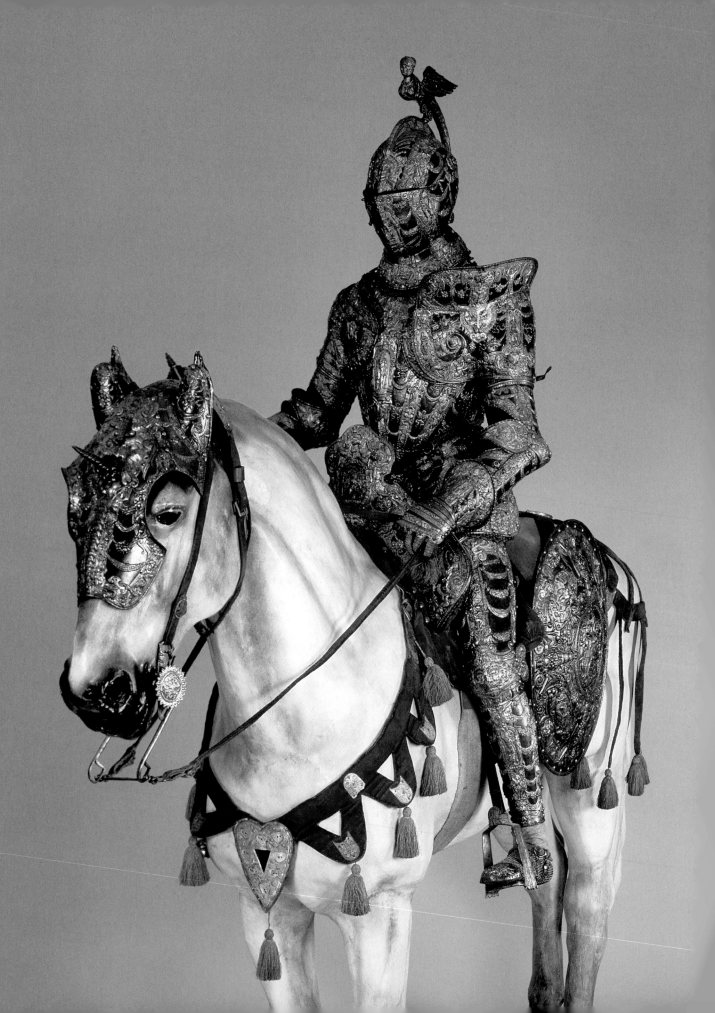

Fig. 137. *Design for the Pommel Plate of a Saddle from a Garniture of Alessandro Farnese (1545–1592)*, Andrea Casalini, Italian, Parma, ca. 1575–80. Pen and brown ink, with color washes, on paper, 19½ x 16⅜ in. (49.5 x 41.6 cm). Purchase, Fletcher Fund and Gift of William H. Riggs, by exchange, 1993 (1993.234)

Opposite: Fig. 136. Armor Garniture of Alessandro Farnese, duke of Parma and Piacenza (1520–1589), Milan, ca. 1576–80. Kunsthistorisches Museum Wien, Hofjagd- und Rüstkammer, inv. A 1132, A1153, A 1153 a-b

Fig. 138. *Design for the Right Pauldron of a Parade Armor*, attributed to Étienne Delaune (French, Orléans 1518/19–1583 Strasbourg), French, ca. 1555. Pen and ink with watercolor wash on paper, 10 x 6⁹/₁₆ in. (25.4 x 16.6 cm). Rogers Fund, 1954 (54.173)

Among the handful of armors still in existence that were made according to these designs, a complete armor for Henry II, King of France (r. 1547–59), shows the subtlety and refined elegance possible when the designs were fully realized (fig. 139). The decoration of this armor features Classical figures surrounded by sinuous leafy scrollwork, grotesques, and putti. Most of its original surface gilding and silver highlights are also preserved. Magnificent by any measure, this armor epitomizes the amalgamation of Italian Mannerism and French aesthetics, thereby resulting in a unique style of embossing that is sumptuous but not overpowering.

The Mannerist style as it existed in Italy, France, and Flanders was widely utilized and liberally adapted by German goldsmiths, engravers, and artists in other mediums, but with very few exceptions, it was not adopted by German armorers. Notable among those exceptions is a burgonet dating to approximately 1550–55 and attributable to the combined efforts of two Augsburg craftsmen, the armorer Desiderius Helmschmid (1513–1579) and the goldsmith Jörg Sigman (1527–1601) (fig. 140). The attributions are based on comparison with an elaborate armor garniture embossed in an extremely similar style, which was made for Prince Philip of Spain (later King Philip II)

Opposite: Fig. 139. Armor of Henry II, King of France (reigned 1547–59), French, possibly Paris, ca. 1555. Steel, gold, silver, leather, and textile, h. 74 in. (187.96 cm); wt. 53 lb. 4 oz. (24.20 kg). Harris Brisbane Dick Fund, 1939 (39.121a-n)

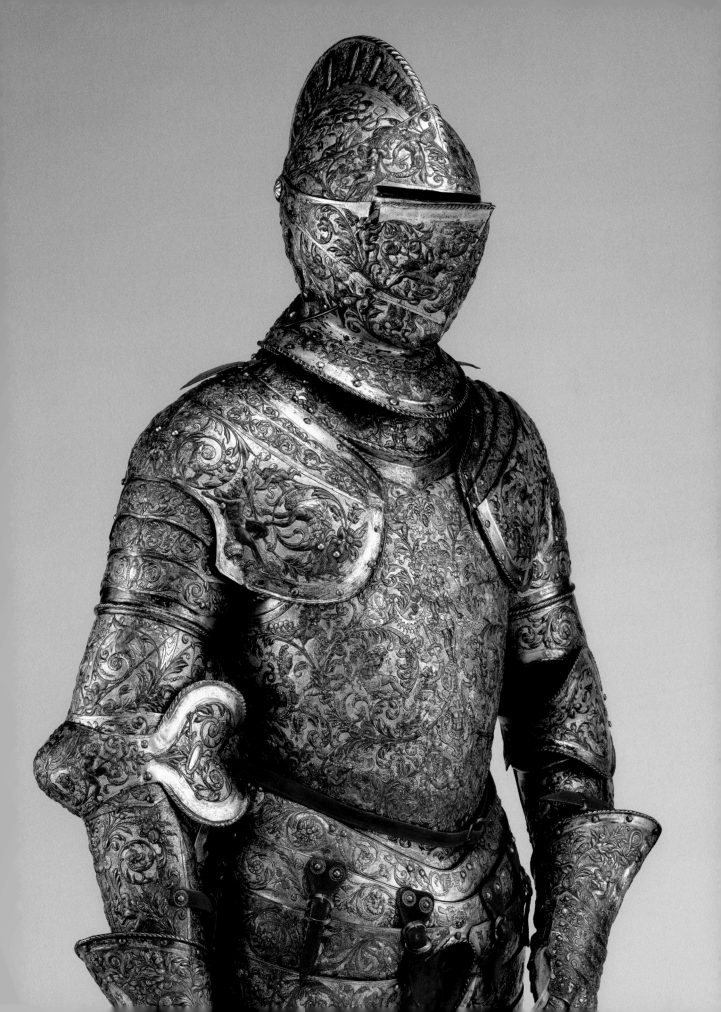

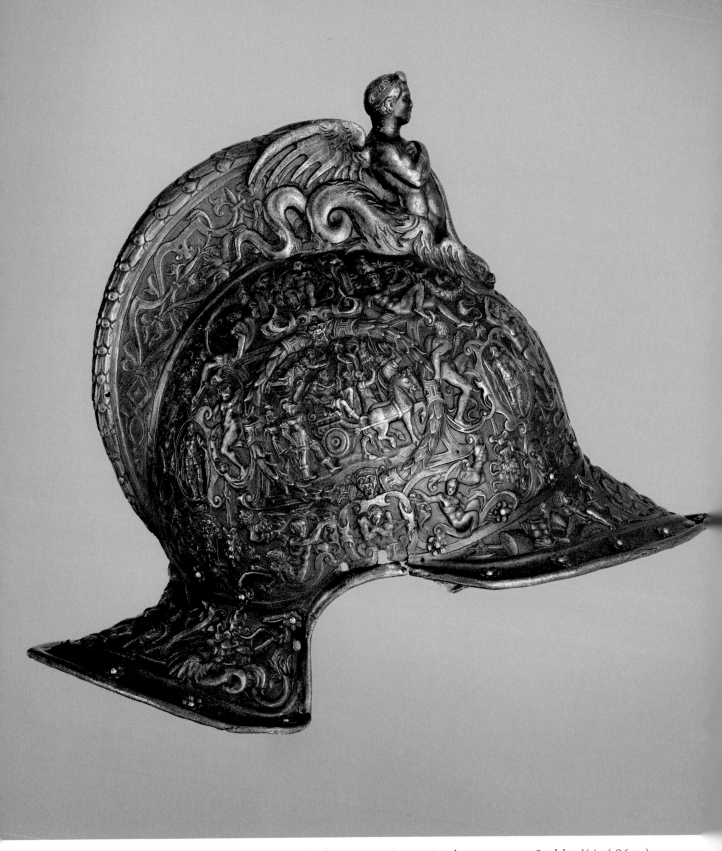

Fig. 140. Burgonet, attributed to Desiderius Helmschmid and Jörg Sigman, German, Augsburg, ca. 1550–55. Steel, h. 11¼ in. (28.6 cm); wt. 4 lb. 11 oz. (2126 g). Gift of William H. Riggs, 1913 (25.135.66)

Fig. 141. Plate from the *Perspectiva corporum regularium*, Wenzel Jamnitzer (Nuremberg, 1508–1584), Vienna, 1570. Etching. Victoria and Albert Museum, London (E 2659-1913)

Fig. 142. Reinforce for a Helmet (*Gupfe*), Mattheus Frauenpreis the Elder (German, Augsburg, recorded 1510–49) or Mattheus Frauenpreis the Younger (1530–1604) and Jörg Sorg the Younger (ca. 1522–1603), German, Augsburg, 1540–50. Steel and gold, h. 5⅝ in. (14.3 cm). Rogers Fund, 1904 (04.3.218)

and is signed by Helmschmid and Sigman and dated 1549, 1550, and 1552. The burgonet shows a mastery of high relief, more so than most contemporary examples, particularly in the treatment of the crest, with its winged merman executed partially in the round. The low relief designs covering the rest of the helmet, including symmetrical arrangements of strapwork cartouches with figural supporters, garlands, swags, putti, and grotesques, likewise show fluency in the vocabulary of Northern Mannerist motifs (fig. 141). In addition, although perhaps not immediately apparent, the burgonet's exterior surface is rubbed and slightly worn down, showing traces of extensive engraving and damascening in gold and silver. This tells us that originally the embossing was more

sharply defined than it is now and that the helmet's overall appearance was more colorful and dramatic. It is a valuable reminder that when assessing the importance or quality of any piece of armor, we should consider its current condition in relation to what it might have been earlier.

More typical than Mannerist-inspired embossing on armor in Germany, however, is embossing that takes the form of broadly shaped designs rendered in low relief and relying on etching and gilding to supply details and highlights (fig. 142). Some of the best examples of this type come from Augsburg and Nuremberg, with favorite motifs including tritons, mermaids, and heraldic emblems. Germany was also home to a fascinating and unique style

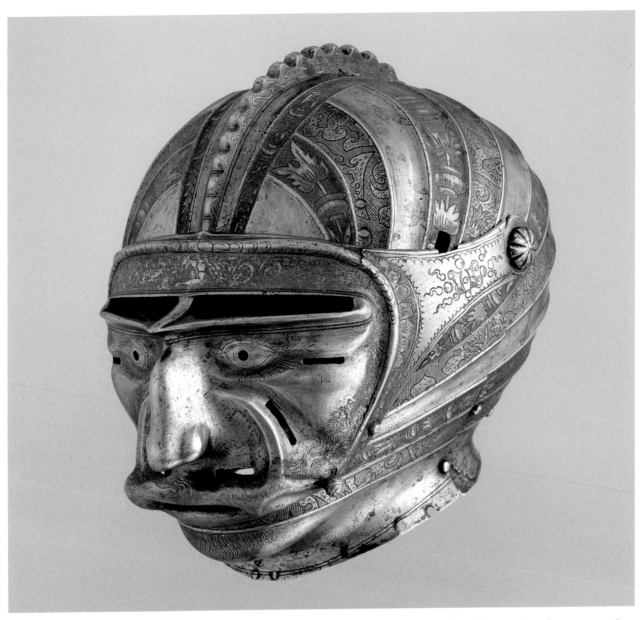

Fig. 143. Close Helmet with Mask Visor in the Form of a Human Face, attributed to Kolman Helmschmid (German, Augsburg, 1471–1532), ca. 1515. Steel and gold, h. 12 in. (30.5 cm); wt. 4 lb. 12 oz. (2146 g). Rogers Fund, 1904 (04.3.286a)

of armor embossing rooted in local vernacular traditions, which coexisted alongside the overarching trends in Renaissance and Mannerist art that suffused the period. The highpoints of this vernacular style include armor dramatically shaped to imitate the voluminous folds of contemporary male clothing and helmets with sculptural, sometimes bizarre, mask visors. Many of the mask visors,

also called grotesque visors, are made in the guise of mustachioed faces (fig. 143), often with exaggerated features, including a prominent nose. A few of them take the shape of animal heads, such as a fox or rooster (fig. 144). To the modern eye, these helmets may seem strange or even comical. This is not necessarily an inappropriate reaction, given that in the early sixteenth century they were

Opposite: Fig. 144. Armet with Mask Visor in the Form of a Rooster, German, probably Augsburg, ca. 1530. Steel, h. 10³⁄₁₆ in. (25.9 cm); wt. 6 lb. 6 oz. (2892 g). Bashford Dean Memorial Collection, Bequest of Bashford Dean, 1928 (29.150.3a)

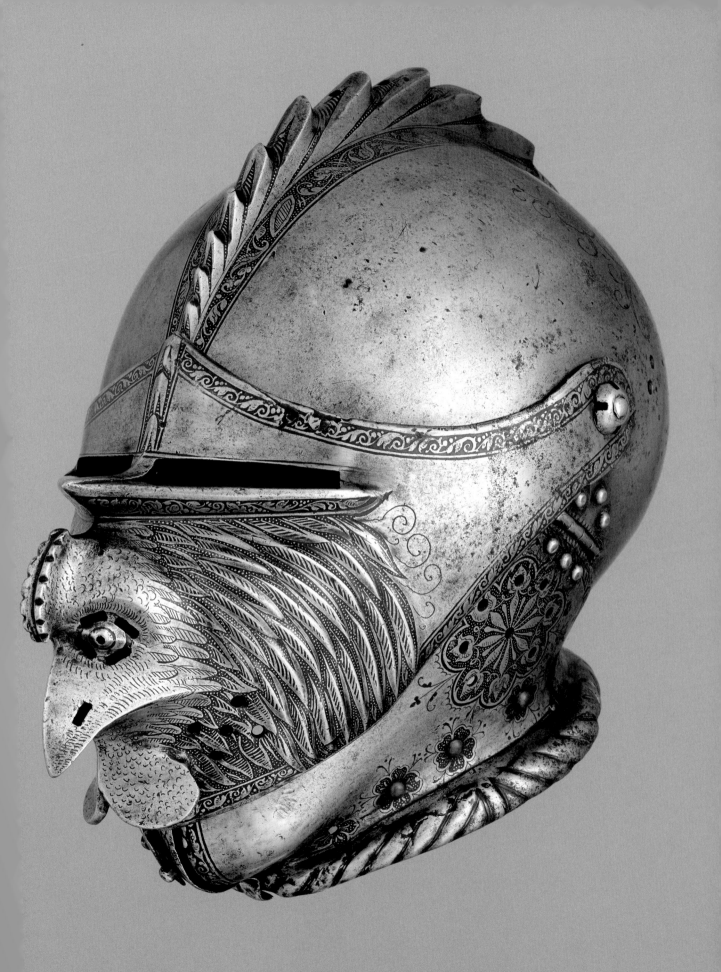

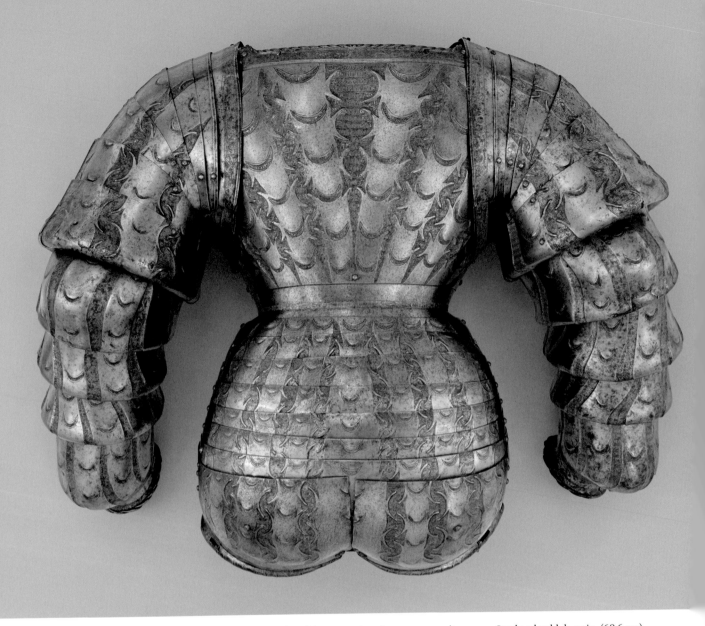

Fig. 145. Portions of a Costume Armor, Kolman Helmschmid (German, Augsburg, 1471–1532), ca. 1525. Steel and gold, h. 27 in. (68.6 cm). Backplate and rump: Gift of Bashford Dean, 1924; vambraces: Mrs. Stephen V. Harkness Fund, 1926; top lames of vambraces: Bashford Dean Memorial Collection, Funds from various donors, 1929 (24.179; 26.188.1, .2; 29.158.363a, b)

probably intended to be viewed as humorous. It is likely that many helmets with mask visors were designed for use in pre-Lenten tournaments, part of the exuberant festivals akin to modern Mardi Gras celebrations, which also involved outlandish and colorful costumes. However, once we get beyond the initial surprise, it also becomes possible to appreciate the best of these helmets as

extremely rare and incredible demonstrations of high-relief sculpture in steel that were commissioned from some of the leading armorers of the period.

Among the rarest types of armor, costume armor was worn in conjunction with mask visors such as these, and like the visors, was in vogue briefly from about the 1520s to the 1540s (fig. 145). It was made to imitate the

Fig. 146. *The Bearer of the Banner of the Canton Glarus*, Urs Graf (Swiss, Solothurn, ca. 1485–1529/30 Basel), 1521. Pen and brown ink, 11⁵⁄₁₆ x 7½ in. (28.8 x 19 cm). Promised Gift of Leon D. and Debra R. Black, and Purchase, Harris Brisbane Dick Fund, 2003 (2003.323)

most fashionable male clothing of the period, particularly the so-called puffed and slashed style. Said to be inspired by the slashed and mended clothes of mercenary soldiers, this style features slits through which underlying layers of contrasting fabric could be seen (fig. 146). Successfully re-creating these effects in steel required the greatest skill. The result of that requirement, coupled with the fact that

costume armor was always a rarified form restricted to elite court circles, is that fewer than half a dozen complete examples, plus various fragments and individual elements, survive today.

Some horse armors of better quality are embossed, usually with low-relief figures on the sides of peytrals or cruppers and tail pieces in the form of dolphins or dragons

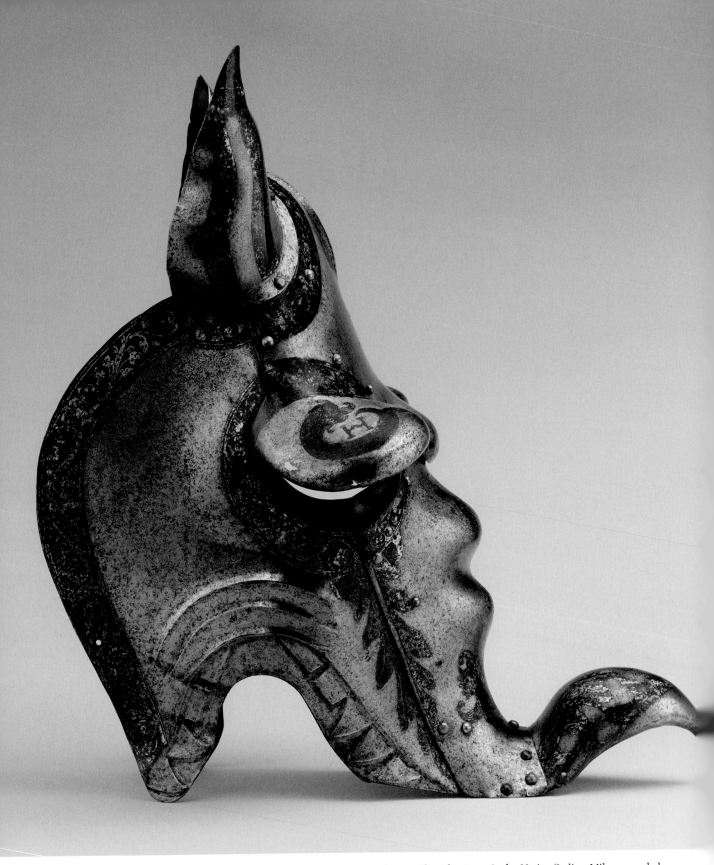

Fig. 147. Shaffron (Horse's Head Defense) of Henry II of France, When Dauphin, attributed to Romain des Ursins (Italian, Milan, recorded in Lyon 1493–95), Franco-Italian, ca. 1490–1500, redecorated 1539. Steel, gold, and brass, h. 27½ in. (69.8 cm). Rogers Fund, 1904 (04.3.253)

Fig. 148. Armor Design for a Horse, anonymous, Italian, 16th century. Brown ink and a light brown wash on paper, 8 11/16 x 10 1/16 in. (22 x 25.5 cm). The Elisha Whittelsey Collection, The Elisha Whittelsey Fund, 1950 (50.605.9)

(see fig. 36). A few examples exist of shaffrons elaborately embossed in steel (fig. 147), perhaps for tournament use, and judging from surviving graphic sources, there must have been many others made for use in festivals, carousels, or pageants, possibly constructed of leather or papier mâché rather than steel (fig. 148).

APPLIED BORDERS AND APPLIQUÉS

Applied borders are essentially strips of decorative trim riveted along the edges of plates. They were in use to decorate armor by at least the fourteenth century (fig. 149). The earliest examples are brass or a copper alloy called latten and often have engraved decoration and are mercury gilded. One of the hallmarks of late fifteenth-century German armor in the Gothic style is that the edges of various plates, particularly breastplates and backplates, are often pierced with delicate Gothic tracery (see fig. 19). Complementing that pierced work, or used alone on solid

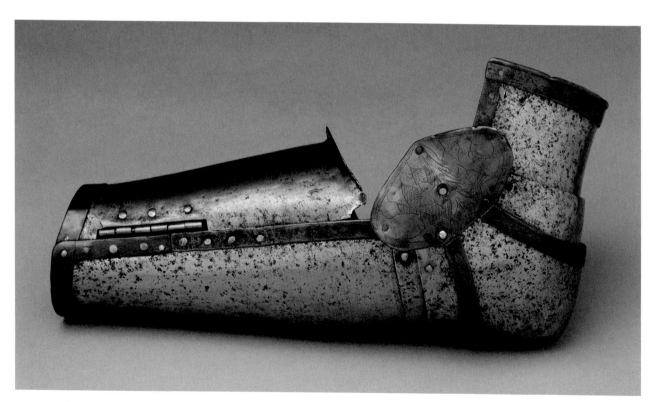

Fig. 149. Left Arm Defense (Vambrace), Italian, ca. 1380–1400. Steel and copper alloy, h. 12 1/4 in. (31.1 cm). Bashford Dean Memorial Collection, Bequest of Bashford Dean, 1928 (29.150.91g)

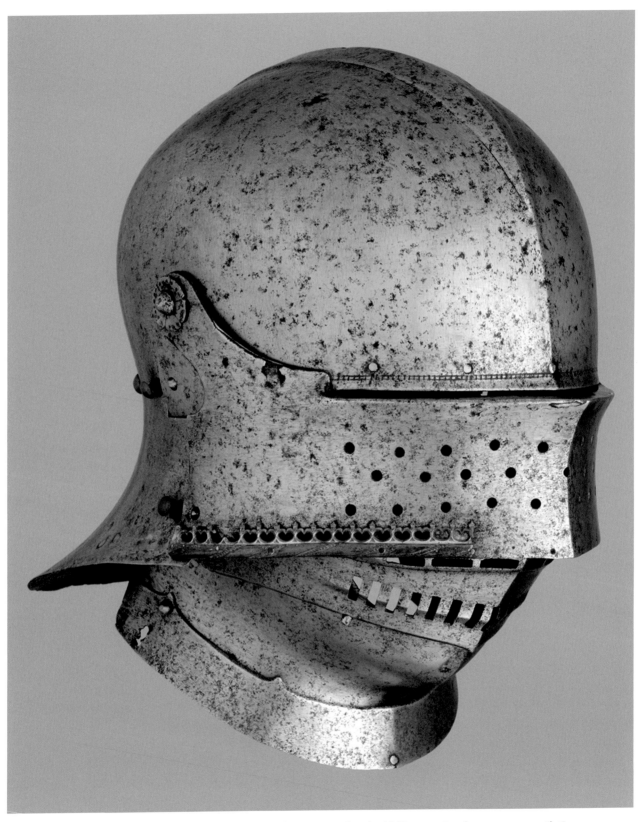

Fig. 150. Sallet of Emperor Maximilian I (1459–1519), attributed to Lorenz Helmschmid (German, Augsburg, ca. 1445–1516), German, Augsburg, ca. 1490–95. Steel, copper alloy, and gold, h. 12 in. (30.5 cm); wt. 4 lb. 15.7 oz. (2261 g). Bashford Dean Memorial Collection, Gift of Edward S. Harkness, 1929 (29.156.45). One section of the applied border remains, which originally covered the entire lower edge of the visor and the tail of the sallet

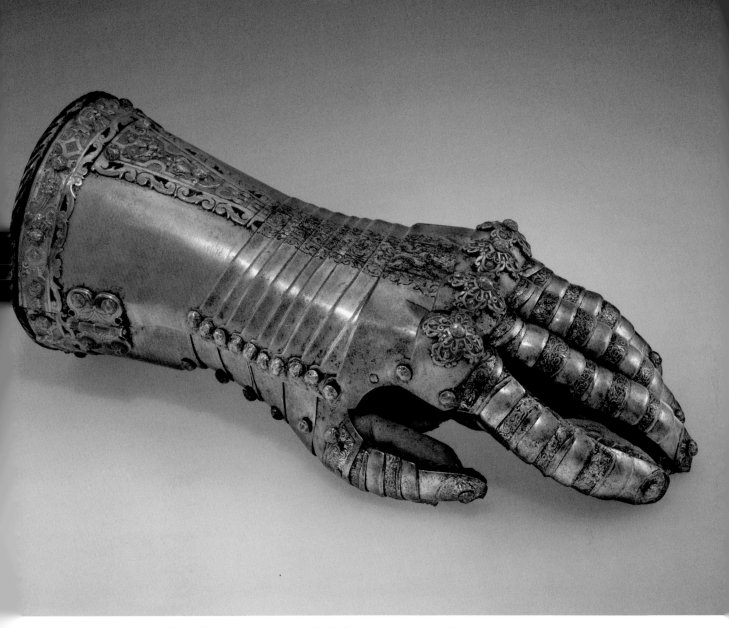

Fig. 151. Gauntlet for the Left Hand, German, Augsburg, applied gilt copper ornament attributed to Jörg Sigman (German, Augsburg, 1527–1601), ca. 1557. Steel, gold, copper alloy, and leather, l. 12 in. (30.5 cm). Purchase, Bequest of Stephen V. Grancsay, by exchange, 1984 (1984.72)

edges, one often finds applied borders of pierced and gilded brass (fig. 150). While related to applied borders, appliqués are separately made ornaments of varying shapes and materials that can be attached anywhere on the surface of armor to supplement or enhance its decoration. Probably originating as a jewelry technique in the ancient world, appliqués were used to decorate shields in Europe as early as the seventh century A.D. The use of appliqués on plate armor continued well into the seventeenth century but reached its most refined stage in about the mid-sixteenth, when some armor was fitted with appliqués of cast, pierced, and gilded copper, or even set with paste or glass gemstones (fig. 151).

HOW TO READ
EUROPEAN ARMOR

Now that we are familiar with the development of European armor, its individual pieces, principal types, and decorative techniques, we can turn to other important questions and considerations that will help us more fully understand the nature of both individual pieces and complete suits of European armor.

First impressions are important. Armor should have presence and look graceful, elegant, or strong, like a Classical sculpture or an athlete in his or her prime. If it looks clumsy, ungainly, or awkward, something is wrong. Armor is a type of kinetic steel sculpture modeled on the human body and will usually mirror the balance and proportions that were the physical ideals of the era in which it was made. The initial impression of armor is often determined by two factors: how well, or how poorly, it is set up for display and whether or not its components or parts actually match and belong together. Because a suit of armor is made up of many parts, its appearance relies heavily on how well it is fitted to a mannequin, or other display fixtures, and whether or not the parts have been assembled correctly. In addition, as we have seen, many individual pieces of armor are flexible and are usually held together by internal and external leather straps and rivets. If the straps or rivets are broken, damaged, missing, or have been incorrectly replaced, then the overall form of a piece, and its relation to any adjoining elements, will be thrown off, resulting in a negative impact on the appearance of the whole.

Even the most beautifully made armor can look terrible if it is not set up properly, so it is important to assess the quality and nature of the armor separately from its display. When in good repair and mounted on an appropriate mannequin or stand, armor has a natural stance, so that, with its parts properly assembled and arranged, it has correct proportions and balance overall. As far as possible within a modern context, this allows us to see the armor as it was originally intended to be seen when worn by the person for whom it was made.

How complete or incomplete is the armor in question? As discussed earlier, while there are many variations, essentially a complete head-to-toe plate armor from the sixteenth century consists of a helmet to cover the head; a gorget over the neck and collarbones; a cuirass with tassets and fauld defending the torso, hips, and upper thighs; a pair of pauldrons for the shoulders; a pair of vambraces for the arms; a gauntlet for each hand; cuisses covering the thighs to the knees; poleyns or knee cops for the knees; greaves, which cover the shins and calves from the base of the knee to the ankles; and a pair of sabatons covering the feet from the instep to the toes.

Opposite: Fig. 152. Detail of *The interior of the Oplotheca in Brook St. Bond St. being the finest Collection of Antient Armour in Europe, now open for public inspection.* British, London, 1816. Etching and engraving, 11⅜ x 13½ in. (28.8 x 34.2 cm). Gift of Paul M. Herzog, 1923 (23.154)

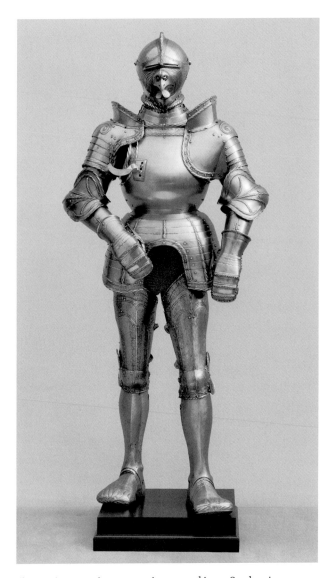

Fig. 153. A composite armor as it appeared in 1928, when it was bequeathed to The Metropolitan Museum of Art. Bashford Dean Memorial Collection, Bequest of Bashford Dean, 1928 (29.150.3a–p)

However, as we have seen repeatedly throughout this book, armor does not necessarily have to be complete to be significant. The remains of an incomplete suit of armor, and often single pieces of armor, can be extremely worthwhile and important both historically and artistically. Usually, it is only by disassembling composite armors that the beauty of their individual elements becomes apparent and can be more fully understood and appreciated (figs. 153 and 154).

Do the parts of the armor belong together? If all the parts are original and belong together, the armor is called homogeneous, a condition that is much rarer than one might expect. If the armor is assembled from parts that did not belong together originally, which may be a mix of genuine pieces from one or more armors combined with restored or fake elements, then the armor is referred to as composite or associated. This is important on a basic level because almost invariably, a composite armor lacks the

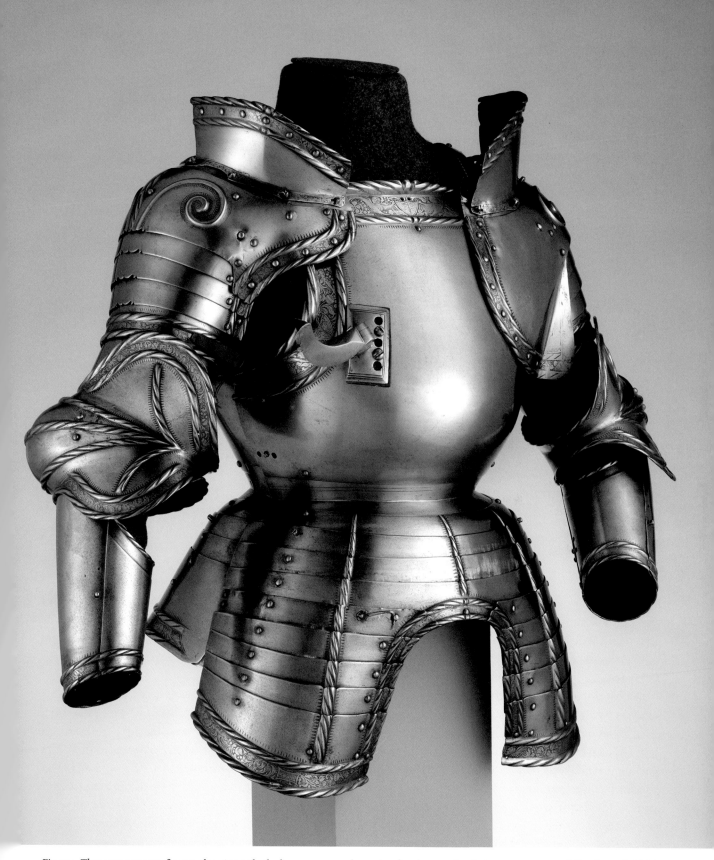

Fig. 154. The same armor as fig. 153, showing only the homogeneous elements, after the associated pieces were removed: Portions of a Field Armor, German, probably Augsburg, dated 1524. Bashford Dean Memorial collection, Bequest of Bashford Dean, 1928 (29.150.3c–j, q). For the helmet formerly associated with this armor, see fig. 144

coherence and elegance of a homogeneous armor. It no longer conveys the vision of the armorer who created it or the person who commissioned it. Nevertheless, when done carefully and by someone knowledgeable and working with good materials, a composite armor can be successful as a representation of a particular period, type, or style. When poorly done, however, composite armors are inaccurate and misleading, and at their worst, they are little more than elements of interior decoration.

How can we tell if the parts of armor belong together? Generally, this is easier to determine in armor that has decorated surfaces as opposed to plain steel. Etching, gilding, and embossing are the decorative techniques most frequently found on armor. The decoration created using any technique or design pattern should carry over from one plate to the next cohesively throughout the entire armor. If the pattern or the technique changes, whether abruptly or subtly, it is usually an indicator that the armor is a composite put together at a later date using elements from different armors.

On a homogeneous suit of armor, the decoration follows a consistent pattern, theme, or series of design motifs, usually continuing over the parts as if over an uninterrupted surface. Often, the designs include human or mythological figures, scrolling foliage and vines, and repeating geometric patterns. To confirm that the decoration really matches, its details have to be examined very carefully. For instance, in the Dos Aguas garniture, the elements are etched with matching designs that feature narrow vertical bands, filled with stylized trophies, which are arranged symmetrically and alternate with areas of plain polished steel (fig. 155).

A lot of Italian armor has this type of decoration, however, which is frequently (and incorrectly) called Pisan armor or Pisan style. Sometimes, it is in the details of the borders that mismatched decoration first becomes apparent, in this or any other style, signaling that parts are associated rather than homogeneous. On the Dos Aguas garniture, the borders of the trophy bands, from the inner edge to the outer edge, break down into four design elements: a narrow line of plain polished steel; a central strip

with a guilloche pattern (a repeating design of diagonally s-curved lines); another plain line; and, on the outer edge, a slightly sunken solid-black line. This border pattern is consistent for all the elements of the Dos Aguas garniture, except the larger of the two exchange pieces that reinforce the left elbow (see fig 81). Several possibilities can explain why the pattern is different on only one element of a garniture. It could be that the piece is associated and was added to the armor randomly at a later date and therefore does not belong to it at all. It is also possible that it was a replacement for a lost or damaged part of the same type or that it was added after the garniture was first created, but during its working lifetime and for actual use with it. Perhaps this reinforcing elbow piece was taken from a similar garniture in the Dos Aguas armory and added to this one, either intentionally during its working lifetime or for other reasons at some later date.

Since a garniture the size of the Dos Aguas armor probably was created in a large workshop by a team of craftsmen, it could be that one of the etchers was simply inattentive or failed to finish the details of the border on that one piece. If the garniture had been in several different private collections or passed through the art market, the first possibility could not be ruled out. However, because the Dos Aguas garniture remained in one family armory for many generations, the other scenarios are more probable and are equally likely to explain the small discrepancy in decoration on this one element. Also, evidence strongly supports that this elbow reinforce belongs to the garniture, as it fits the armor well and is not a random addition but an essential component for the garniture when configured for the Italian tilt.

For most styles of etched decoration on armor, this degree of detailed comparison would be enough to determine whether the armor is composite or homogeneous. However, more details have to be examined before a judgment can be made about the Italian trophy style and a few other styles of decoration. Generally, the next features to check and compare closely are the decoration on the edges of the plates, particularly where the narrow lames overlap each other, and also the treatment or finishing of the

Opposite: Fig. 155. The close helmet of the Dos Aguas garniture with the volant piece in place, fig. 83 (27.159.1a, .2b)

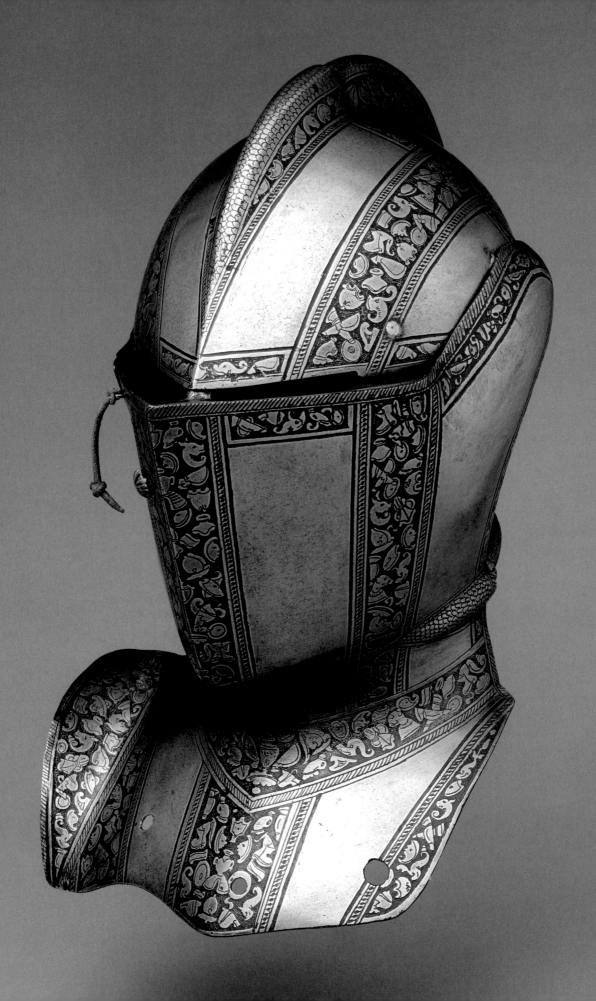

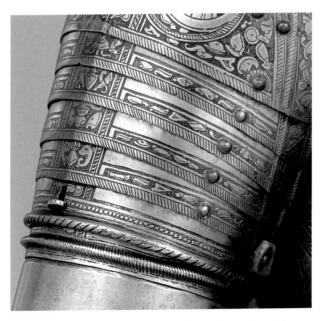

Fig. 156. Detail of etched and roped borders on the right pauldron of the Dos Aguas garniture, fig. 42 (27.159.1m)

borders at the outer edges of the plates. Again, the Dos Aguas armor provides a good example. There are a few variations, but at most of the edges where the plates overlap, the border consists of a sunken black line, a polished line, a narrower single line of trophy motifs, and then a flat band with closely set diagonal lines at the outside (fig. 156). On armor, this narrow band with diagonal lines at the edge of a plate is referred to as roping. Usually, the lines of the roping are produced by etching when the border occurs where the lames overlap, or as shallow lines formed with the edge of a file or chisel and called file roping. Deeper file roping occurs frequently on the raised or rolled lip or a turned edge, which forms the finished outer rim of a plate, such as the top of the breastplate or cuisses. The appearance and technique of the roping should be consistent throughout the various components of the armor if it is homogeneous.

Additional small details in the decoration might be present that further link the many elements of an armor or a garniture. On the Dos Aguas garniture, there is a distinctive scale pattern on the comb at the top of the helmet,

which appears again on the rim that forms the helmet's collar and continues from that rim onto the volant piece (see fig 155). A beaded line, made up of a narrow row of small circles set side by side, appears on several pieces, encircling the lowest plate of each pauldron, bordering the openings above and below the crook of each elbow, as part of the borders of the lames covering the back of the hand on each gauntlet, at the bottom edge of the greaves just above the instep area, and on the narrow lames of the sabatons. In addition, centrally placed rivets surrounded by a simple circular pattern of stylized flower petals are found on several pieces, including the gorget, the back of the pauldrons, the cuisses, the bottom edges of each sabaton, and once on each of the two reinforcing elbow pieces.

If the armor is not decorated, how can we tell if its parts belong together? Even on armor without etching, gilding, or other types of obvious decoration, there should be a coherent treatment and logic to details such as the finished edges of plates and the form of the borders. For instance, the edges of the plates could be straight or cusped or notched. The borders could be smooth or roped, and in the latter case, the roping should be consistent. Next to the border, whether smooth or roped, there may be an inner border consisting of an engraved line or one or two smooth and slightly sunken bands, which should repeat on other parts of the armor. For instance, on the late sixteenth-century Saxon jousting armor (see fig. 108), all the main elements (except for the reinforcing tournament pieces on the lower part of the helmet and the left elbow) have file-roped turned edges next to a shallow sunken band, which dips into a V-shape at the center of the edge (fig. 157). This V-shape appears at the tops of the shoulder pieces, on the wing of the right elbow cop, at the point of the cuffs of the gauntlets, in the center of the fauld lame, at the bottom of the tassets, and at the top of the cuisses. Incorporating a border treatment like this is one way of visually unifying the parts of an armor. Generally, there is some particular feature serving this function that can be detected on most types of armor, plain or decorated.

For what purpose was the armor, or its parts, made? This question can be asked at any stage and, with some

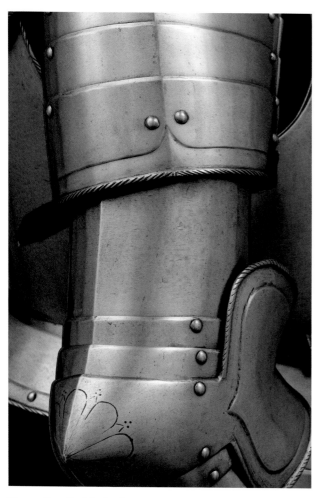

Fig. 157. Detail of the borders on the Jousting Armor (*Rennzeug*), Dresden or Annaberg, ca. 1580–90. Gift of Henry G. Keasbey, 1926, see fig. 108 (26.92.3a-w)

Fig. 158. Archival photograph showing the reflection of a pocket watch seen in an area of the original polished surface that is preserved underneath the reinforcing brow plate of Armet, Italian, Milan, ca. 1460. Steel, h. 11½ in. (29.2 cm). Bashford Dean Memorial Collection, Funds from various donors, 1929 (29.158.22)

experience, is usually an initial part of sizing up any armor or piece of armor. Once we recognize whether it was designed for field, tournament, or ceremonial use, often we can understand why it has a particular form or comprises certain parts. This, in turn, can tell us if the parts belong together, if any are missing, or if a piece has been altered or restored.

How well do the surfaces of the parts match? In addition to decoration, an important aspect of understanding any piece of armor is to carefully examine the color, texture, and overall treatment of its surfaces, starting with the outside, but also including the interiors, if possible. Although it may all appear as gray steel to begin with, different gradations of tone and finish can become apparent on closer inspection. Originally, most armor was brightly polished in the final stages of production, hence the iconic image of a knight in shining armor (fig. 158). Because steel is very susceptible to rust and corrosion, virtually every piece of armor has been cleaned or polished many times, periodically during its working life and then in later centuries as armor was preserved in civic arsenals and ancestral armories, and as individuals and then museums began to collect it from the late eighteenth century onward. Ideally, all the parts of a homogeneous armor should have relatively uniform surface patination. However, in many instances, some parts of an armor have suffered more than others from corrosion or another form of damage, making their surfaces inconsistent. Conversely, there are many examples of composite or heavily restored armors in which all the pieces have been repolished, colored, or patinated to match, giving them a deceptively homogeneous appearance. Therefore, while it is important to compare the surfaces, this is only one of the many factors that should be considered.

Look for armorers' marks, signatures, or dates.
Depending on local regulations or guild rules, armorers
stamped their work with a personal mark, usually a com-
bination of initials or symbols, which was the equivalent
of their signature. The mark was cut into one end of a steel
punch, and the other end was struck with a hammer to
indelibly stamp the mark into the steel plate of the armor
(see figs. 29, 31, 33, 35). An armorer's mark is often found
in conjunction with the view mark of the city where he
worked; it meant that the local guild or municipality had
approved the quality of the work and that it could be sold
legally. On armor made in Germany and Austria, only the
mark of a single master armorer should be found on a
given armor. In Italy, however, different armorers special-
ized in making particular parts, so an Italian armor may
have the marks of more than one master, usually beneath
the stamp of the workshop (see figs. 31 and 33). Other
stamped marks include city or state arsenal marks, indi-
cating that the piece was kept in a local or regional arsenal
rather than in a private family armory. On a few armors,
the name of the maker is incorporated into the etched
decoration; the most notable of these is the POMPEO
mark of the Milanese armorer Pompeo della Cesa (active
ca. 1537–1610) (fig. 159). Some armors have dates worked
into the decoration. In general, it is important to deter-
mine if the marks, signatures, or dates found on an armor
are consistent and make sense in relation to its type, style,
and period. Mismatched marks sometimes indicate that
an armor is composite or that fake marks have been added
to make a composite armor seem homogeneous or to
make a fake piece appear genuine.

Why fakes matter. A fake or forgery, which is inten-
tionally made to deceive (fig. 160), is entirely different
from a replica or a copy, or from a legitimate repair, resto-
ration, or conservation work that strives to preserve or
complete an object. In reference to antiques and fine art,
faking means creating an object and then misrepresenting
it as authentic for the purpose of financial profit. Even
beautiful and skillfully made fakes are rarely created exactly
in the correct style, form, or materials of the objects they
claim to be. Therefore, in addition to the ethical, legal,

Fig. 159. Detail showing the maker's name POMPEO on the
Breastplate of Portions of an Armor for Vincenzo Luigi di Capua
(d. 1627), Pompeo della Cesa, Italian, Milan, ca. 1595. Steel, gold,
leather, and copper alloy. Purchase, Arthur Ochs Sulzberger Gift,
2001 (2001.72a–d)

and financial ramifications, when a fake passes as genu-
ine, it distorts our understanding of the type of object it
purports to represent and undermines our knowledge
and appreciation of genuine historical works.

The quality of any fake can range from very obvious
to extremely convincing. Many examples of historical
armor and weapons mix genuine and fake pieces or com-
bine modern and old parts that have been altered and
reworked to match (fig. 161). The faking of historical arms
and armor began at least as early as the period of the
Gothic Revival in the late eighteenth century. What can
be considered the golden age of armor forgeries ranges

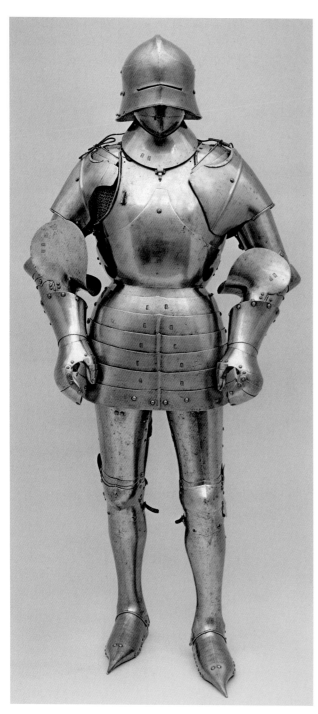

Fig. 160. A fake armor, long accepted as an important original, attempting to represent the style of the mid-fifteenth century, made in Italy about 1850 from new, old, and reworked parts. Steel and leather. Rogers Fund, 1904 (04.3.295a–t)

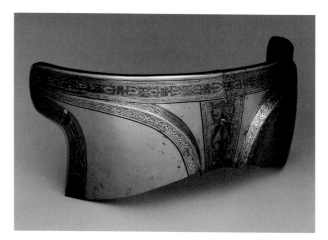

Fig. 161. Cantle plate of an Armored Saddle. Right half: Italian, probably Milan, ca. 1575; left half: hammerwork by Sylvain Marchat (ca. 1870–1927), decoration by François Daubresse (born 1853), French, late 19th century. Steel and gold. Gift of William H. Riggs, 1913 (14.25.1880)

from about the middle of the nineteenth century through the first few decades of the twentieth century. Countless fakes exist, and more continue to be made (fig. 162).

The ties that bind: straps, hinges, rivets, and linings. Armor was made to move rapidly, vigorously, and continuously. The fittings and fixtures that hold armor together are what originally enabled it to function properly. With the exception of certain types of individual elements, such as a helmet forged in one piece, plate armor is made up of multiple movable steel parts. The mark of a well-made armor is that all these parts, in whatever combination of shapes and sizes, fit together perfectly and maintain their proper alignment in relation to one another, while they are also flexible or rigid as required by their position and function. To this end, the plates of any part of an armor are carefully designed so that they will overlap, nest, abut, or connect as needed. To connect the plates, armorers utilized a variety of fittings or fastening mechanisms, principally straps and buckles, hinges, rivets, and internal leather straps (see figs. 61, 65, and 69). Some armor parts were also covered on the interior with a padded textile or leather lining for the comfort of the wearer and to prevent plates from rubbing together. It is

Fig. 162. Armorer's punch, made to falsify an armorer's mark of the 15th century Milanese style. Probably German or Swiss, early to mid-20th century. Steel. Gift of Jürg A. Meier, former Curator, Castle of Grandson, 2017

important to keep in mind, however, that original fittings such as these are fairly rare. Many, particularly those involving textile and leather, could have been replaced as a result of wear and tear during the working lifetime of an armor as part of its regular maintenance. But, from the late eighteenth century on, when armor began to be collected regularly as a desirable antique, it was very common for original fittings to be removed or replaced when the piece was refurbished or restored. It is likely that damaged linings were simply detached and discarded. It was not uncommon for restorers in the nineteenth century to disassemble armor completely, removing all the original straps and buckles, all traces of original linings, and even all the rivets, in order to more easily clean and restore the individual parts of the armor to the standards of that period. Sometimes, as part of the restoration process, the armor was reassembled using all new fittings, often made to look old. This practice continued in varying degrees well into the twentieth century, both in the art market and in museums. Therefore, original fittings, where they do survive, are very important for their rarity and for what they can tell us about the history and condition of a particular piece of armor and the history of armor making in general. Even in a modern-day setting and under ideal conditions, it is still sometimes necessary and desirable to replace leather straps or other fittings, which

may be defective nineteenth- or twentieth-century restorations, when they are so badly deteriorated or damaged that the armor cannot be stored or displayed properly.

Straps and buckles joining pieces of armor are depicted in sculpture and other works of art from the thirteenth century on and can be found on surviving objects from the fourteenth century on (fig. 163). On sixteenth century plate armor, they are commonly used as an expedient and easily adjustable way of attaching the pauldrons; as shoulder straps linking the breastplate to the backplate; as a waist belt to cinch the cuirass; to suspend the tassets from the fauld lames below the breastplate; and to fasten other parts, such as the straps that secure the cuisses at the back of the thighs (see fig. 42b). The buckles are most often iron, but they can also be copper or brass, which is sometimes gilded. The straps are usually made of tanned leather, but on more luxurious armor, they can be silk.

Simple hinges, for instance attaching cheek pieces to the sides of helmets, survive on examples dating from

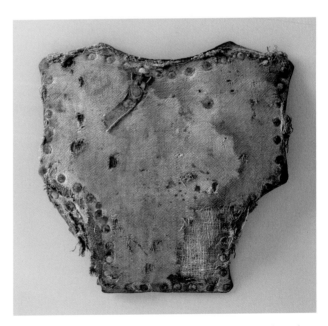

Fig. 163. Backplate from a Brigandine, retaining its original textile covering, strap, and buckle, Italian, ca. 1400–1425. Steel, brass, leather, and textile (linen, wool). Bashford Dean Memorial Collection, Bequest of Bashford Dean, 1928 (29.150.104)

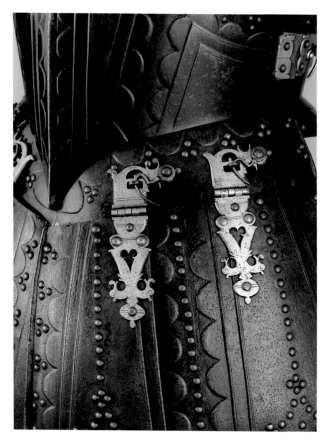

Fig. 164. Hinge and hook-eye fastening on the early 17th century Pikeman's Armor seen in fig. 23

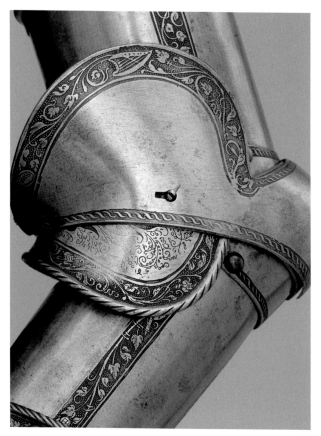

Fig. 165. Keyhole slot and turning pin on Armor of Emperor Ferdinand I seen in figs. 120–123

at least as early as the seventh century and remain in frequent use on armor for the next one thousand years. The style of a hinge, particularly the flat plate, called the leaf, can be helpful in assigning a date and sometimes even a region of origin to a piece (fig. 164). Other fixtures include various types of hook-and-eye attachments, keyhole slots engaged by domed rivets or turning pins (fig. 165), a short post with a spring-loaded lug attached to one plate that passes through a hole in an adjoining plate, and a pin catch in which the springiness of one plate holds a button or knob through a hole in an adjacent plate thereby locking them together. The latter fitting is most often used to secure the two halves of the lower cannons of vambraces (see fig. 65) and front and back halves of greaves.

Rivets, usually with domed heads, are visible on nearly every piece of plate armor. The placement of most

rivets is determined by their function, but some, such as those grouped in small clusters, are arranged for decorative effect. Usually, original rivets are made of iron, which can be determined by turning the plate over and looking at the end of the rivet shank, which is the cylindrical part of the rivet that passes through the plates and is peened over in the interior. The domed heads can be gilded or capped with brass, but if the entire rivet, comprising the rivet head and shank, is brass, then most often, it is a later replacement. The rivets that follow the contours at the edges of a piece are usually lining rivets; these secure a narrow strip of leather around the edges of the interior of a piece, such as a pauldron or the bowl of a helmet, to keep the metal plates from rubbing together or to which a textile lining could be stitched. Structural rivets, which hold lames together and allow movement, run in straight lines

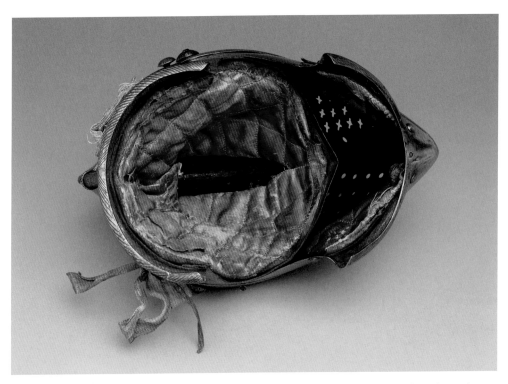

Fig. 166. Original textile lining preserved in Close Helmet for the Tourney, German, Augsburg, late 16th century. Bequest of George D. Pratt, 1935 (48.149.31)

from lame to lame. These rivets hold the internal leather straps that articulate the plates, or they link the lames directly to one another (see fig. 61). Blind rivets, without domed heads, are usually unseen from the outside and are hammered flush with the surface of the surrounding plate. They are used to attach internal articulating leather straps and lie under the overlap between two plates or lames. If rivets pass through small rectangular slots rather than circular holes then they are called sliding rivets. The slots give the adjoining plates some extra range of motion. Whether the rivets hold a piece of leather or two plates directly, they are peened over a washer. On exterior straps, the rivet washer can be plain but are often stamped brass with a decorative pattern (see fig. 58). In interiors, the washers are plain and sometimes appear crudely cut from pieces of scrap metal. When an armor or piece of an armor is properly riveted, its movements, flexibility, and articulation are surprisingly fluid and supple, as long as the internal leathers are secure and in good condition.

Most linings that survive are in helmets, but pauldrons, breastplates, backplates, tassets, and some pieces of horse armor also were lined. The lining material can be leather, plain cloth, or silk, and is usually stuffed or padded with horsehair, cotton, or other materials (fig. 166). One of the few armors to retain all its original fittings and linings is the diminutive armor attributed to the ownership of Infante Luis, Prince of Asturias (1707–1724), made by a royal armorer in Paris in 1712, when Luis was only five (fig. 167). Perhaps because it was quickly outgrown by its young owner, this armor survives in nearly pristine condition, preserving all its original velvet straps, trimmed with galloon, gilt buckles, gilt rivet heads, and with all its elements lined in red silk edged with semicircular tabs called piccadills. It is possibly the very last armor that was made in Europe by a trained armorer who was part of an unbroken tradition dating back to the early Middle Ages.

Opposite: Fig. 167. Armor of Infante Luis, Prince of Asturias, Jean Drouart (French, Paris, died before October 1715), dated 1712. Steel, gold, brass, silk, cotton, metallic yarn, and paper, h. 28 in. (71.1 cm). Purchase, Armand Hammer, Occidental Petroleum Corporation Gift, 1989 (1989.3)

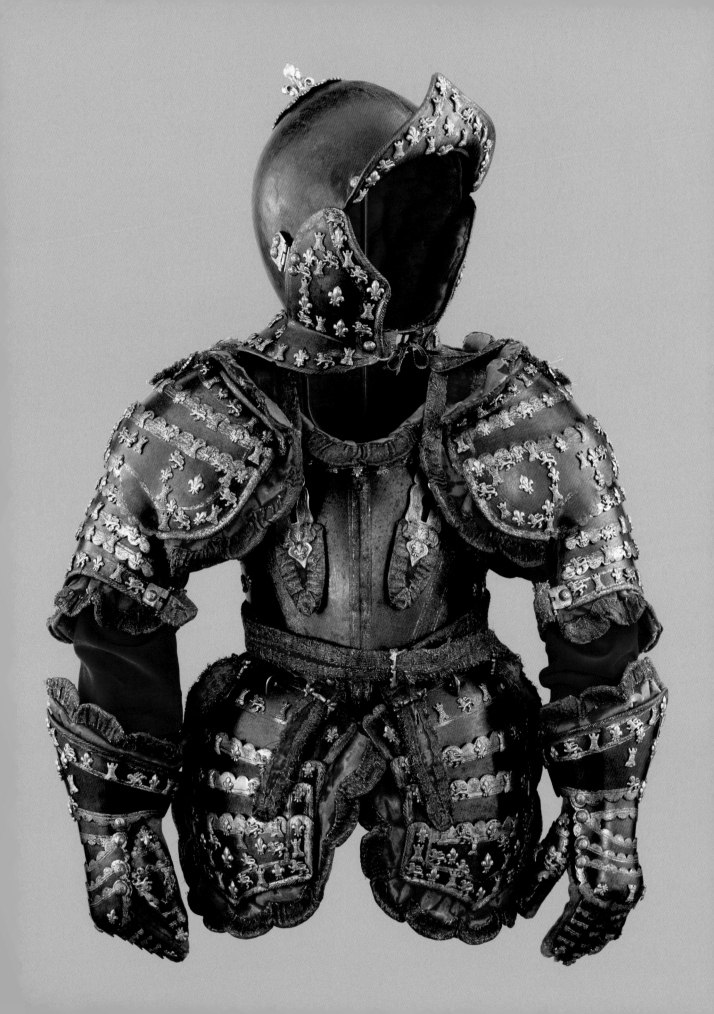

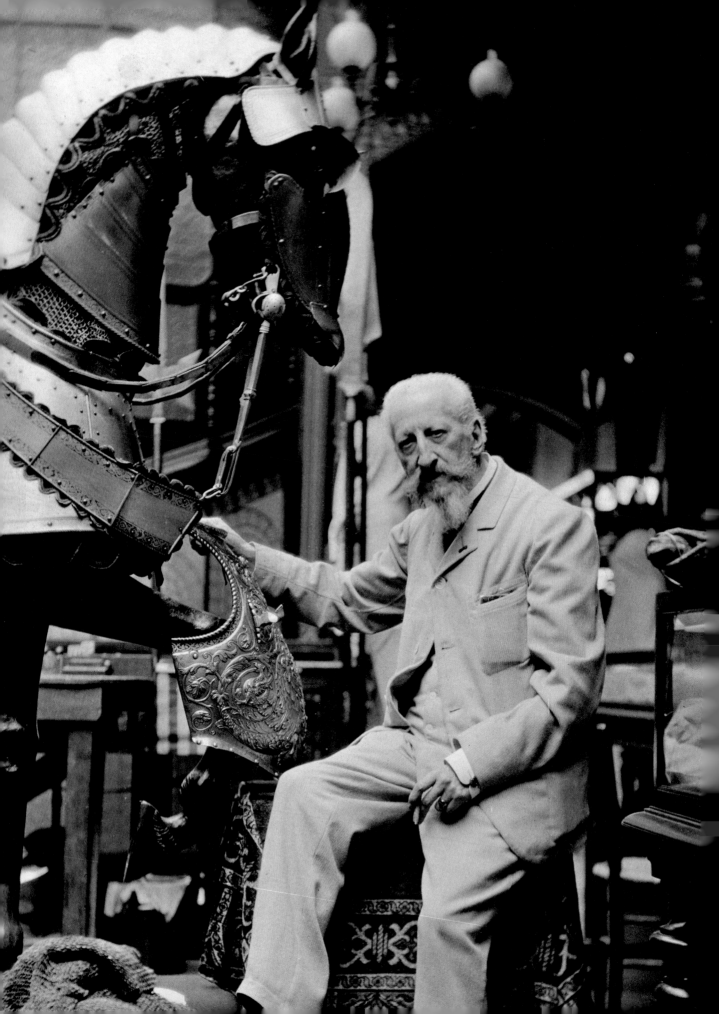

EPILOGUE

To conclude our survey, we will consider the fate of European plate armor after it became obsolete, suffered a long period of neglect, and later was transformed into an important part of many museum collections in Europe and the United States.

In the seventeenth century, outmoded plate armor was often cut up and reused to make other types of armor (fig. 169). Later, much of it was simply discarded or scrapped, although some armor was repurposed in interesting ways (fig. 170). Traditionally, the largest concentrations of armor were housed in designated storerooms

Fig. 169. Detail of the faint remains of mid-16th trophy-style etching found on the interior of the 17th-century gorget in fig. 57 (1992.137), showing that the gorget was made of reused earlier armor

Fig. 170. Armor for the festival known as the *gioco del ponte*, made in the late 18th or early 19th century from repurposed 16th century parts. Purchase, Arthur Ochs Sulzberger Gift, 2012 (2012.134a, b)

Opposite: Fig. 168. William Henry Riggs (1837–1924) photographed in his Paris townhouse with his collection shortly before he donated it to The Metropolitan Museum of Art in 1913. Archives of the Department of Arms and Armor

called armories, found in countless castles, palaces, and private residences of the nobility and in the municipal arsenals of various cities. While the contents of most armories were dispersed with little or no trace remaining, individual armors or entire armories sometimes were preserved among the heirlooms of noble families or as symbols of civic pride. By the late seventeenth century, some armories were opened to the public as historical curiosities, and by the mid- to late nineteenth century, several of these evolved into museums or formed the nucleus of museum collections. In this way, the armories of royal and high ranking noble families became the foundations of today's Museum of the Royal Armory in Madrid, the Court Hunting and Armor Cabinet of the Art History Museum in Vienna, the Royal Armouries at the Tower of London and Leeds, the Army Museum in Paris, the Royal Armory in Stockholm, and the Armory of the Dresden State Art Collections, while major civic arsenals preserved as museums include the Styrian Armory or Landeszeughaus (Regional Arsenal) in Graz, Austria, and the Altes Zeughaus (Museum of the Old Arsenal) in Solothurn, Switzerland.

The practice of collecting arms and armor by private individuals overlapped with this period and coincided with the Gothic Revival, a broad cultural movement centered on renewed interest in and reinterpretation of the

Fig. 171. *Die Rittersaal zu Erbach*, German Darmstadt, ca. 1850. Engraving, 9 x 5¾ in. (22.9 x 14.6 cm). Purchase, Arms and Armor Budget Fund, 2002 (2002.293). The armor of Ferdinand I (see figs. 120–123) originated from this Gothic Revival armory

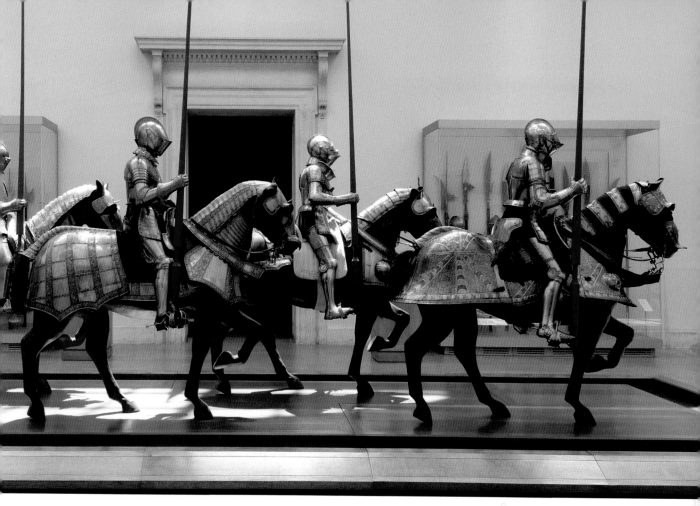

Fig. 172. Armors for Man and Horse on display at The Metropolitan Museum of Art. Left to right: Italian, Milan and Brescia, ca. 1580–90, Man's armor: Gift of William H. Riggs, 1913 (14.25.709a–p); Horse armor: Fletcher Fund, 1921 (21.139.1a–w); Italian, probably Milan, ca. 1560, Man's armor: Gift of William H. Riggs, 1913 (14.25.717a, c–r); Horse armor: Fletcher Fund, 1921 (21.139.2); Wolfgang Grosschedel, 1517–1562, German, Landshut, Man's armor: ca. 1535; Horse armor: dated 1554, Fletcher Fund, 1923 (23.261); Kunz Lochner (1510–1567), German, Nuremberg, both dated 1548, Man's armor: Bashford Dean Memorial Collection, Gift of Mrs. Bashford Dean, 1929 (29.151.2); Horse armor: Rogers Fund, 1932 (32.69), which also came from the armory in fig. 171

Middle Ages, which influenced art, architecture, and literature in Europe and America from the late eighteenth century to the late nineteenth century (fig. 171). Collectors ranged from noblemen and even heads of state, such as Emperor Napoleon III (1808–73) of France, to local antiquarians, amateur historians, businessmen, and gentlemen of means, many of whom were passionate in their devotion to acquiring antique arms and armor. While the majority of these private collections, formed between the mid-nineteenth and mid-twentieth century, were sold off or otherwise dispersed after the death of their owners, some, through gift, bequest, or purchase, became vital parts of public institutions (see fig. 168). Among the most important museum collections of European armor that stem directly or indirectly from great private collections are the Wallace Collection in London, the Kienbusch Collection in the Philadelphia Museum of Art, and the Department of Arms and Armor in The Metropolitan Museum of Art (fig. 172).

In these public collections, armor is accessible for study and enjoyment by a wide-ranging international audience. As something made to be worn, either in life and death situations or in moments of pomp and circumstance, it presents a personal and evocative manifestation of the past that is rivaled by few other historical objects. Along with armor's rarity, beauty, and mystique, it is a captivating expression of creativity, uniquely merging our innate desire for safety and our timeless fascination with adornment.

Fig. 173. *Officers and Other Civic Guardsmen of the XIth District of Amsterdam*, Jan Tengnagel (1584–1631), Dutch, 1613. Oil on canvas, 61 x 104 in. (155 x 264 cm). Rijksmuseum Amsterdam (SK-C-407), on loan from the City of Amsterdam. Three of the sitters wear elaborately decorated cuirasses. Two on the left, worn by Captain Geurt Dircksz van Beuningen and Lieutenant Pieter Martensz Hoeffijser, are Flemish

or Dutch. One on the far right, worn by Aert Keyser, is Milanese and very similar in date and style to the Dos Aguas armor (see fig. 42). Several of the other guardsmen wear ornate gorgets (like those in fig. 57, middle row) over buff coats or doublets

A

TREATISE

ON

ANCIENT ARMOUR

AND

WEAPONS,

ILLUSTRATED BY

Plates taken from the ORIGINAL ARMOUR in the Tower of London,
and other Arfenals, Mufeums, and Cabinets.

By FRANCIS GROSE, Efq.ʳ F.A.S.

J. Newton fculp.t

PRINTED FOR S. HOOPER Nº 212 HIGH HOLBORN.

MDCCLXXXVI.

SUGGESTED READING

The first few books that attempted to understand the history and development of European armor were published in the late eighteenth century (fig. 174). Critical knowledge of the subject developed slowly in the first half of the nineteenth century in England, Germany, and France, and then with increasing momentum, from the late nineteenth century onward, in the rest of Europe and the United States. As with other specialized fields of study, most of the leading researchers tend to publish primarily, if not solely, in their native language. Therefore, to fully benefit from the extensive literature on armor, a reading knowledge of the principal Western European languages, in addition to English, is an unavoidable necessity. However, the English-language publications listed below offer reliable and accessible pathways to many important aspects of the subject.

Blair, Claude. *European Armour, circa 1066 to circa 1700.* 3rd ed. London: B. T. Batsford Ltd., 1979 (1st ed. 1958).

Capwell, Tobias, with David Edge and Jeremy Warren. *Masterpieces of European Arms and Armour in the Wallace Collection.* London: Wallace Collection; Paul Holberton, 2011.

Edge, David, and John Miles Paddock. *Arms and Armor of the Medieval Knight: An Illustrated History of Weaponry in the Middle Ages.* New York: Crescent Books, 1988.

Fallows, Noel. *Jousting in Medieval and Renaissance Iberia.* Armour and Weapons. Woodbridge, U. K.: Boydell Press, 2010.

Grancsay, Stephen V. *Arms and Armor: Essays by Stephen V. Grancsay from The Metropolitan Museum of Art Bulletin, 1920–1964.* With introduction and bibliography by Stuart W. Pyhrr. New York: The Metropolitan Museum of Art, 1986.

Karcheski, Walter J., and Thom Richardson. *The Medieval Armour from Rhodes.* Leeds: Royal Armouries Museum; Worcester, Mass.: Higgins Armory Museum, 2000.

Laking, Sir Guy Francis. *A Record of European Armour and Arms through Seven Centuries.* With introductions by Charles Alexander Cosson and Claude Blair. Vol. 6 edited by Francis Henry Cripps-Day. 6 vols. Cambridge, U. K.: Ken Trotman, 2000 (1st ed. London: G. Bell and Sons, 1920–22).

LaRocca, Donald J. *The Gods of War: Sacred Imagery and the Decoration of Arms and Armor.* Exh. cat., 1996–97. New York: The Metropolitan Museum of Art, 1996.

LaRocca, Donald J., ed. *The Armorer's Art: Essays in Honor of Stuart Pyhrr.* Woonsocket, R.I.: Mowbray Publishing, 2014.

Martin, Paul. *Arms and Armour from the 9th to the 17th Century.* Translated by René North. Rutland, Vt.: Charles E. Tuttle, 1968 (French and German eds. 1967).

Norman, A. V. B., and Don Pottinger. *English Weapons and Warfare, 449–1660.* 1st U.S. ed. Englewood Cliffs, N.J.: Prentice-Hall, 1979.

Pfaffenbichler, Matthias. *Armourers.* Medieval Craftsmen. London: British Museum Press, 1992.

Pyhrr, Stuart W. *European Helmets, 1450–1650: Treasures from the Reserve Collection.* Exh. cat., 2000–2001. New York: The Metropolitan Museum of Art, 2000.

Pyhrr, Stuart W. *Of Arms and Men: Arms and Armor at the Metropolitan, 1912–2012.* New York: The Metropolitan Museum of Art, 2012. Reprint of *The Metropolitan Museum of Art Bulletin* 70, no. 1 (Summer 2012).

Pyhrr, Stuart W., and José-A. Godoy. *Heroic Armor of the Italian Renaissance: Filippo Negroli and His Contemporaries.* With essays and compilation of documents by Silvio Leydi. Exh. cat., 1998–99. New York: The Metropolitan Museum of Art, 1998.

Pyhrr, Stuart W., Donald J. LaRocca, and Dirk H. Breiding. *The Armored Horse in Europe, 1480–1620.* Exh. cat., 2005–6. New York: The Metropolitan Museum of Art; New Haven and London: Yale University Press, 2005.

Pyhrr, Stuart W., Donald J. LaRocca, and Morihiro Ogawa. *Arms and Armor: Notable Acquisitions, 1991–2002.* Exh. cat., 2002–3. New York: The Metropolitan Museum of Art; New Haven and London: Yale University Press, 2002.

Richardson, Thom. *Arms and Armour of the Elizabethan Court.* Leeds: Royal Armouries Museum, 2015.

Richardson, Thom. *The Armour and Arms of Henry VIII.* Leeds: Royal Armouries Museum, 2002.

Terjanian, Pierre. *Princely Armor in the Age of Dürer: A Renaissance Masterpiece in the Philadelphia Museum of Art.* Philadelphia Museum of Art Bulletin, n.s., 4. Philadelphia: Philadelphia Museum of Art; New Haven and London: Yale University Press, 2011.

Terjanian, Pierre. "The Art of the Armorer in Late Medieval and Renaissance Augsburg: The Rediscovery of the *Thun Sketchbooks.*" Thun-Hohenstein Albums 1. *Jahrbuch des Kunsthistorischen Museums Wien* 13–14, 2011–12, pp. 298–395.

Terjanian, Pierre. "The Art of the Armorer in Late Medieval and Renaissance Augsburg: The Rediscovery of the *Thun Sketchbooks*; Part II." *Jahrbuch des Kunsthistorischen Museums Wien* 17–18 (2015–16), pp. 152–292.

Williams, Alan. *The Knight and the Blast Furnace: A History of the Metallurgy of Armour in the Middle Ages and the Early Modern Period.* History of Warfare 12. Leiden and Boston: Brill, 2002.

Opposite: Fig. 174. Title page from the first English-language book on the subject of historical armor. *A Treatise on Ancient Armour and Weapons*, Francis Grose, London, 1786. Library of the Department of Arms and Armor

ACKNOWLEDGMENTS

I am very grateful for the assistance and encouragement of many colleagues at The Metropolitan Museum of Art. In the Department of Arms and Armor: Pierre Terjanian, Arthur Ochs Sulzberger Curator in Charge, Stuart Pyhrr, Stephen Bluto, John Byck, Catherine Chesney Carotenuto, Hermes Knauer, Lindsay Rabkin, George Sferra, Marina Viallon, and especially Edward Hunter and Sean Belair for skillfully conserving more than forty objects and preparing nearly one hundred for new photography; in the Department of Drawings and Prints: Femke Speelberg and Freyda Spira; in the Publications and Editorial Department: Mark Polizzotti, Gwen Roginsky, Michael Sittenfeld, Peter Antony, Elizabeth De Mase, Christopher Zichello for his adroit production, Rita Jules of Miko McGinty Inc. for her remarkable design, and my stalwart editor, Barbara Cavaliere; in the Imaging Department: Barbara Bridgers, Mark Morosse, Wilson Santiago, and, above all, Bruce Schwarz for his superb photography. In addition, my thanks to several colleagues outside the Metropolitan, including Jürg Meier, Noel Fallows, Jeroen Punt, Mario Scalini, Jonathan Tavares, and Jeff Wasson.

For generous financial support that helped make this book possible, I am happy to thank the Diane W. and James E. Burke Fund for its lead support of this publication and the following members of the Visiting Committee of the Department of Arms and Armor at the Metropolitan Museum for their greatly appreciated generosity: Ronald S. Lauder, Marica F. Vilcek, Laird R. Landmann, Kenneth Lam and Vivian Chui Lam, Irene Roosevelt Aitken, and Paul Ruddock.

Donald J. La Rocca
Curator, Department of Arms and Armor
The Metropolitan Museum of Art